For my son,
**Charlie**

Any profit I make from this book
will go to help children who suffer
from Asperger's syndrome & autism

# Preface
## John Swannell

This book originated from a conversation I had over a glass of champagne with Hilary Alexander, the fashion editor of the *Daily Telegraph*, after a shoot. She told me she had been to a Rolling Stones concert the previous night, which she said was fantastic, but she added that she couldn't believe that they were all still standing.

I said that would make a great title for a book: "I'm still standing". So we both started to make a list of all the people who had survived the second half of the 20th century. The book was going to be about survivors: it's one thing to make it to the top, but it's another to stay at the top for so long. The next day I composed a letter to all the people on our list.

Of course not everybody is in this book. Some couldn't do it; some wouldn't. Some had commitments; others lived in America or other parts of the world and were not coming back to the UK in the near future.

The subjects of the book are predominantly British, but there are a few exceptions. I know most of the people between these covers and enjoyed meeting the ones I didn't. With Peter O'Toole, for example, after I'd finished taking his portrait he said, "Don't go, I've got a friend dropping in to see me and I'd love a photograph of us both together." Ten minutes later Kevin Spacey walked through the door.

Glenda Jackson (who was much smaller than I had expected) was a dream. I was desperate to chat to her about her movies but thought that, considering she was an MP, she would be far too serious and not want to hark back to the past. Not a bit of it. She talked about Ken Russell and most of the other stars she'd worked with, and answered all of my boring and over-familiar questions with incredible patience. Mel Smith, one of the kindest men I have ever met, is incredibly talented, a wonderful talker and fantastic company. I only wish there were more Mels in the world.

George Melly made me laugh a lot. I asked him if he knew Mick Jagger. I told him I was trying to get him for this book. George said he used to know him well, but hadn't seen him for years, until a party he'd gone to a while back, where Jagger came through the door with a beautiful young girl. He left her alone for a moment, so George asked the girl if that was Jagger she came in with.
"Yes," she replied.
"I haven't seen Mick for about twelve years," Melly said. "He's looking so wrinkly these days."
"They're not wrinkles," she snapped, "they're laughter lines."
"Nothing is that funny," said George.

The Marquis of Bath was kind enough to invite me and my assistant to lunch. His cook had the day off and lunch was a bit like school dinners, but he was charming, very civilised and a dream to photograph.

Then there was Michael Winner, also charming and very amiable, but he told me not to let my lens venture below his chin. He told me Orson Wells taught him that secret. He also asked me to send him a copy of the picture. When I did, he wrote back saying that, in his 67 years on this earth, it was the worst picture ever taken of him. I thought, it's only rock'n'roll. Roger Moore insisted on taking my picture too, which was very amusing.

Sir Norman Foster, who I think is one of England's greatest talents, was a quiet, sincere man with one of the most spectacular apartments in London (which of course he designed himself) overlooking the Thames and Albert bridge.

Bob Geldof, as we all know, is a one-off. I like him very much. He has a sort of honest dignity, which is kind of rare in the rock and roll industry. I am glad he agreed to be in this book.

David Bailey, who completely changed fashion photography in the 1960s , is one of the best portrait photographers in this country. James Joyce was a great 20th century writer. Francis Bacon was a great 20th century painter. Bailey, I believe, is a great 20th century photographer. History may prove me wrong, but I doubt it.

Baroness Thatcher could not have been more helpful when I photographed her. After I sent her some snaps, she replied with a note saying she hoped she would go down in posterity looking like that.

Sir Anthony Bamford is an incredibly kind man with impeccable manners, one of the few real English gentlemen left in this country. Delia Smith rang up after the shoot and invited my wife and me to her home, where she cooked dinner for us and two other guests. I have been dining out on that story ever since!

Then there is Joanna Lumley, who is on the cover of this book, who is a very special lady that we all know and love: a brilliant actor and still a great beauty. Maureen Lipman is a lovely lady and very bright, and as we all know very funny, with an intellectual wit that is as sharp as a knife. Johnny Gold's name fits him like a glove: Johnny is such a friendly name, and he really does have a heart of gold.

Finally, Andrew Lloyd Webber has always been extremely generous to me over the years. Just one example of this is the private audience he gave my daughter Sophia, who is studying in New York and whose ambition is to go on the stage. Andrew made time to get a pianist in and listen to her sing. He is a very special person.

Unfortunately, a few people didn't make it, like John Gielgud, who was witty and very wise. I asked him if I could walk round his garden after the shoot. His face lit up, and he put his coat on and gave me a guided tour.

Another who didn't make it was HM The Queen Mother, who I photographed with HM The Queen, HRH Prince Charles and Prince William for the Royal Mail stamp commemorating her 100th birthday. We talked mostly about Cecil Beaton, her favourite photographer. She'll be sadly missed.

Finally, Spike Milligan. When I photographed him at his house in the country he was 83. He had a pool in the garden and said he swam every day. I asked if he had seen or spoken to Prince Charles since the notorious incident in which he called him a "grovelling bastard" upon receiving a note of congratulation from an awards ceremony.
"No," he said. "I did send him a letter though."
"What did it say?" I asked.
" 'I suppose a knighthood is out of the question!' "

I really have enjoyed doing this book, never quite knowing what people are going to be like. That's what being a photographer is: the unpredictability of the whole process, the excitement, no time to get bored or complacent. I really do think I have the best job in the world. ROCK n'ROLL!

# Introduction
## Sir Roy Strong

The portrait gallery gathered together in this book is a reminder of how long some people have been around. Here we are at the opening of the 21st century. Up there in the 60s and 70s, and earlier, these faces were untouched by the hand of time and in their youthful prime. A few, like The Queen Mother and Sir John Gielgud, have fallen, but only at stupendous ages.

Its composition is heavily weighted in favour of those engaged in some way or other with what we categorise as show business. Well over half the sitters here belong to the world of theatre, film or television. They range from those who occupy the Olympian heights, like Dame Judi Dench and David Puttnam, to those on the foothills, like Cilla Black and Lulu. Apart from Baroness Thatcher, Glenda Jackson and Ken Livingstone, we are spared the tarnished world of politics. The remainder is a *pot pourri*: the occasional writer, a design guru, an architect, an entrepreneur, a hairdresser, a model. These make a happy contrast.

The intriguing task for the peruser of this garland of faces is to pick out the long-term winners in the hall of fame from those who will not be worthy of even a footnote. Indeed, perhaps their immortality may come only from their inclusion here.

John Swannell I always think of as a bit of a chameleon, albeit a brilliant one. He is able to wave the magic wand, but here, far more, we see his preoccupation with human beings as they age, most of the portraits not shrinking from the warts-and-all approach. Glenda Jackson looks as though she has just been parted from her supermarket shopping trolley, Sir Jocelyn Stevens glints in a manner which recalls *The Godfather*, and Mel Smith's mischievous persona is caught as his eye-popping features peer around a vertical arrangement of screens. No composition is unconsidered.

Certain stylistic tricks run as *leitmotifs* through these pictures. Heads are truncated and sitters are often moved asymmetrically to one side of the camera's frame, usually to the left, and a section cut off. Windows recur, with sitters placed either in front of one or to one side, resulting in *contre jour* effects. There is a penchant too for doors and gates. Inevitably one registers a litany of those whose work has inspired him: the elegant romanticism of Cecil Beaton, the "in your face" punch of David Bailey and Richard Avedon's delight in silhouette. They and others have all contributed to the making of the art of John Swannell.

# Contents

**Bryan Ferry**
Musician & singer

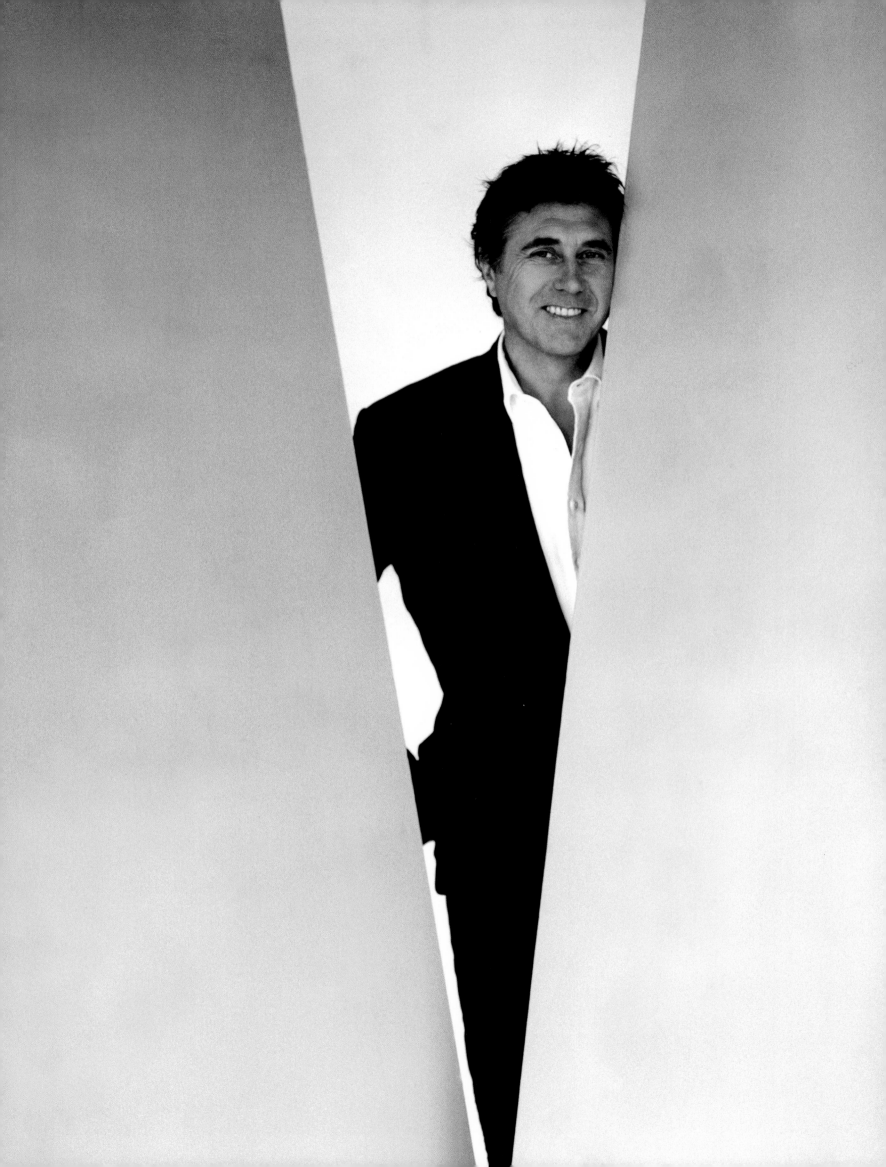

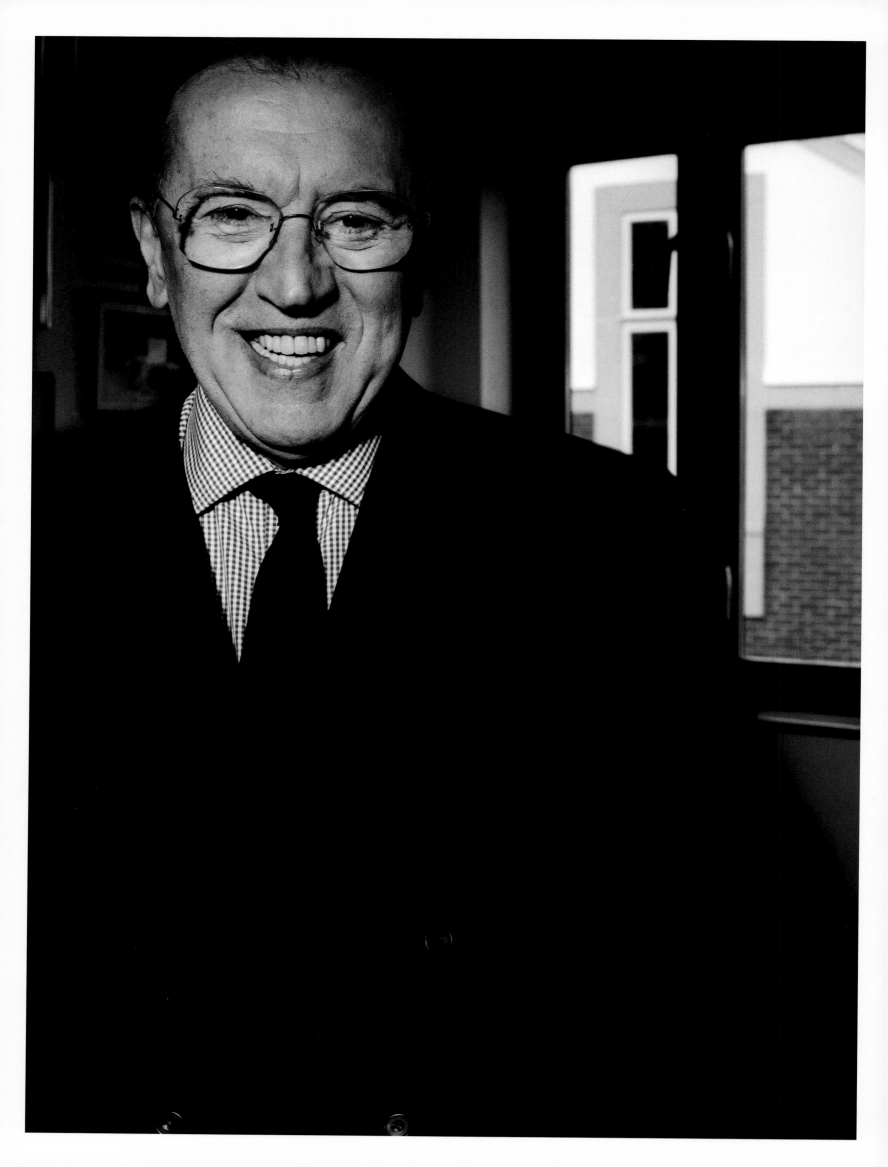

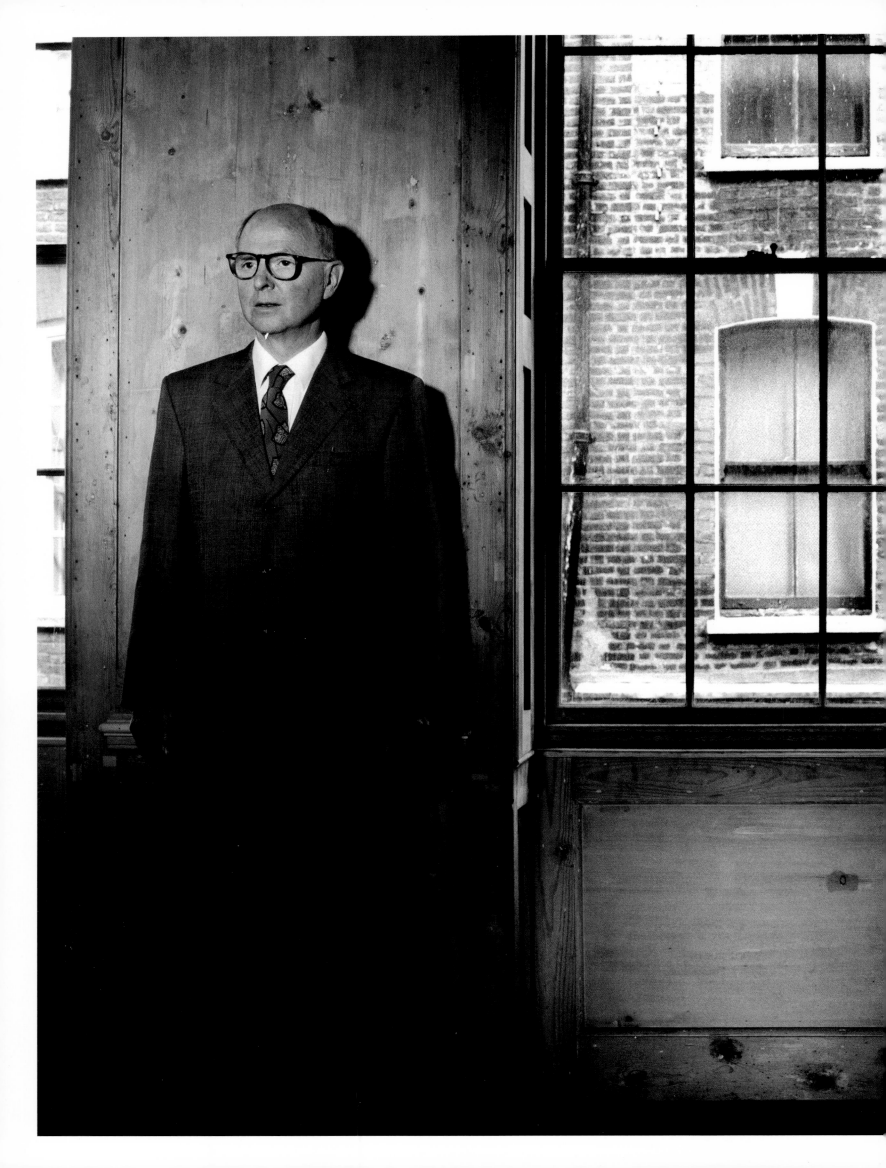

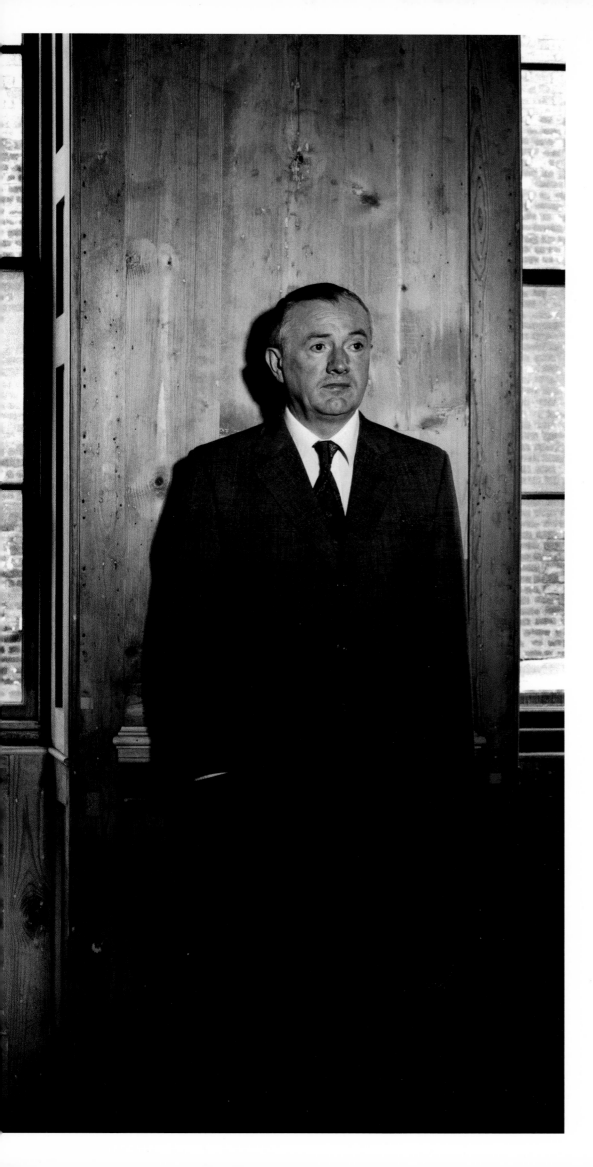

**Helen Mirren**
Actor

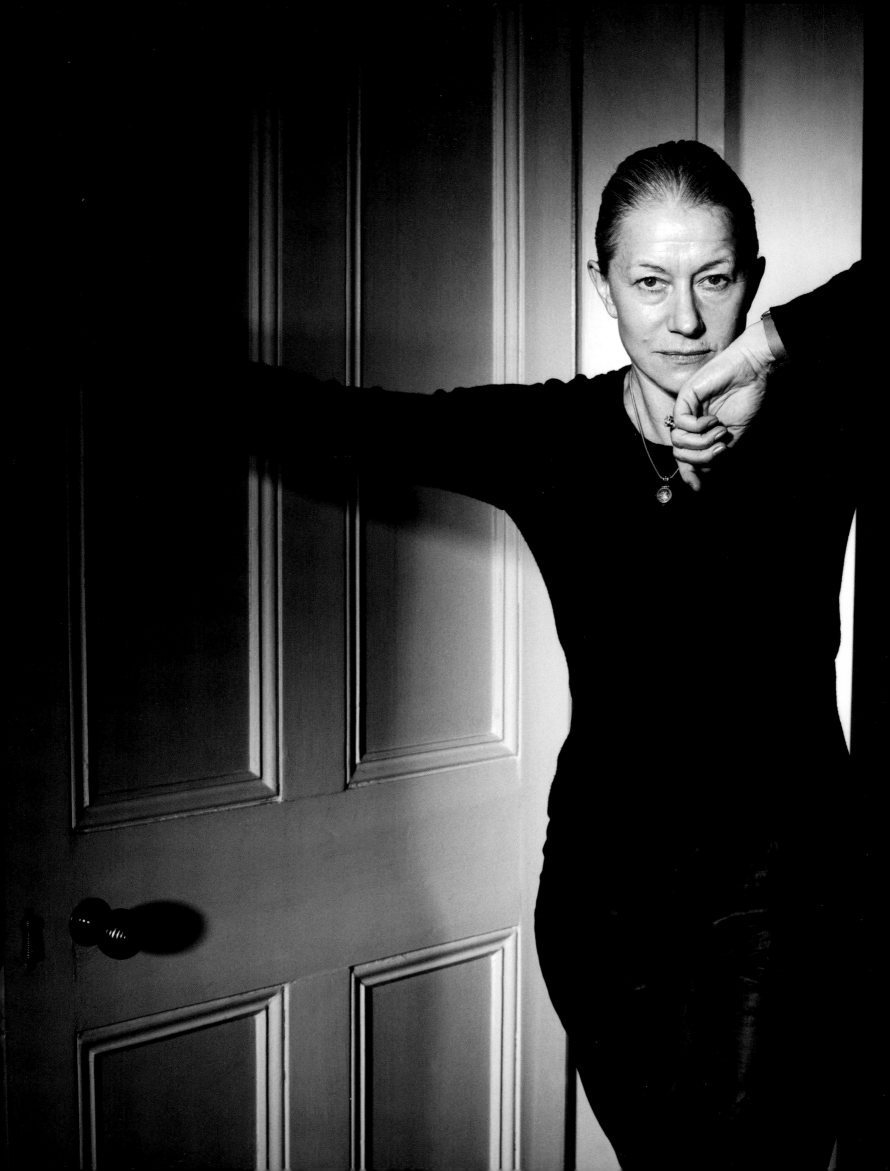

**Joanna Lumley OBE**
Actor

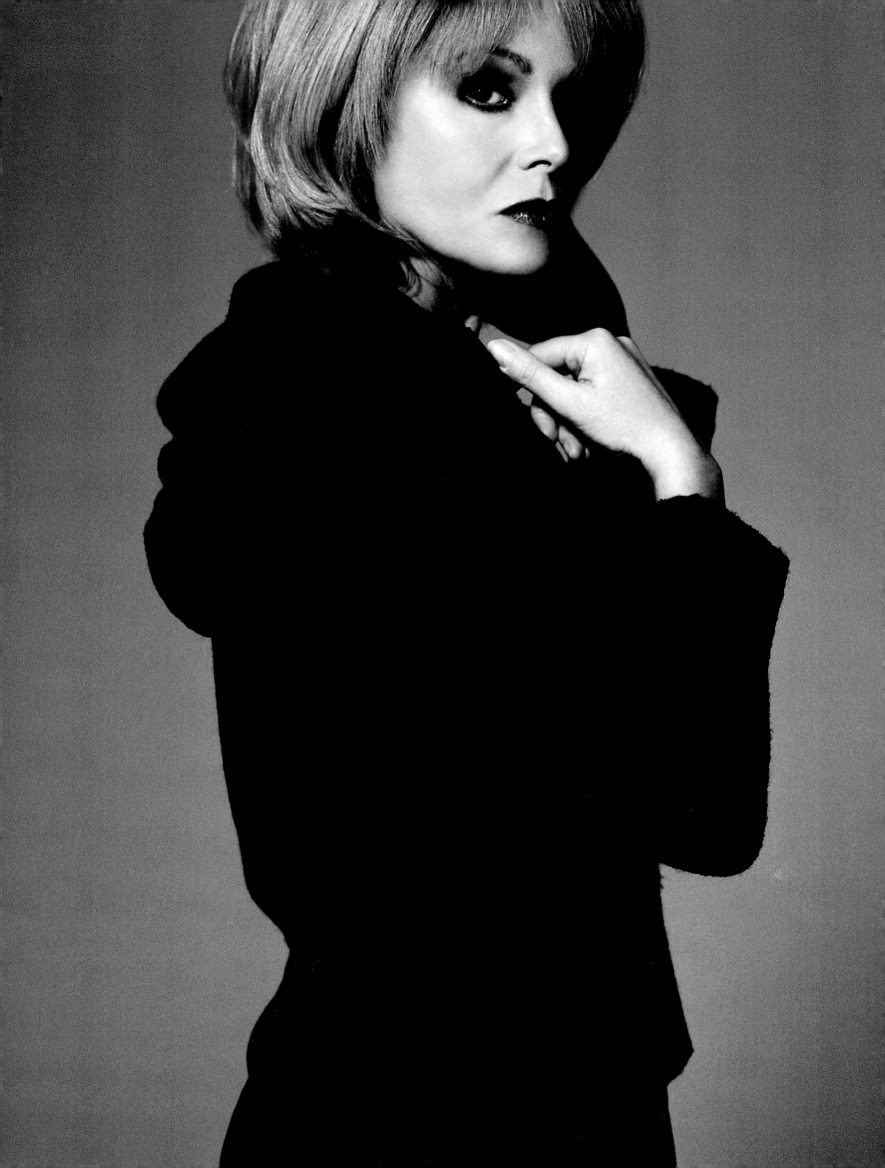

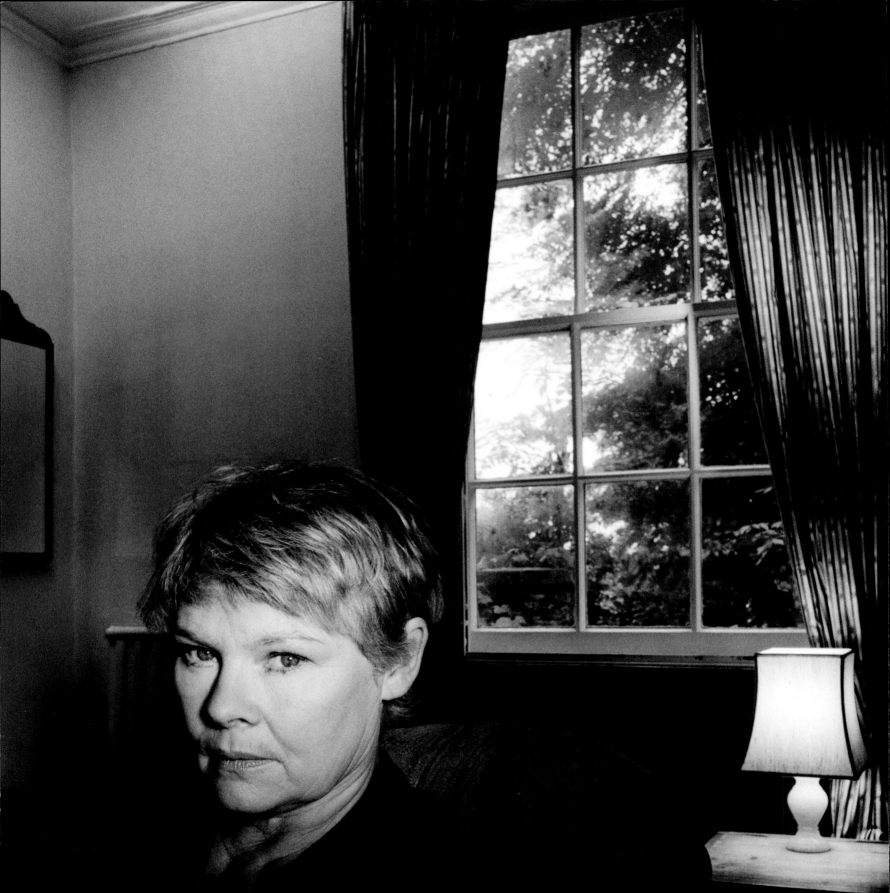

**Dame Judi Dench**
Actor

**Barry Humphries**
Entertainer & writer

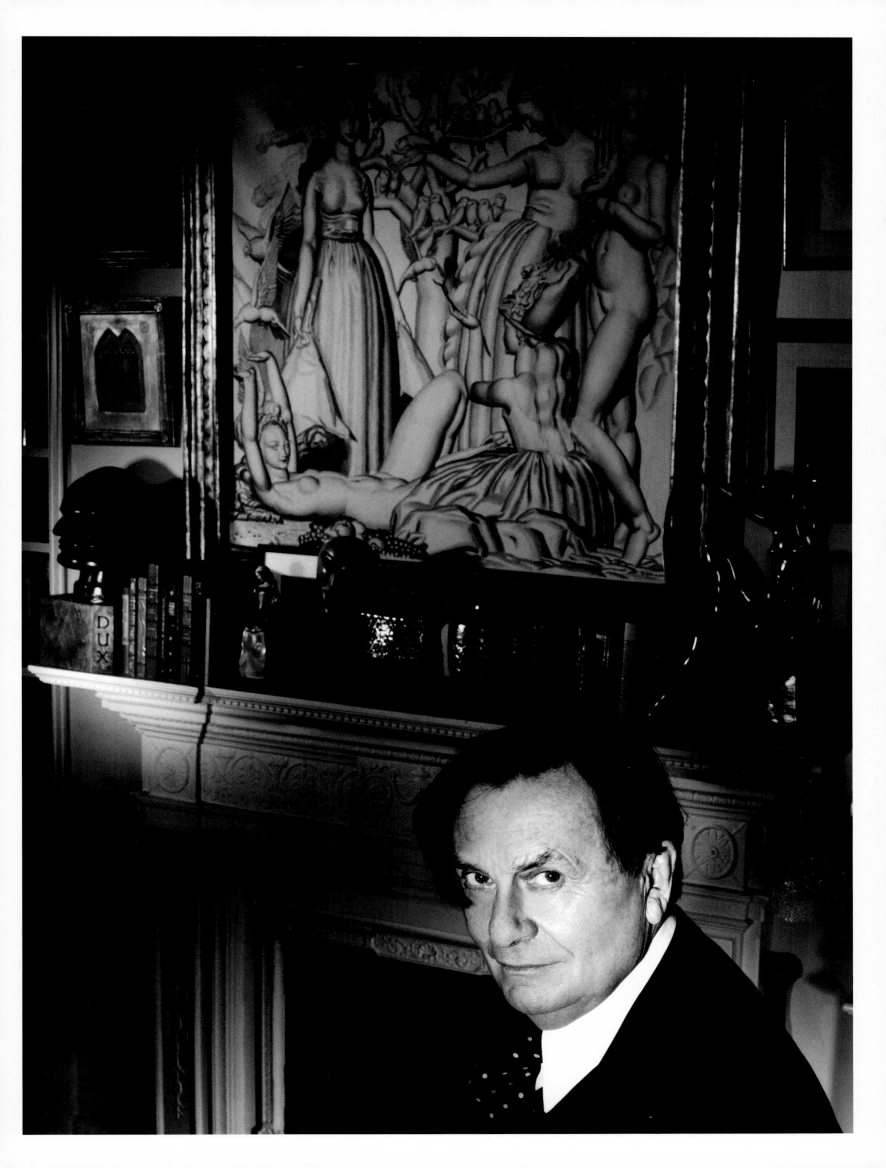

**Mel Smith**
Director & comedian

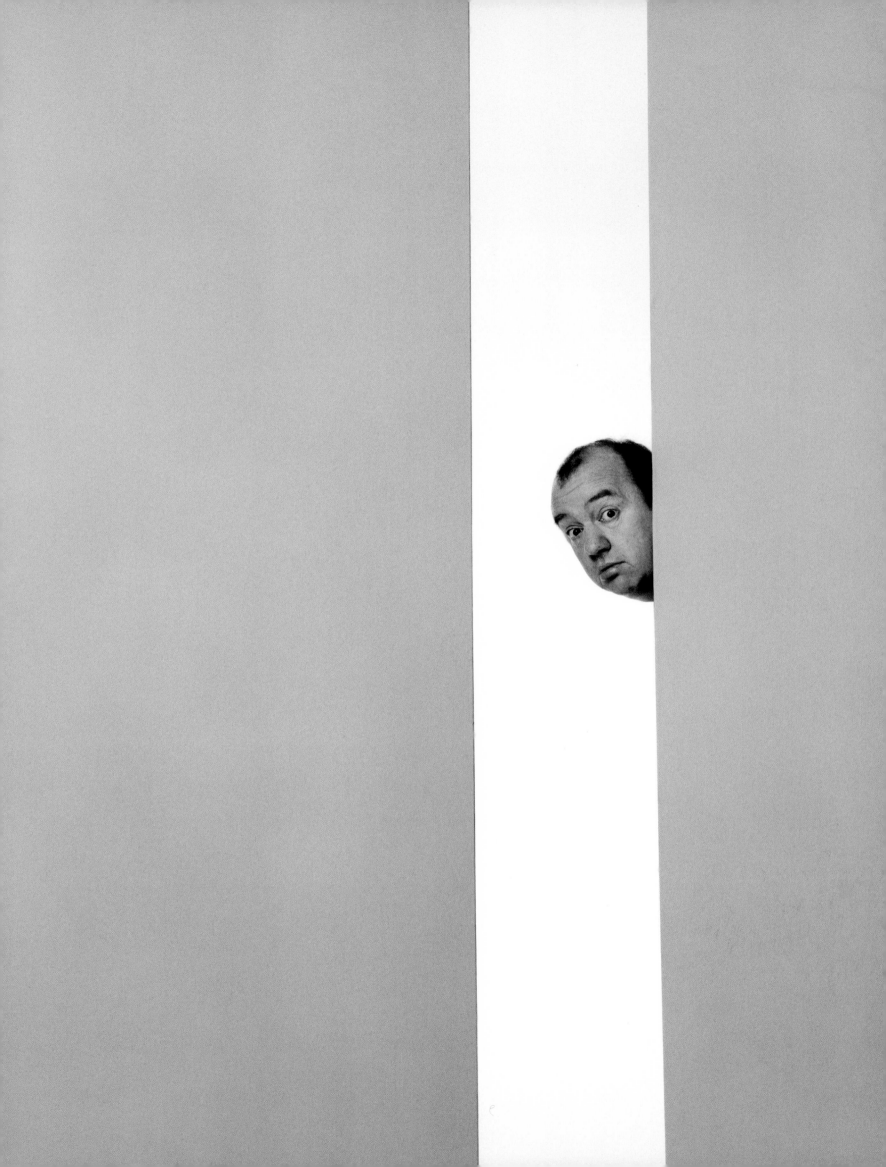

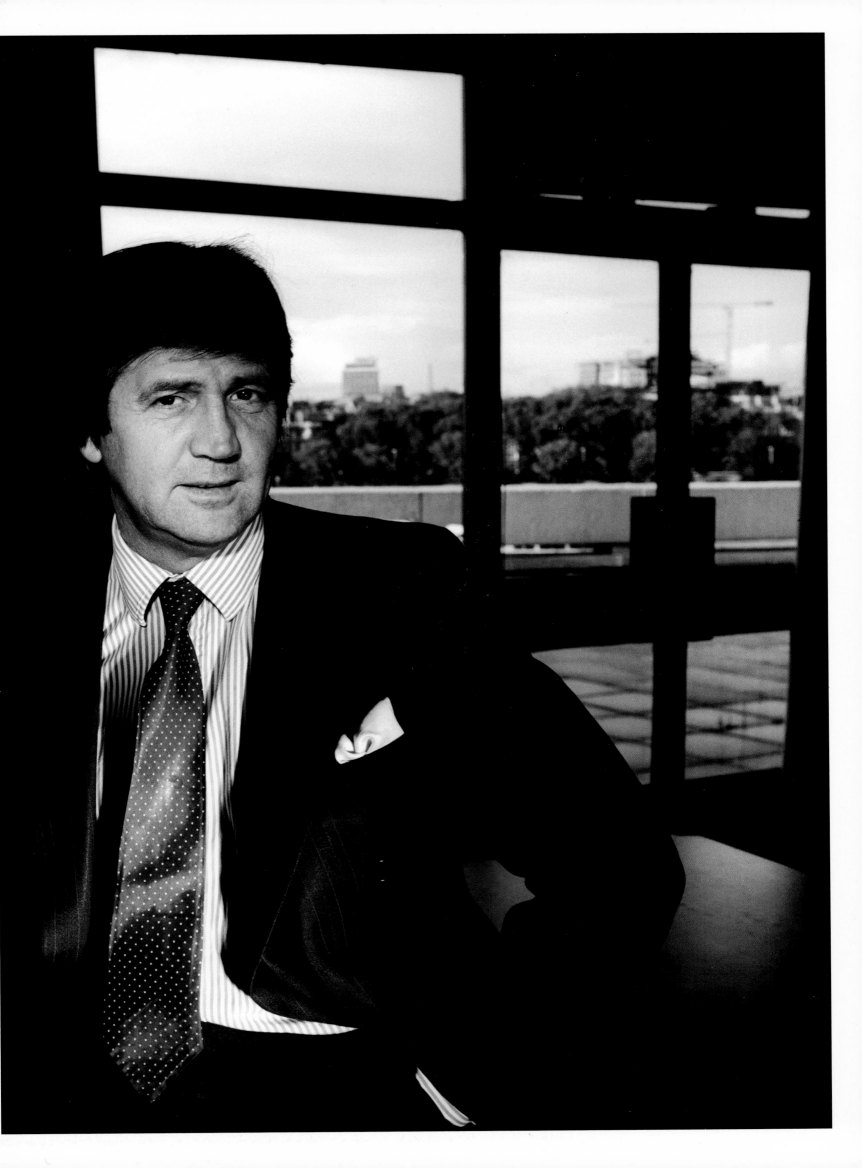

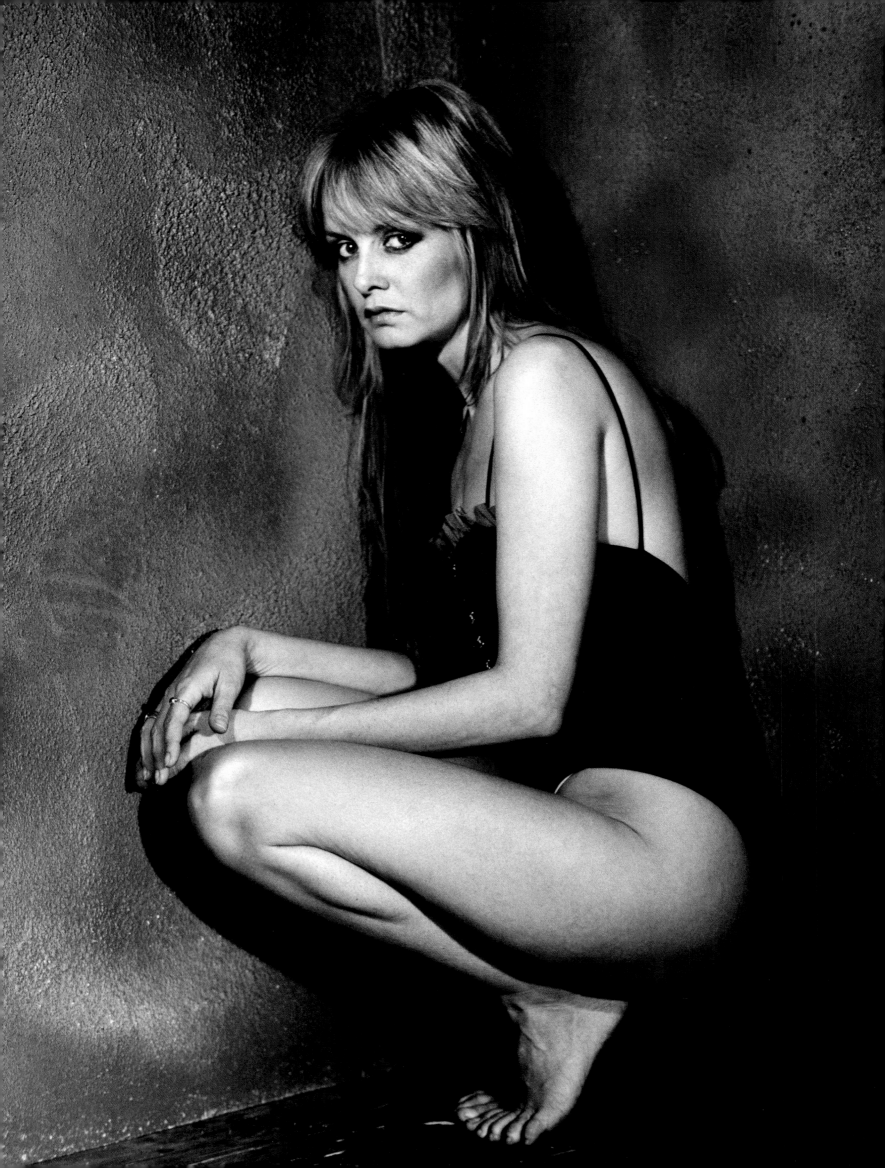

**Vidal Sassoon**
Crimper; Honorary Doctorate in
Philosophy, Hebrew University

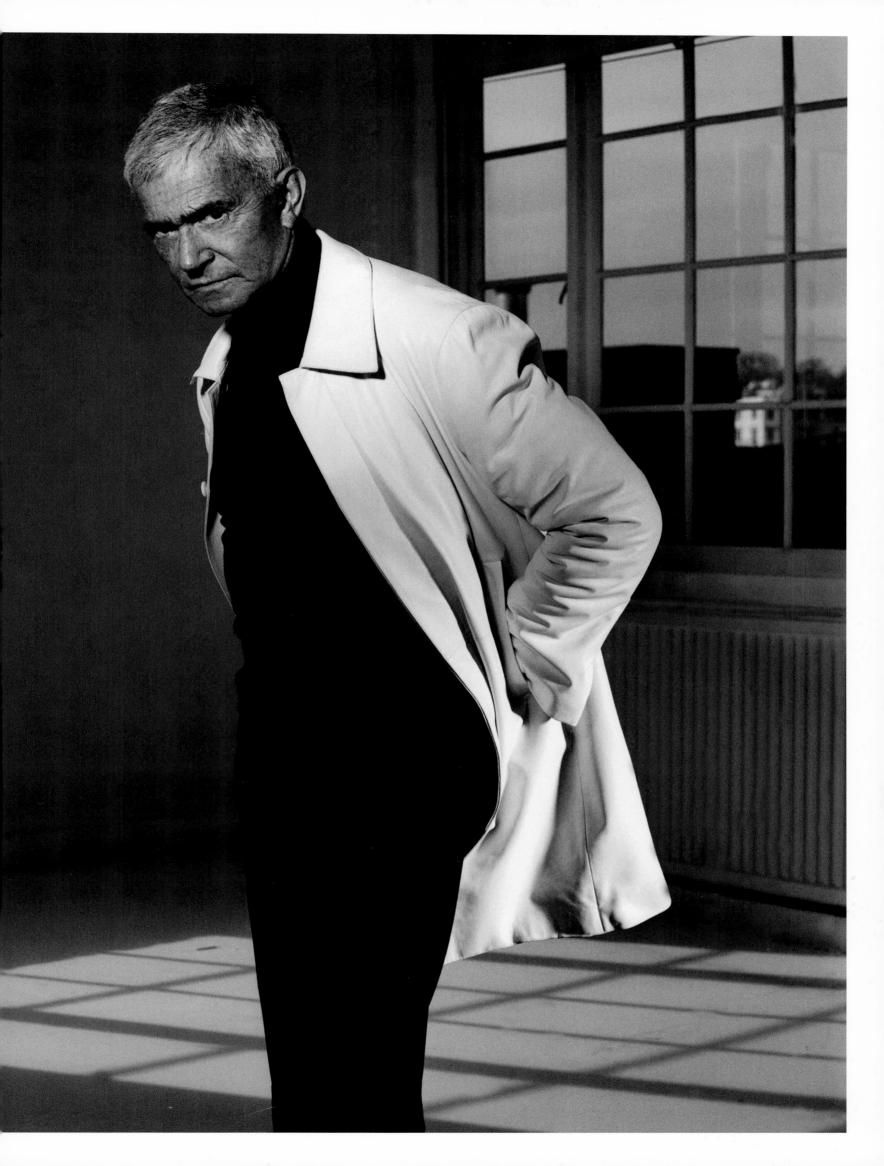

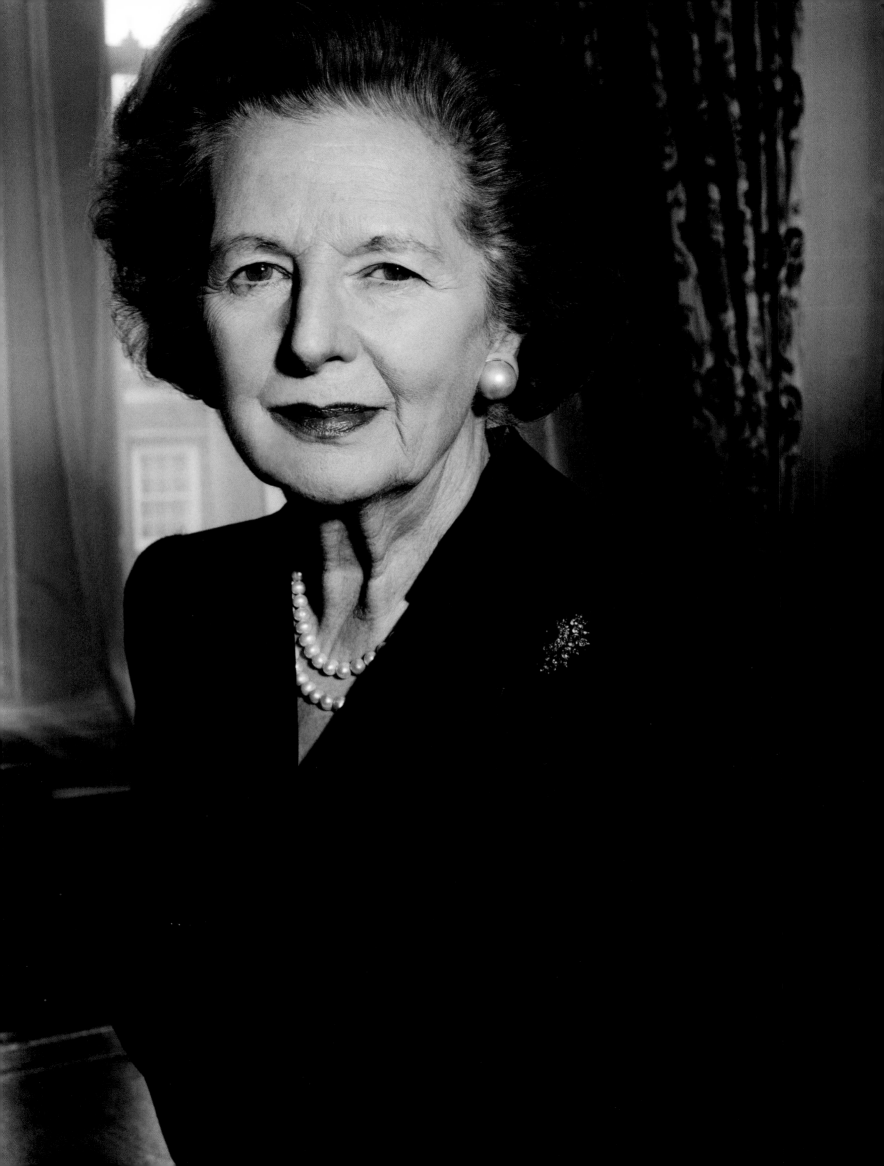

Baroness Thatcher
Prime Minister 1979-1990

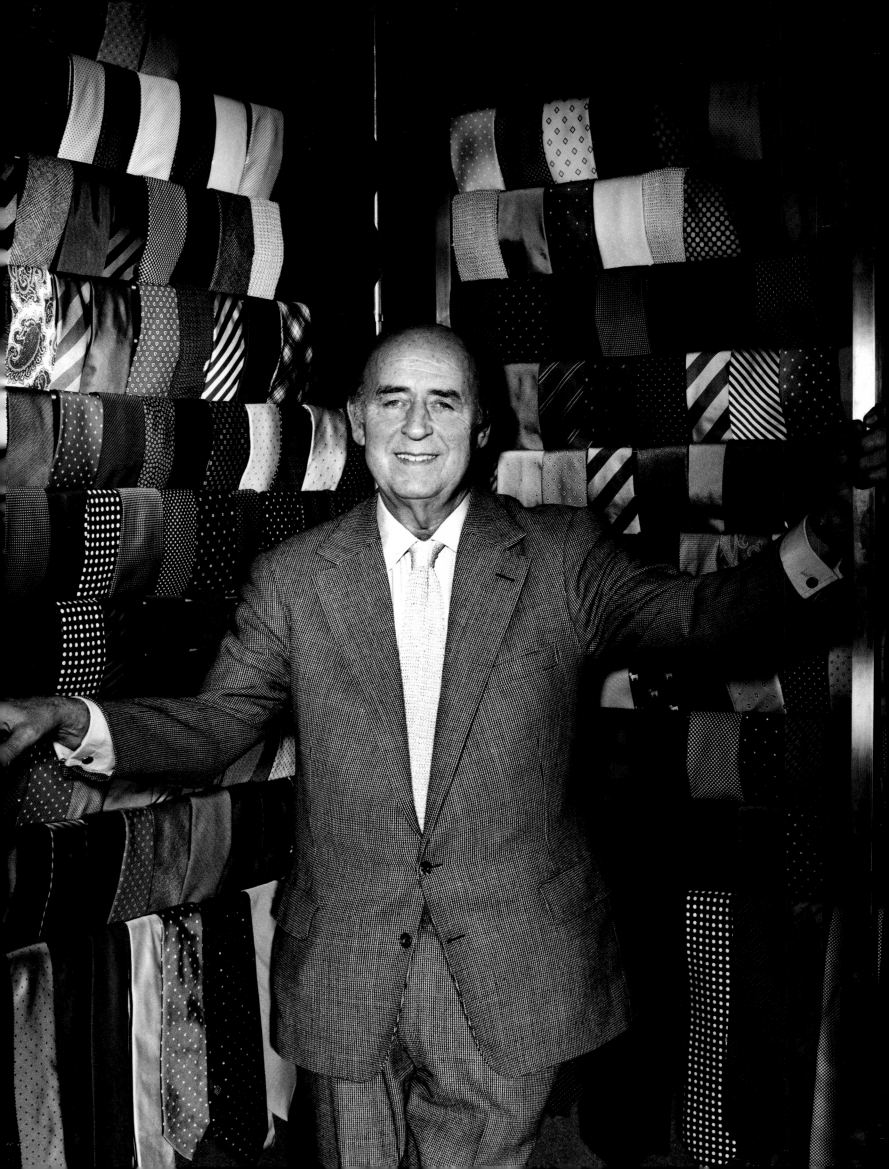

**Eric Sykes**
Actor & comedian

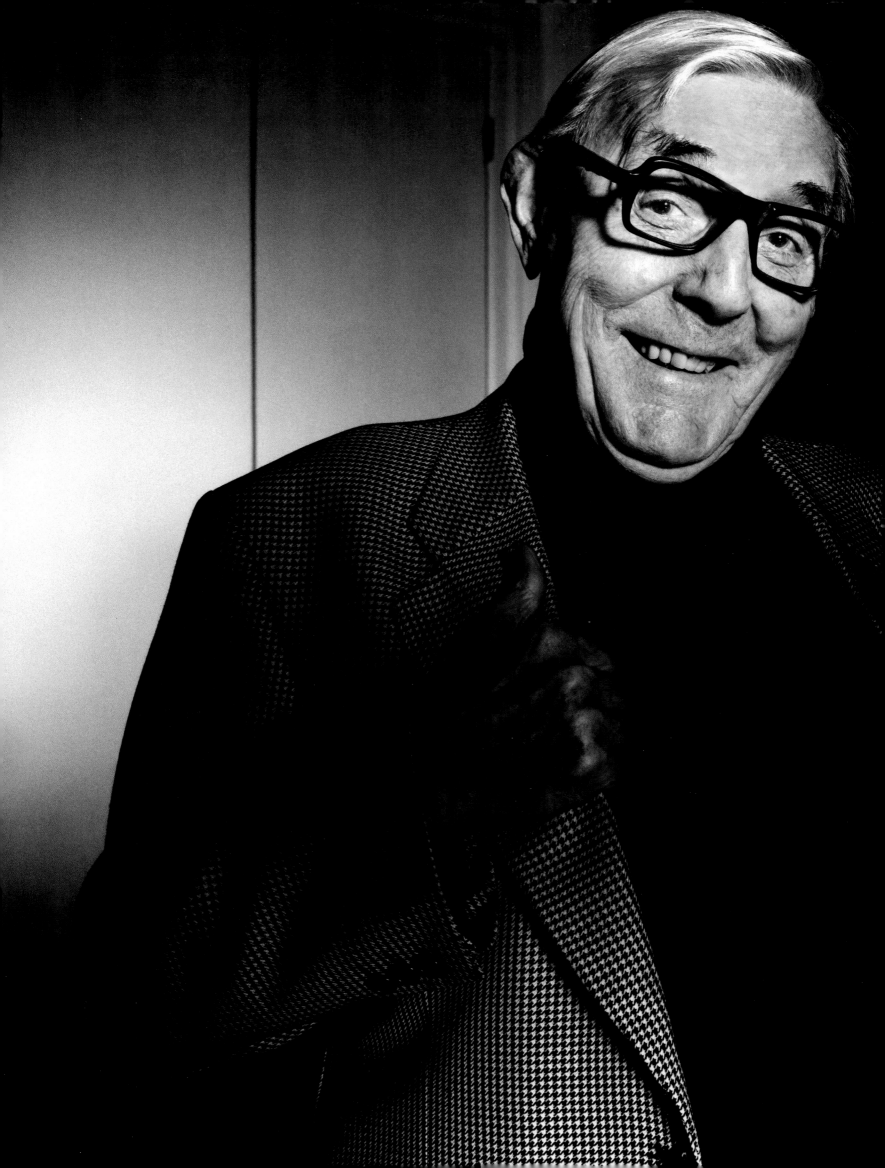

**Sir Frank Lowe**
Advertising

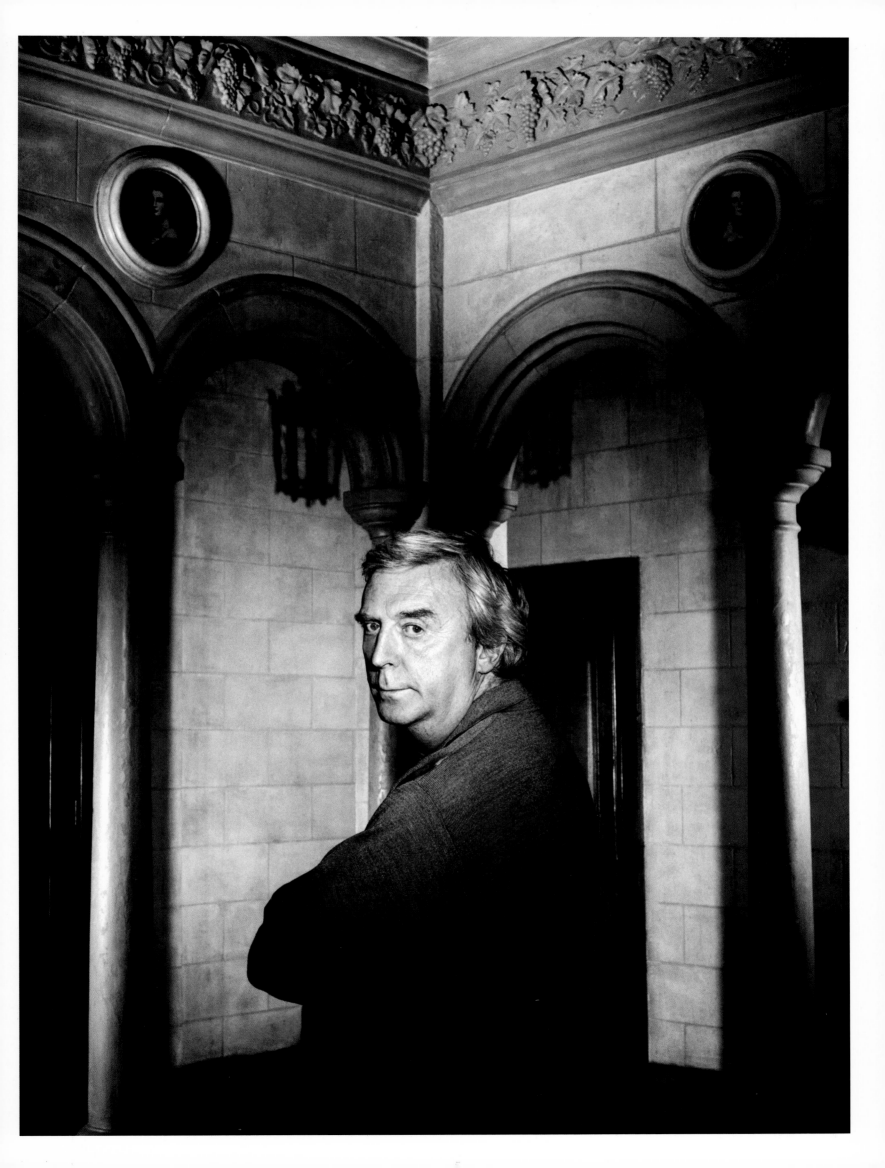

**Joan Collins OBE**
Actor

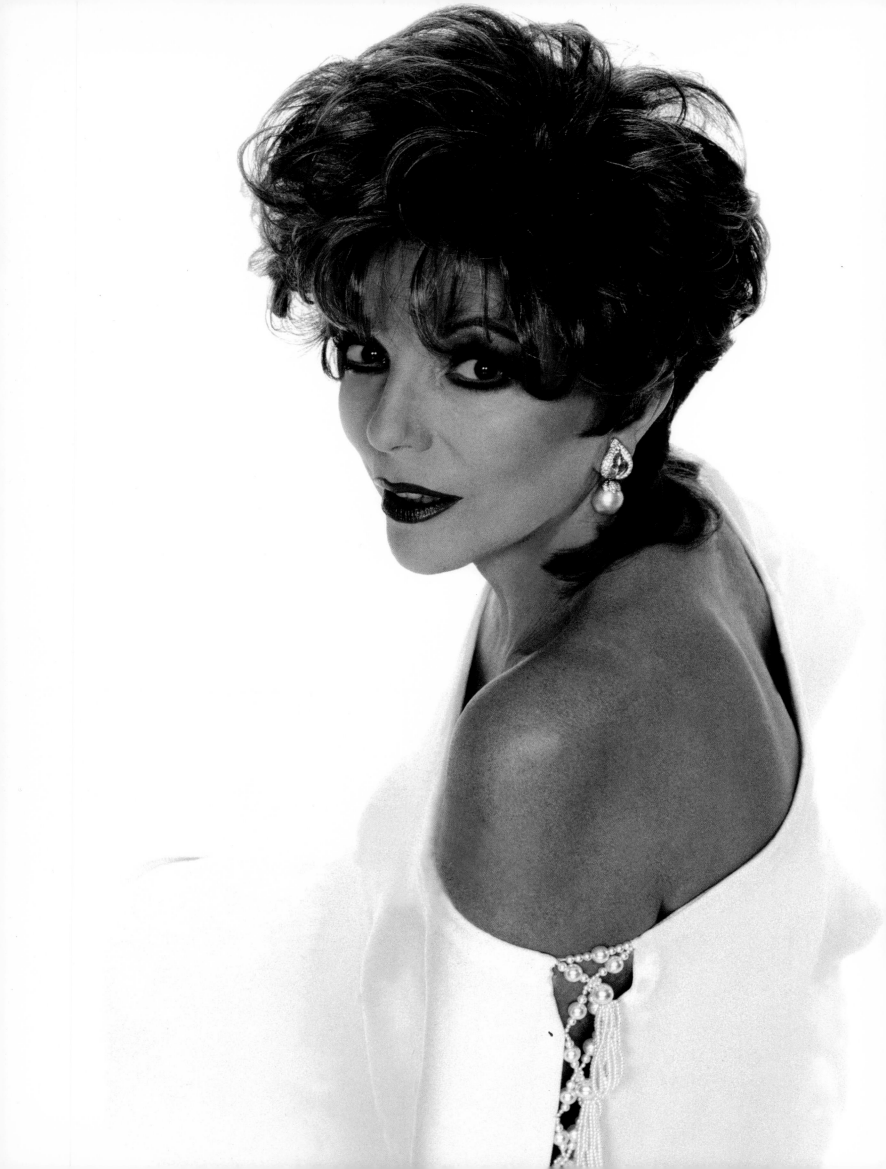

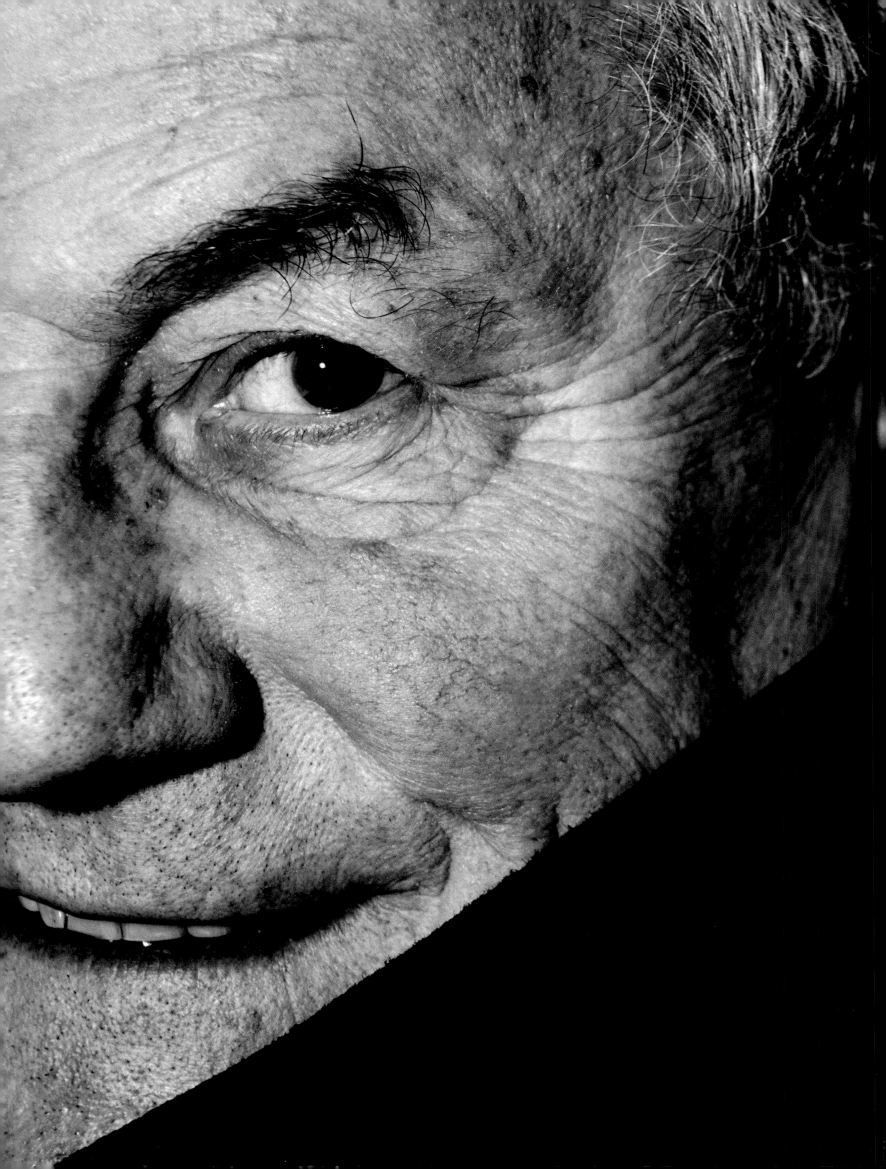

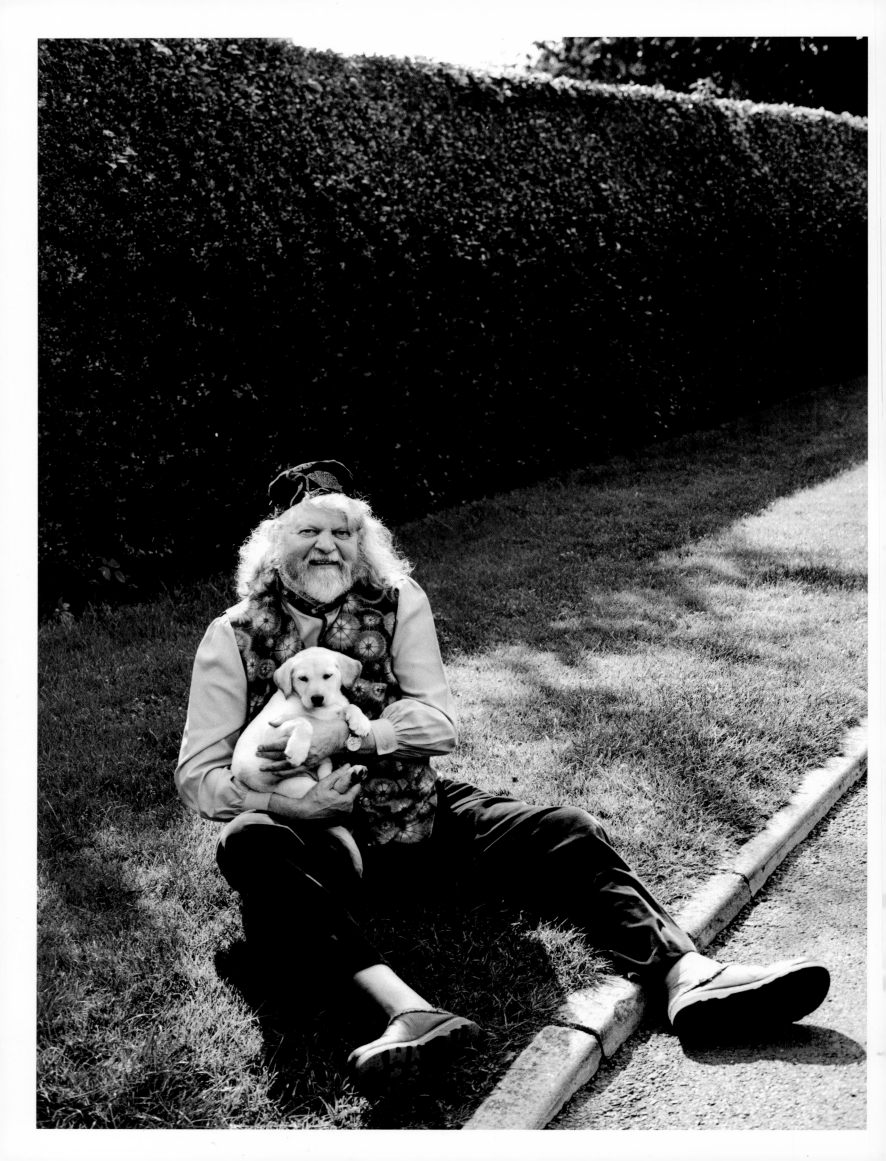

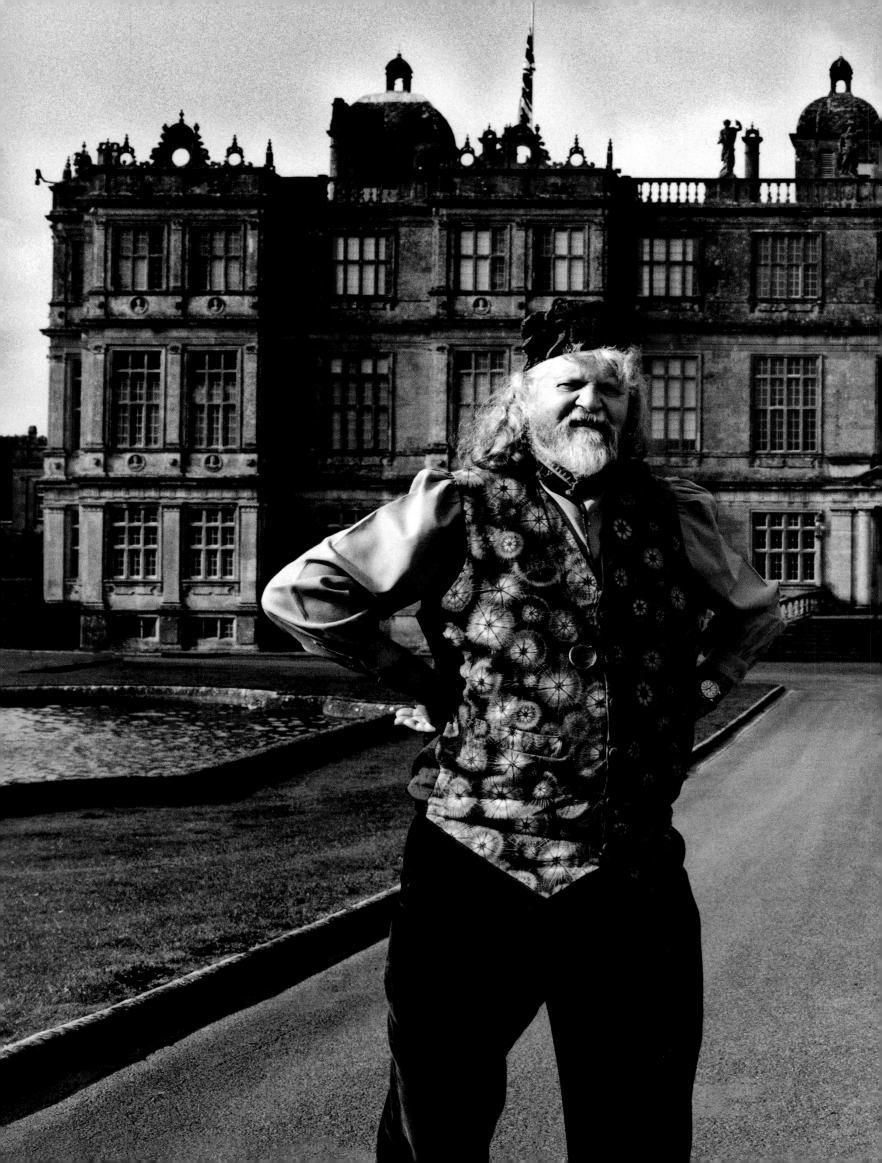

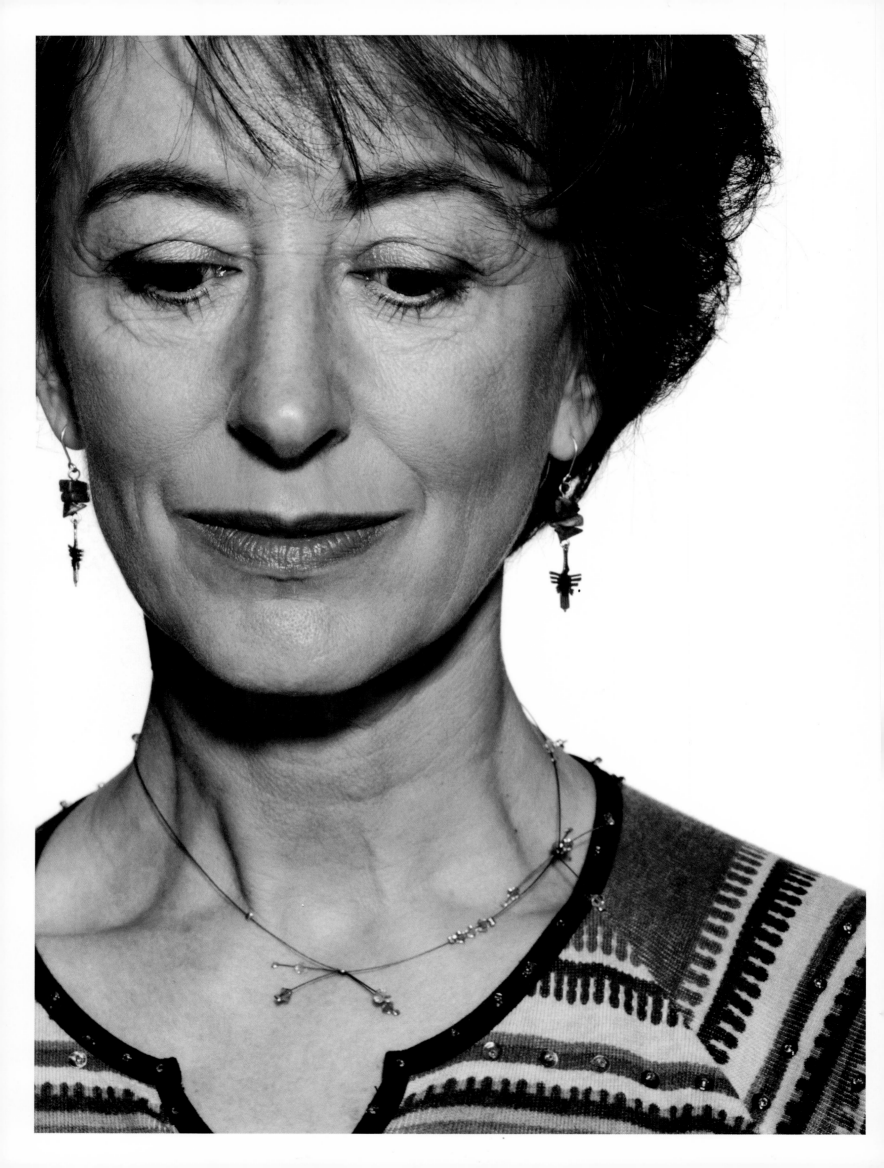

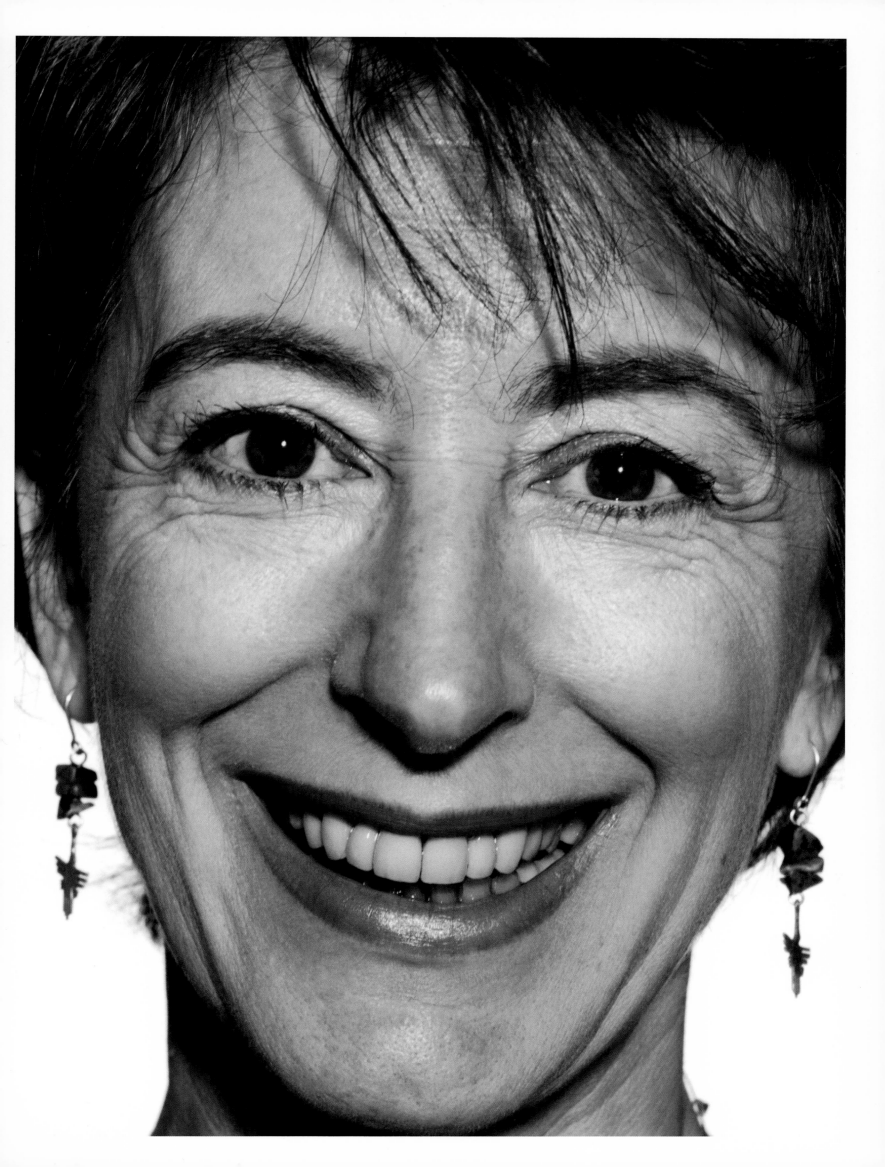

**Michael Winner**
Director & restaurant critic

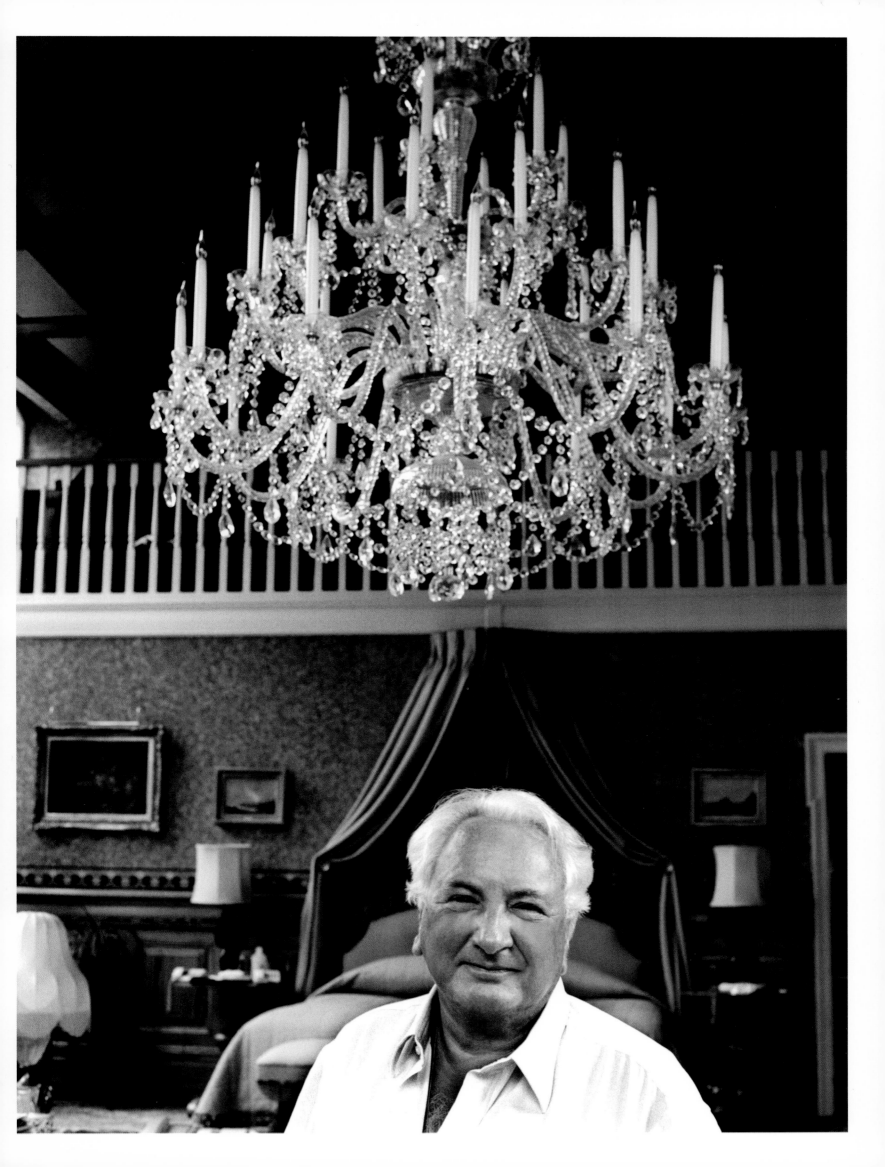

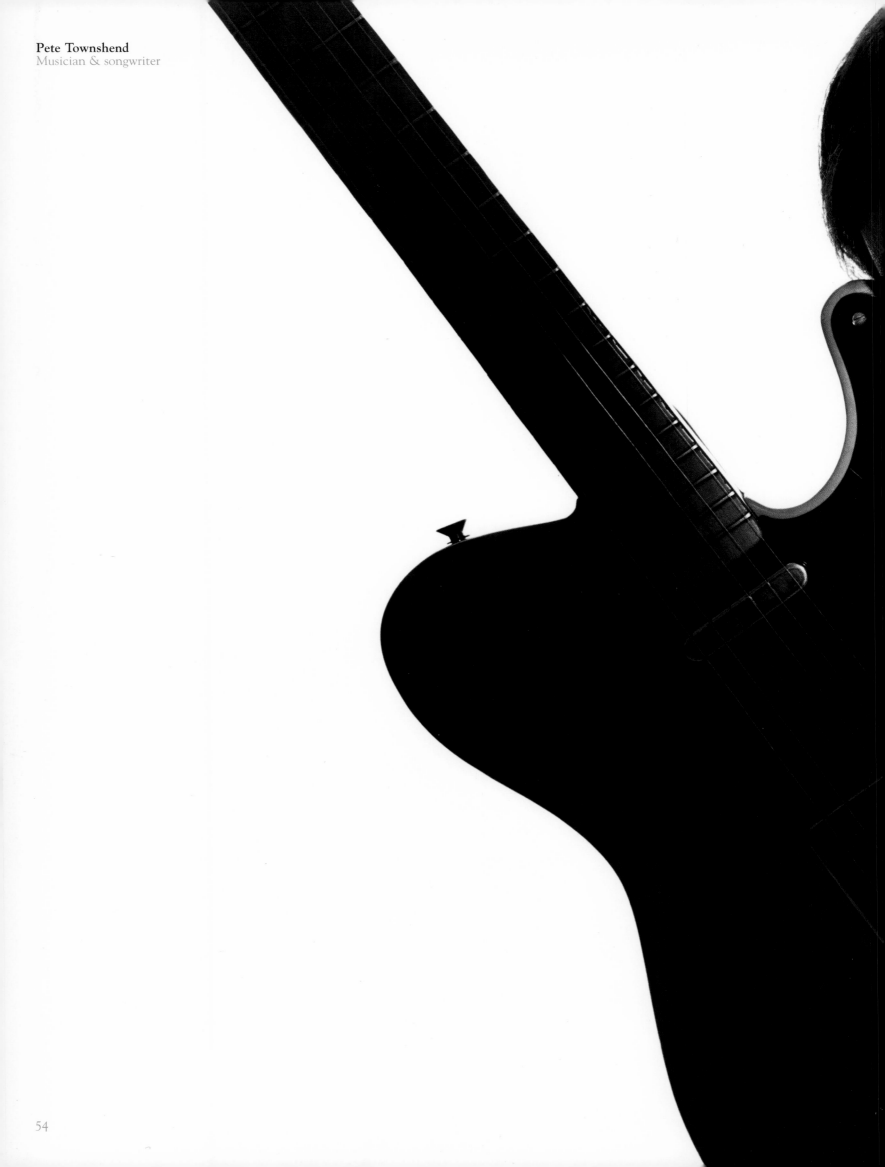

**Pete Townshend**
Musician & songwriter

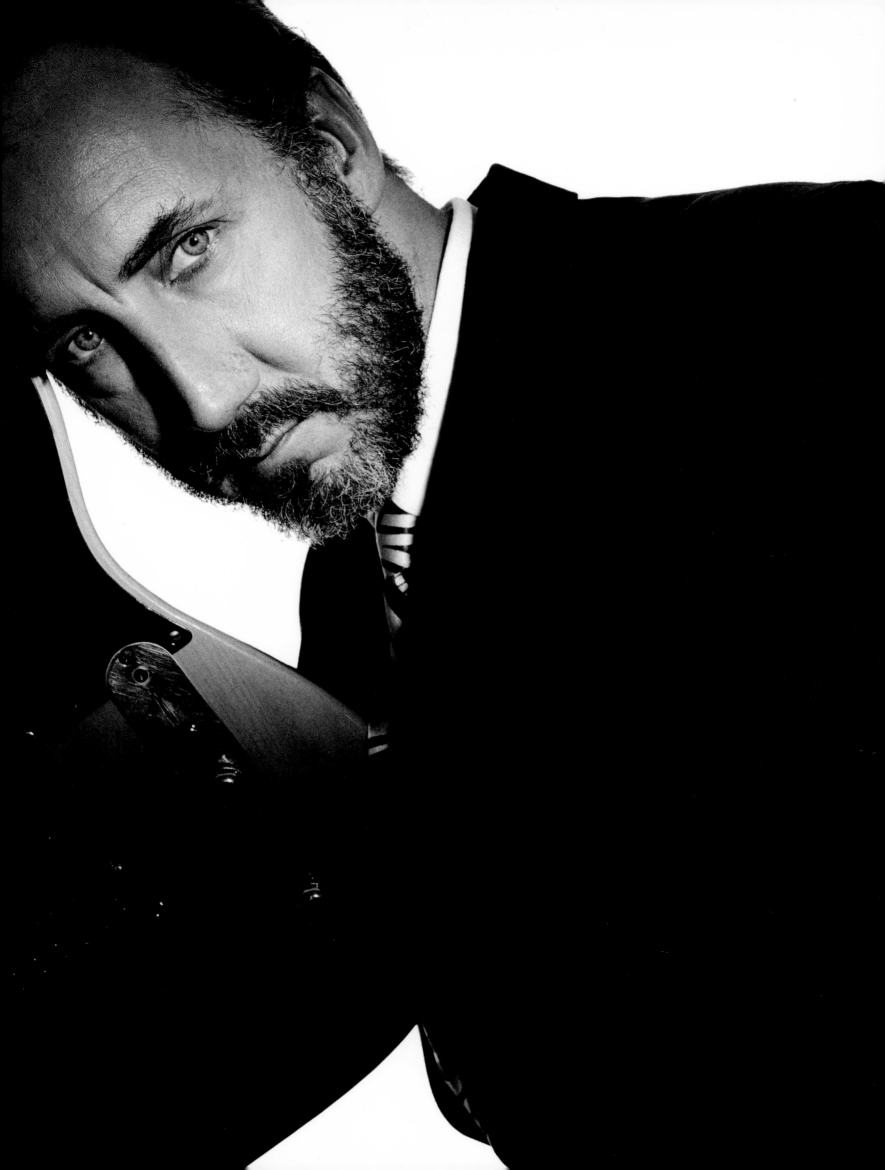

**Roger Moore CBE**
Actor

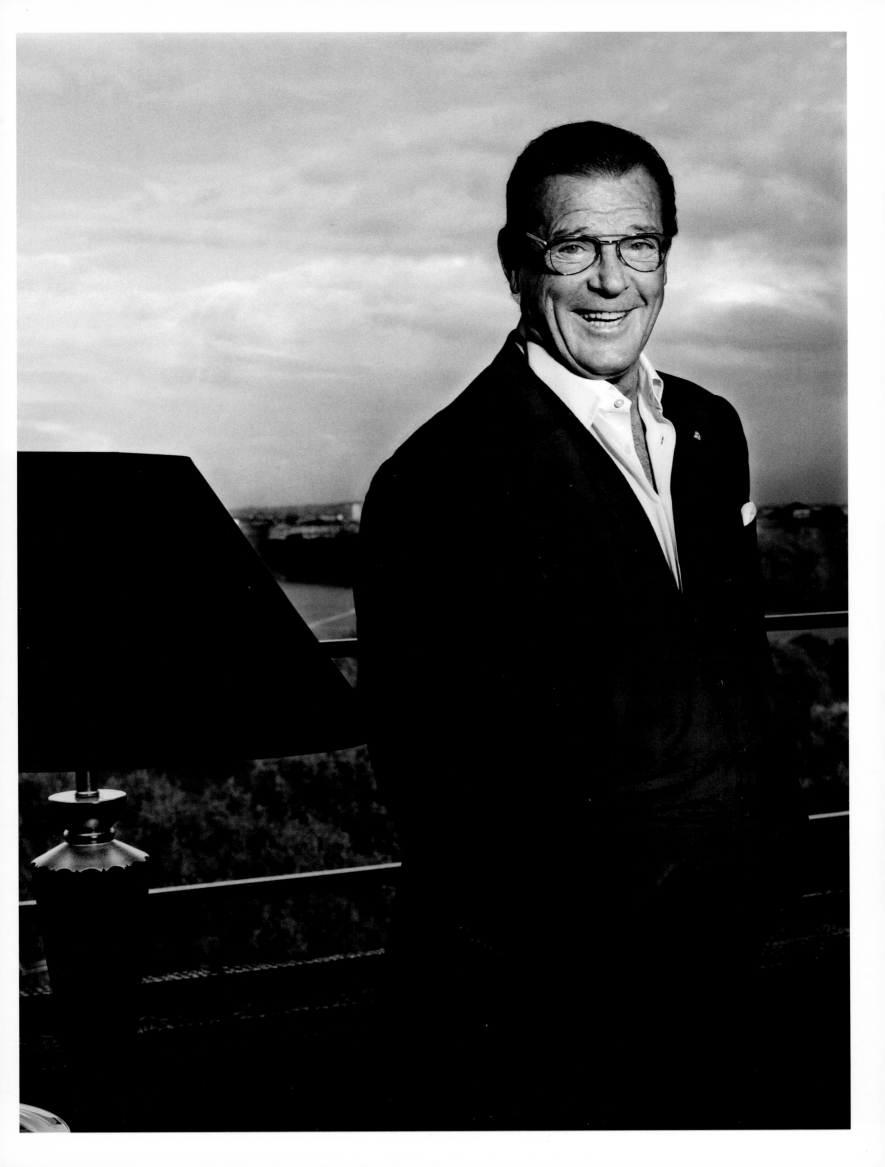

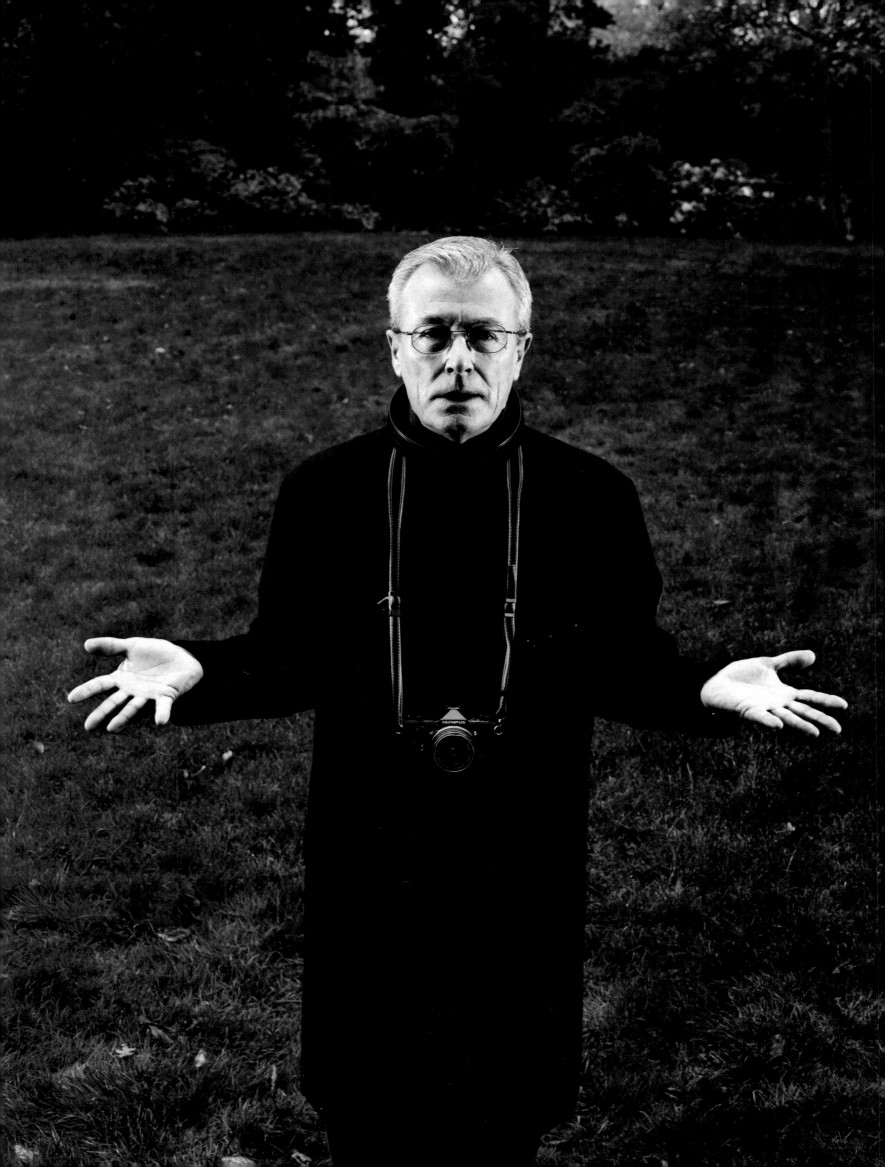

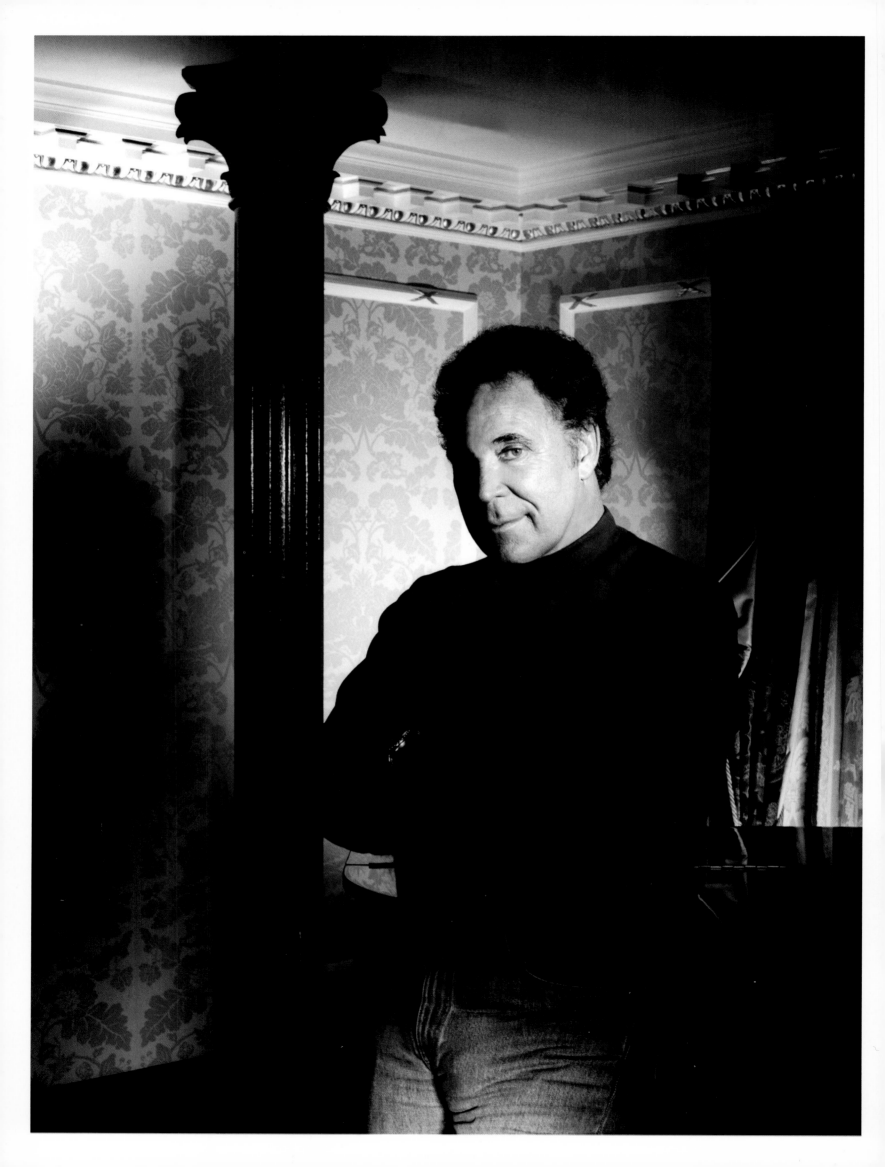

Tom Jones OBE
Singer

**Anita Roddick OBE**
Founder of The Body Shop

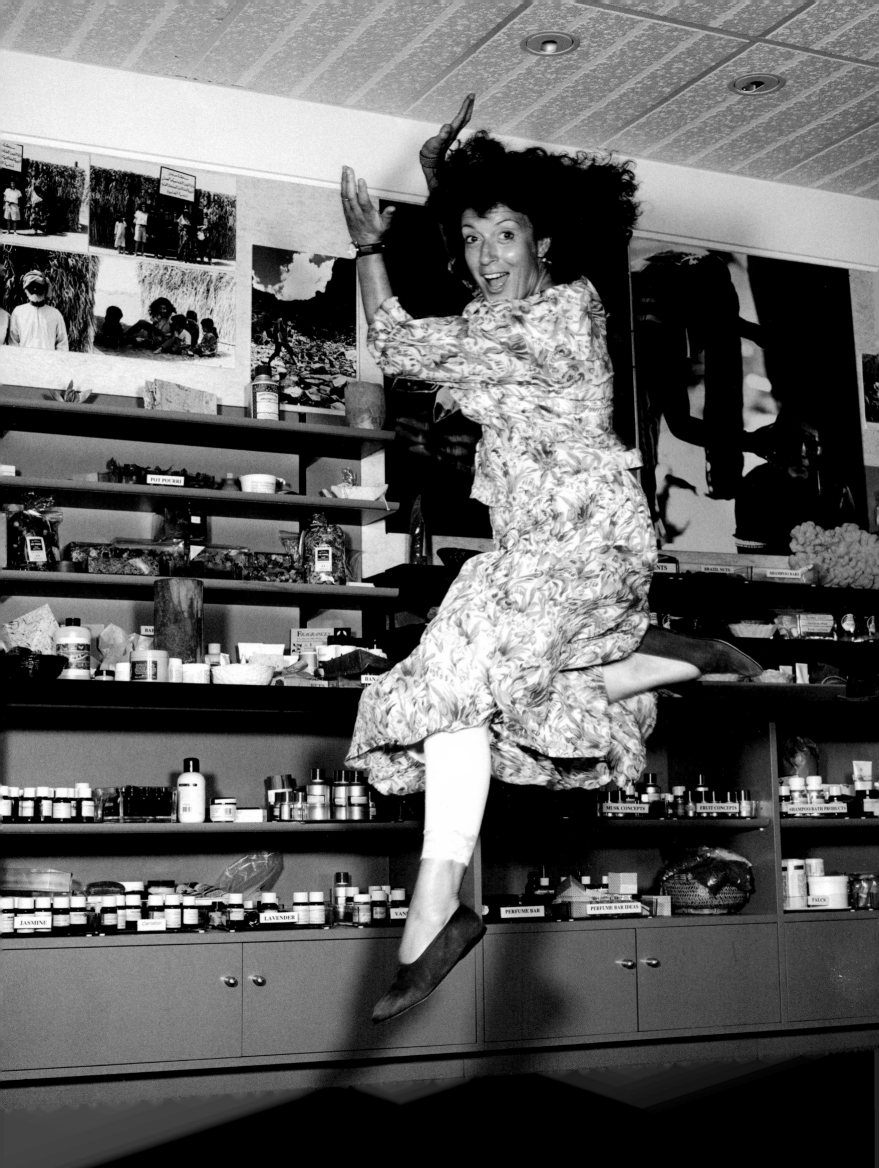

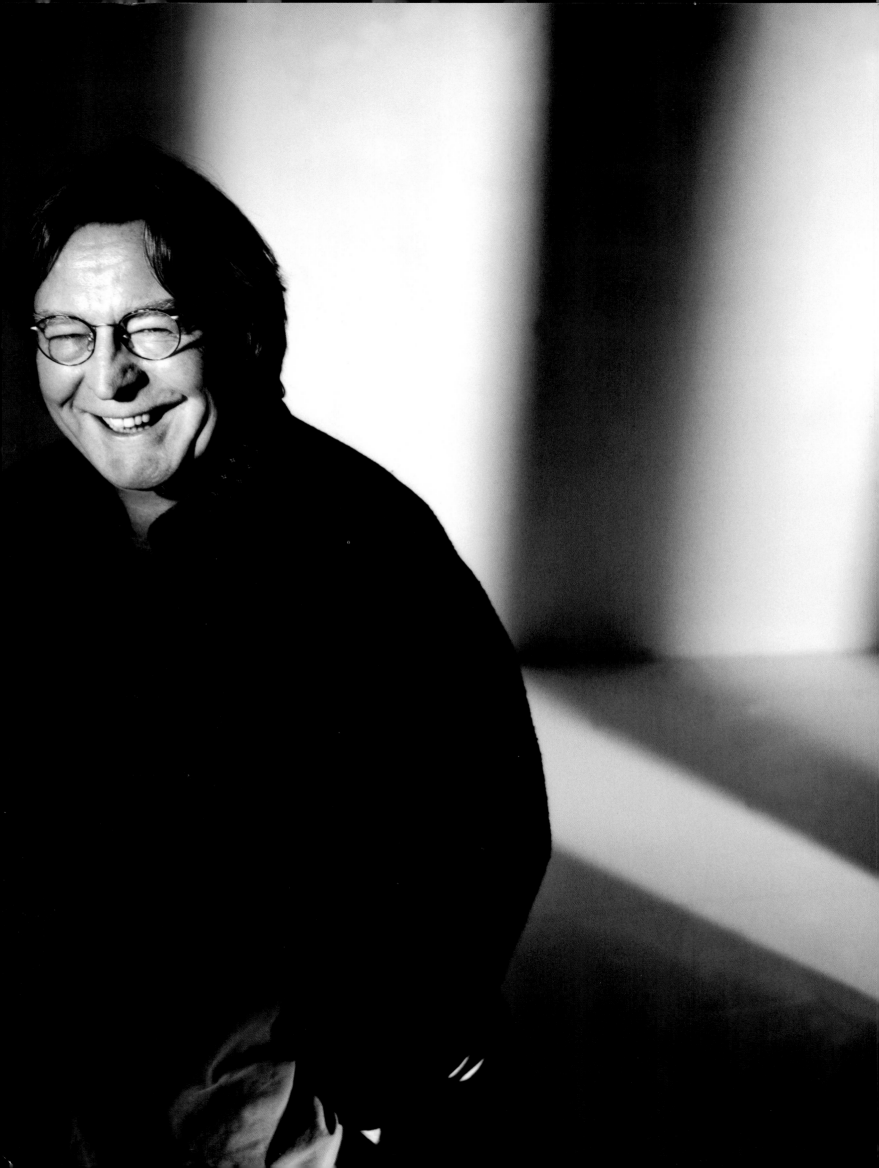

**Bob Hoskins**
Actor & director

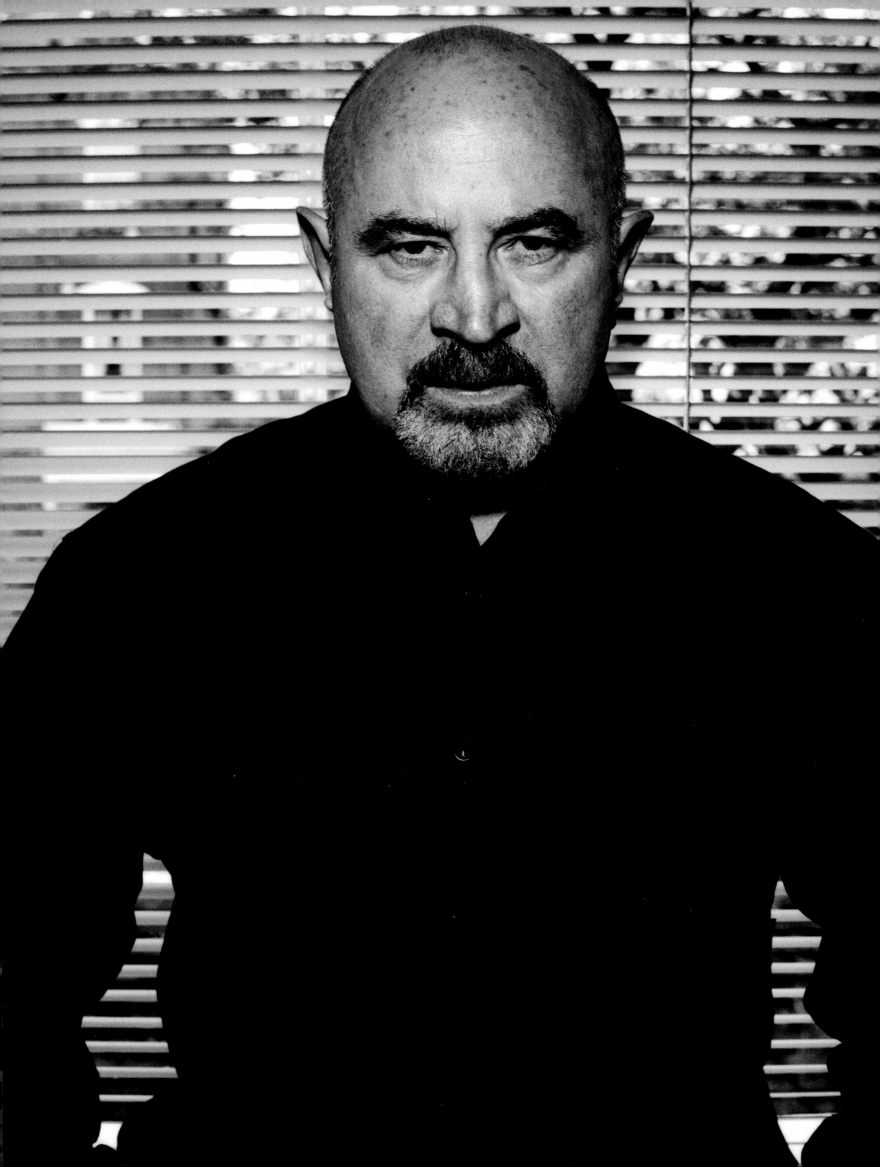

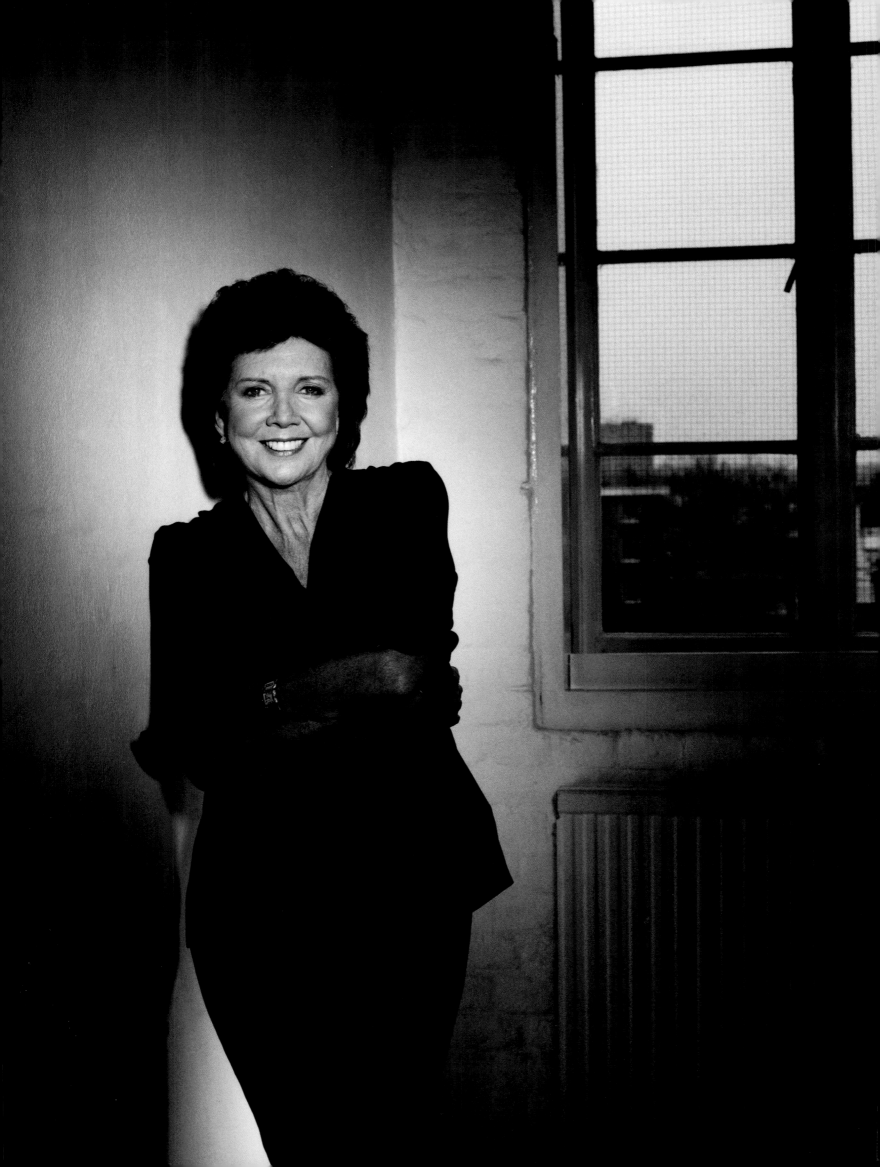

**Delia Smith**
Cookery author

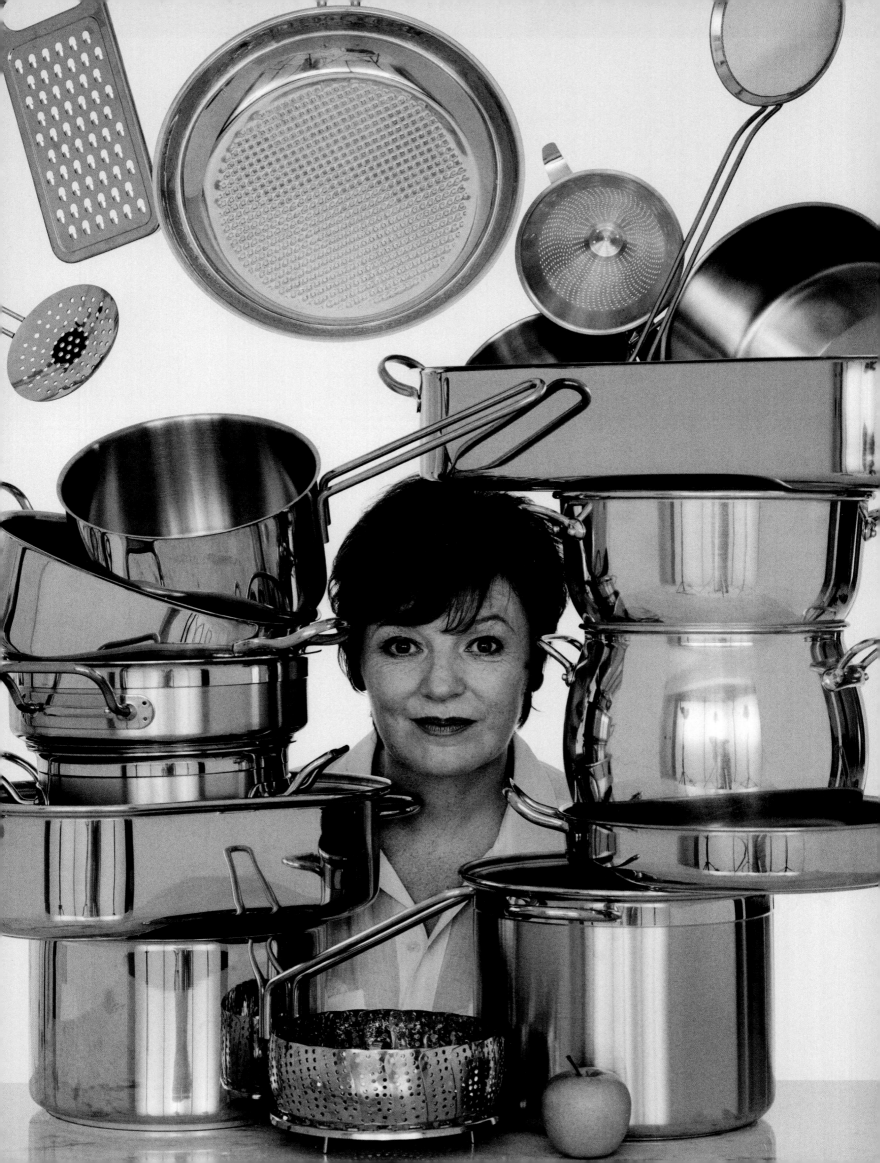

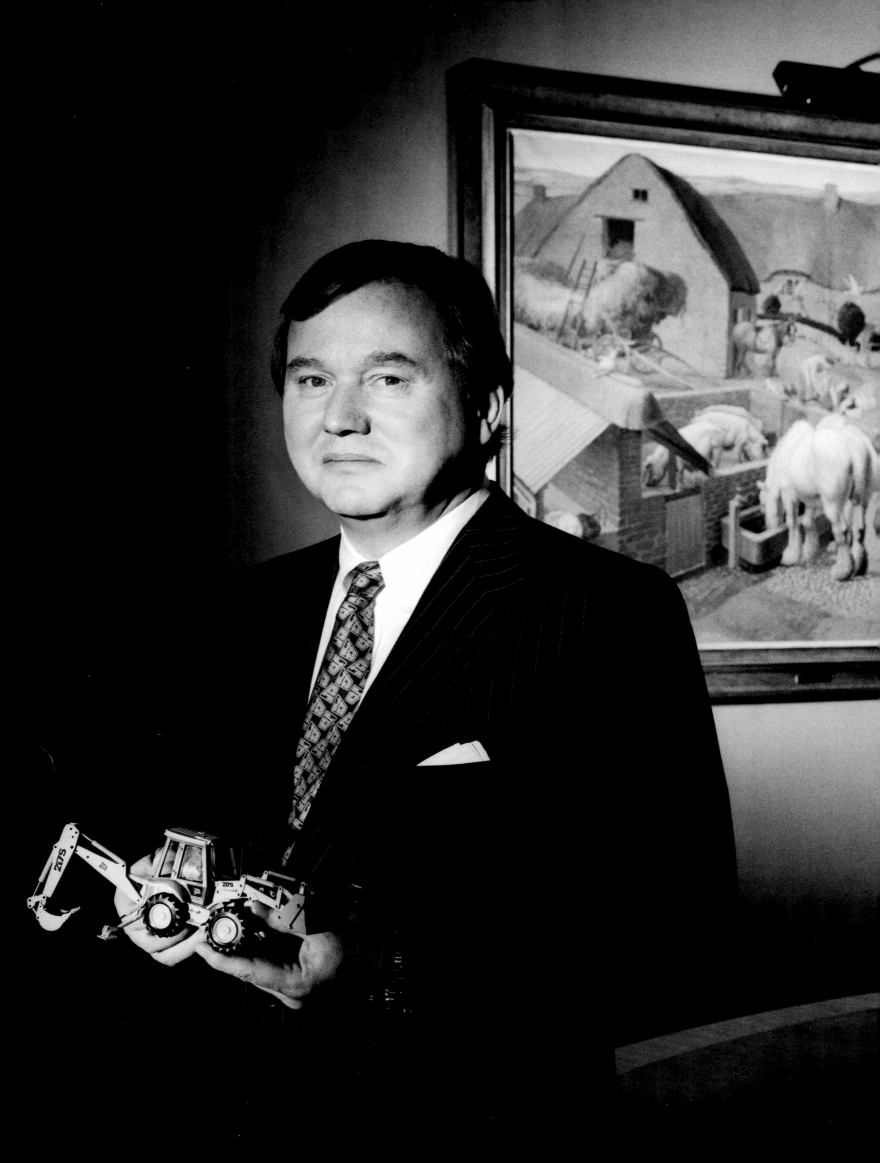

**Sir Anthony Bamford DL**
Chairman, JCB Group

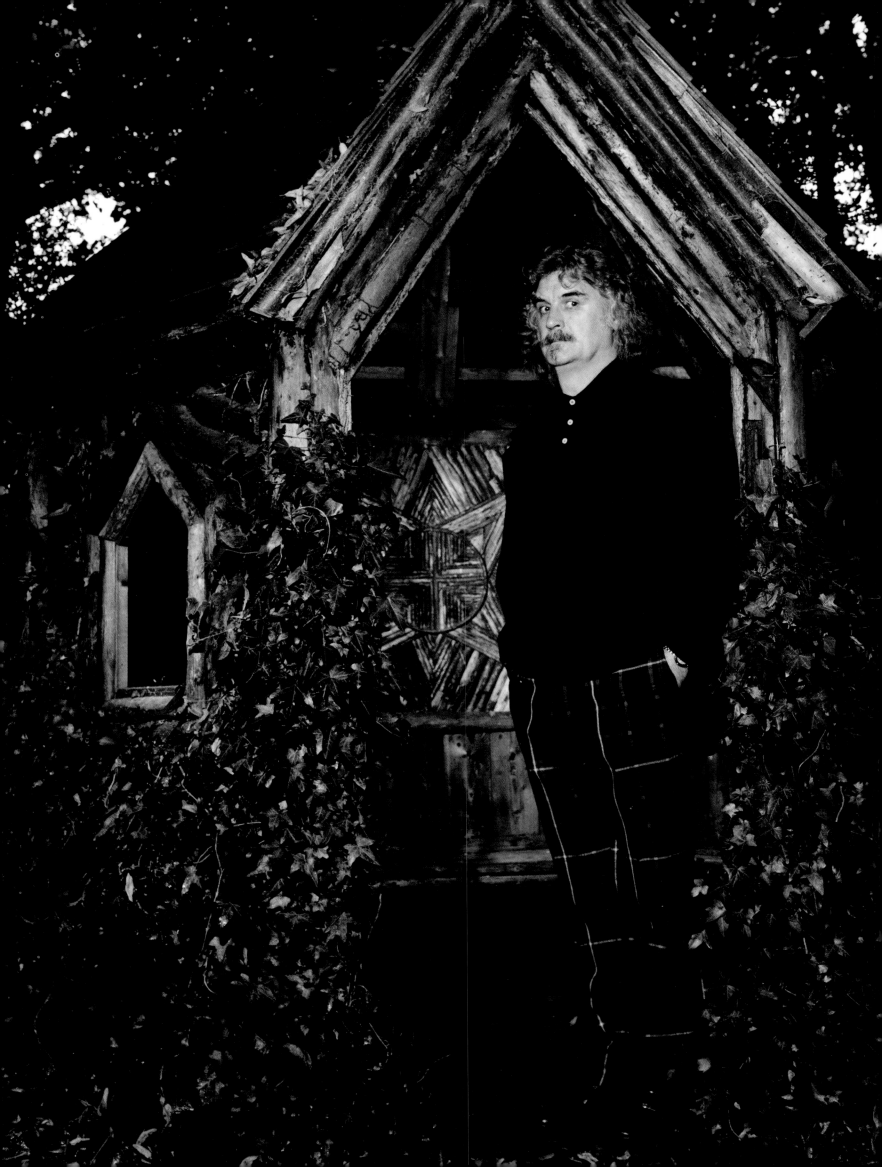

**Charlotte Rampling**
Actor

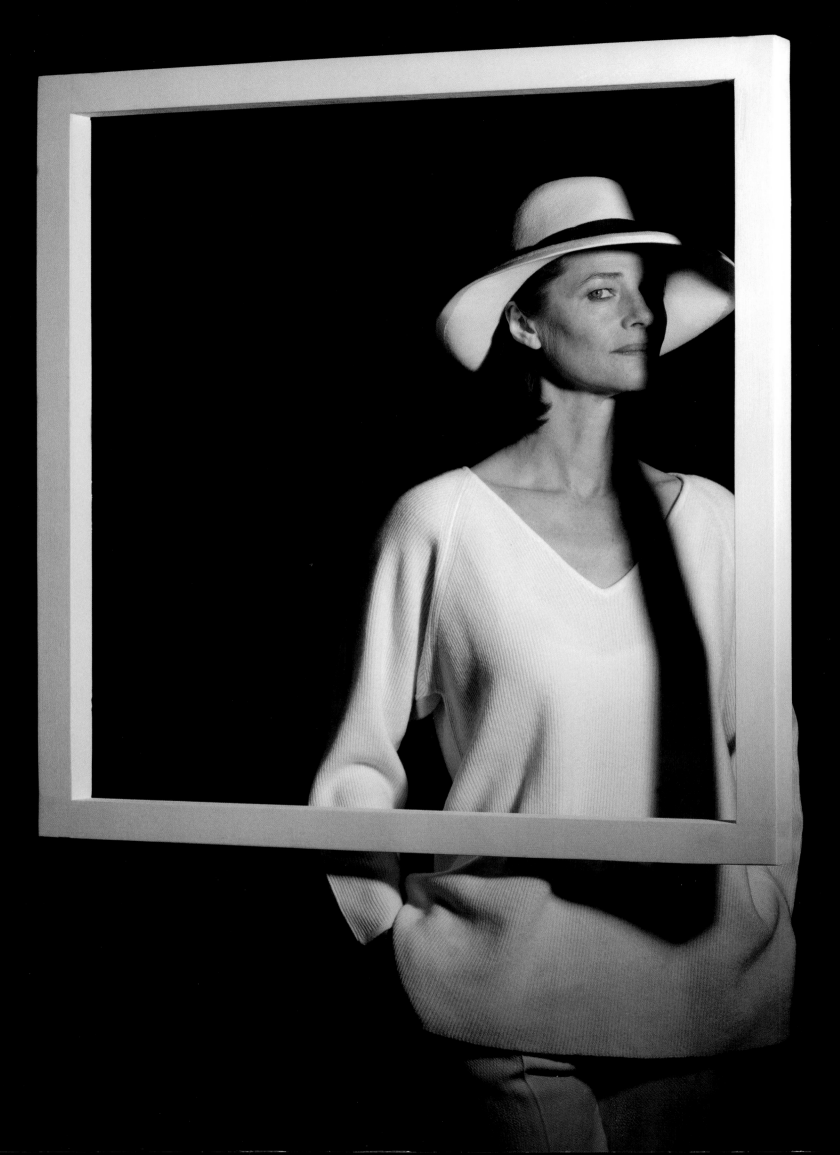

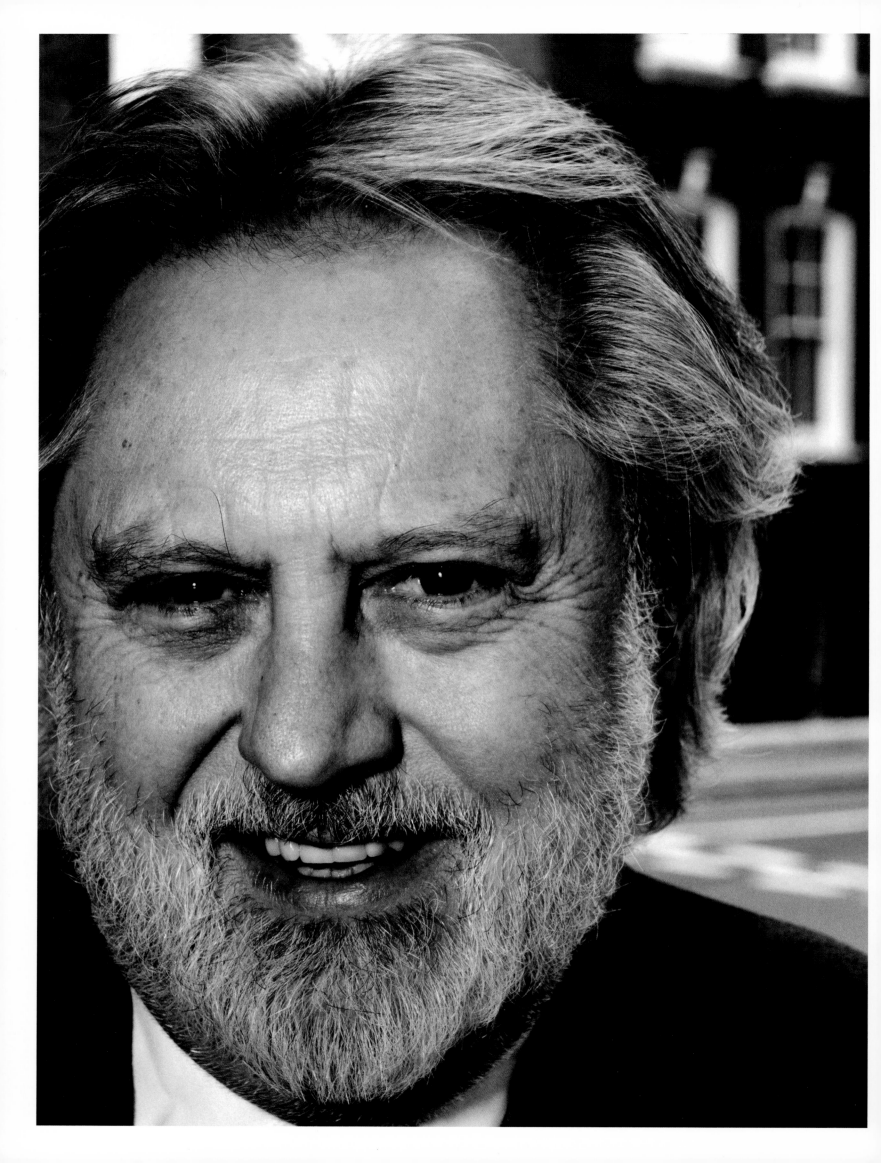

**Sir Elton John**
Musician & singer

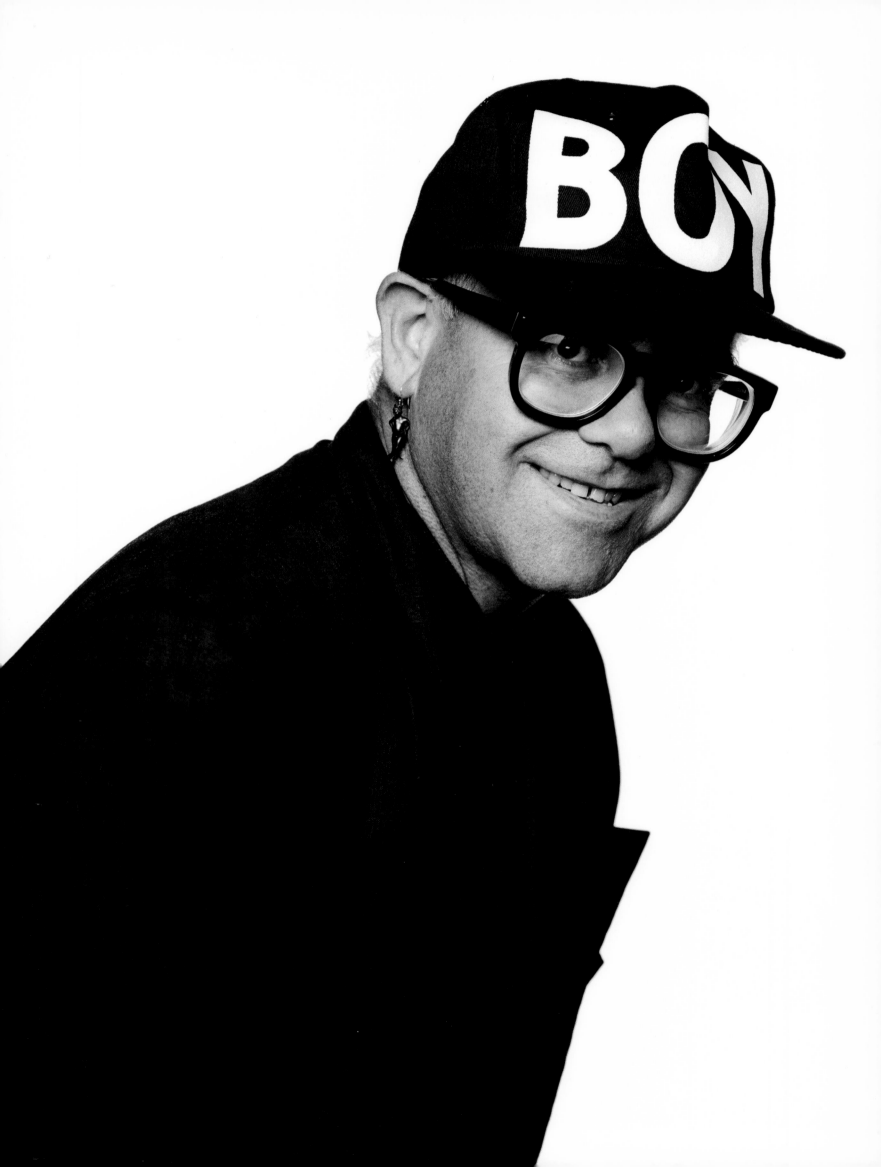

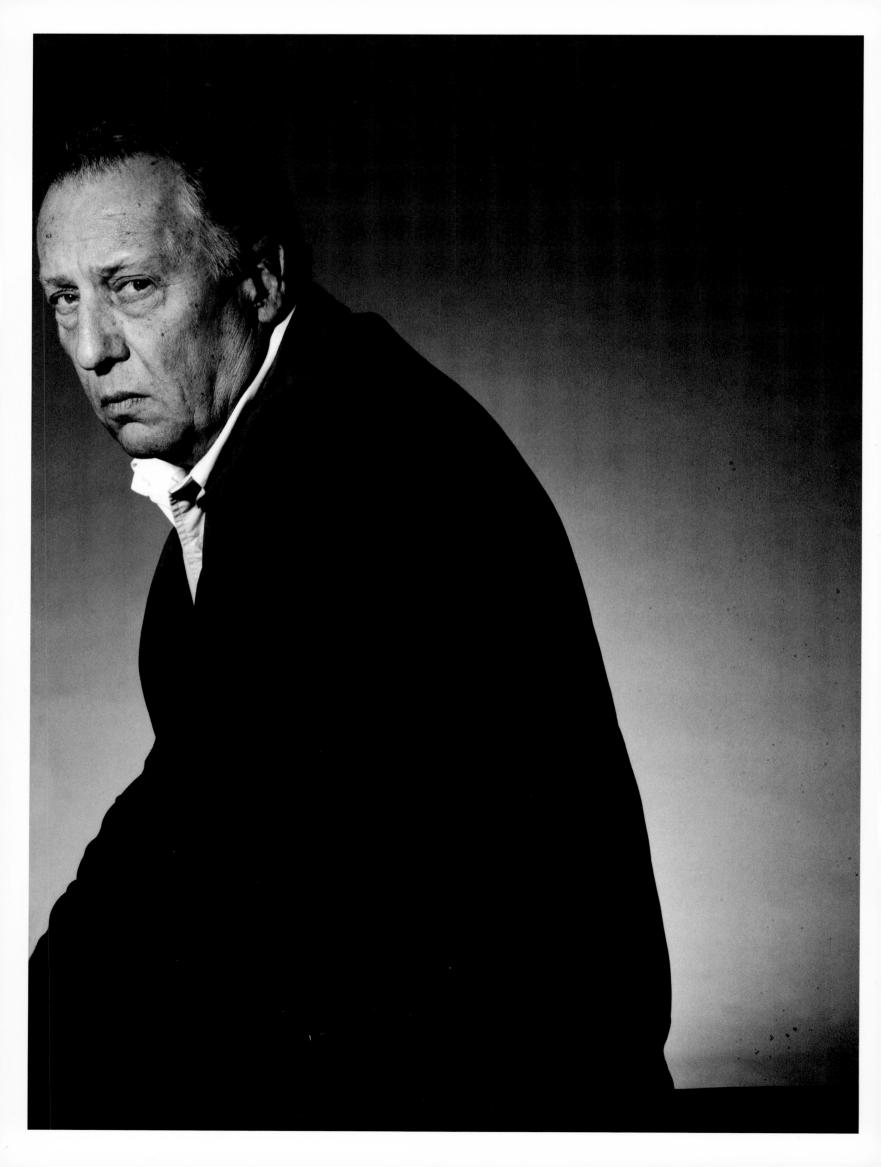

**Frederick Forsyth**
Author

**Sir Bob Geldof**
Musician & writer

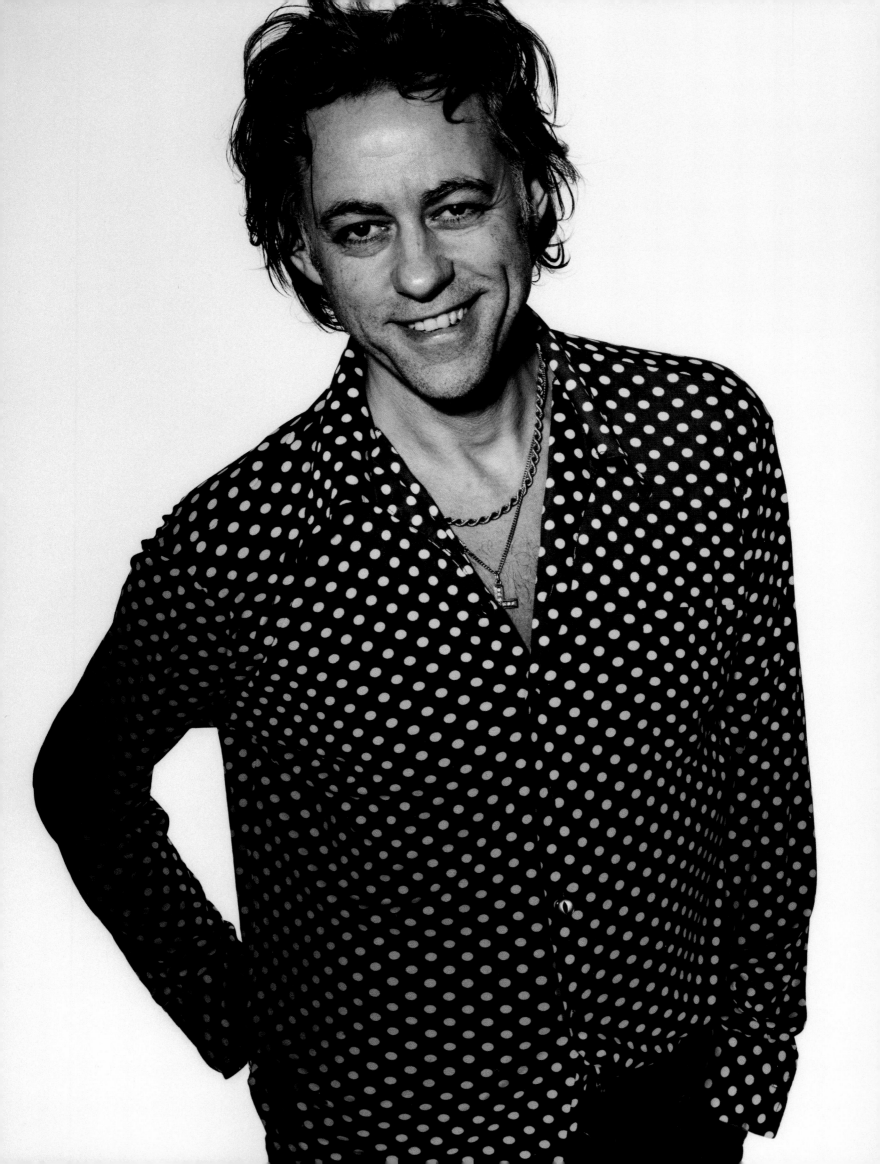

**George Melly**
Singer, author & lecturer

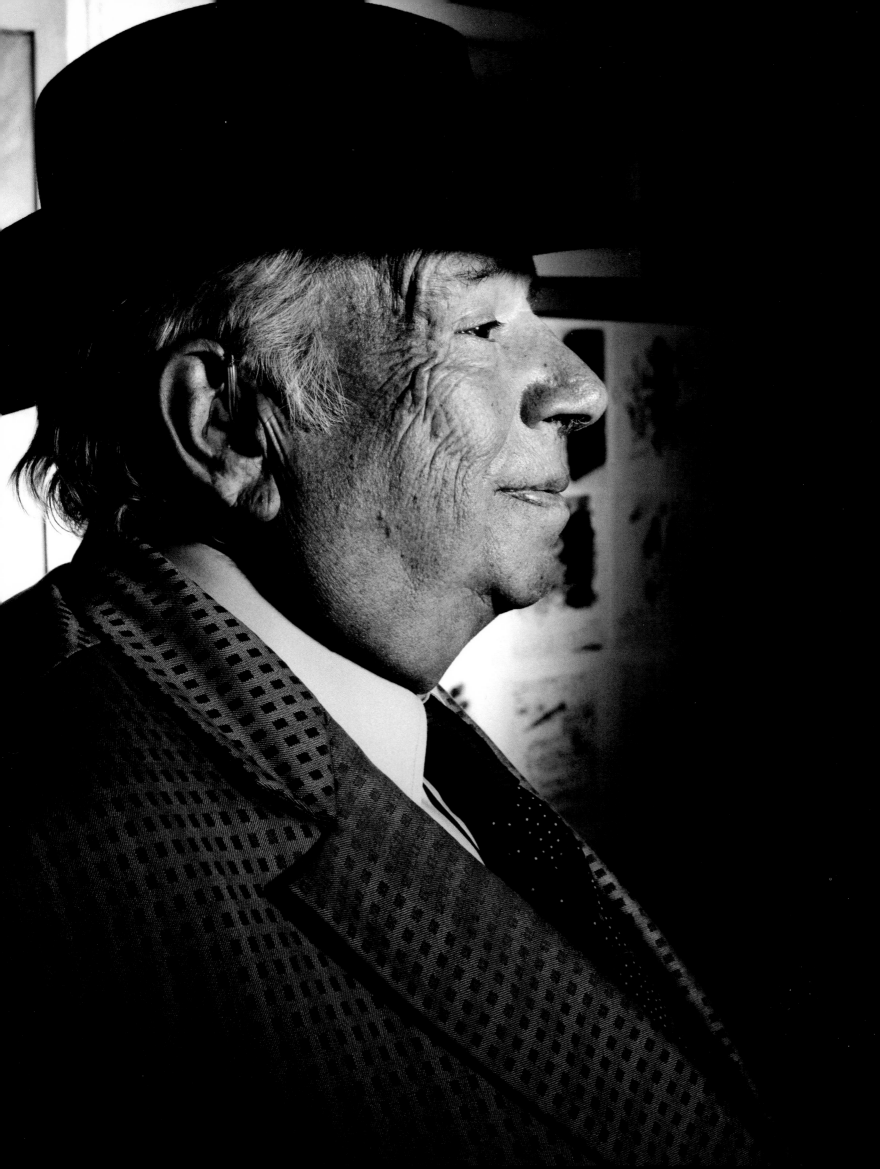

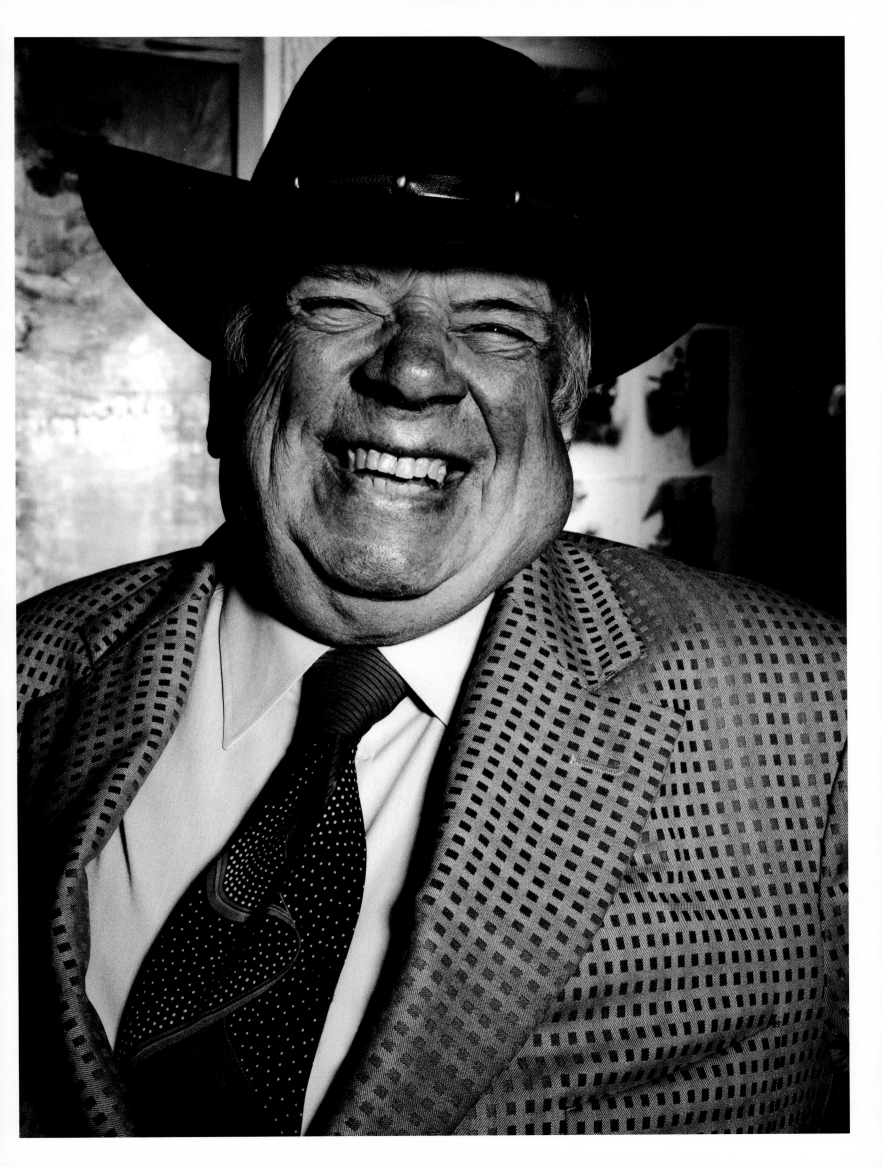

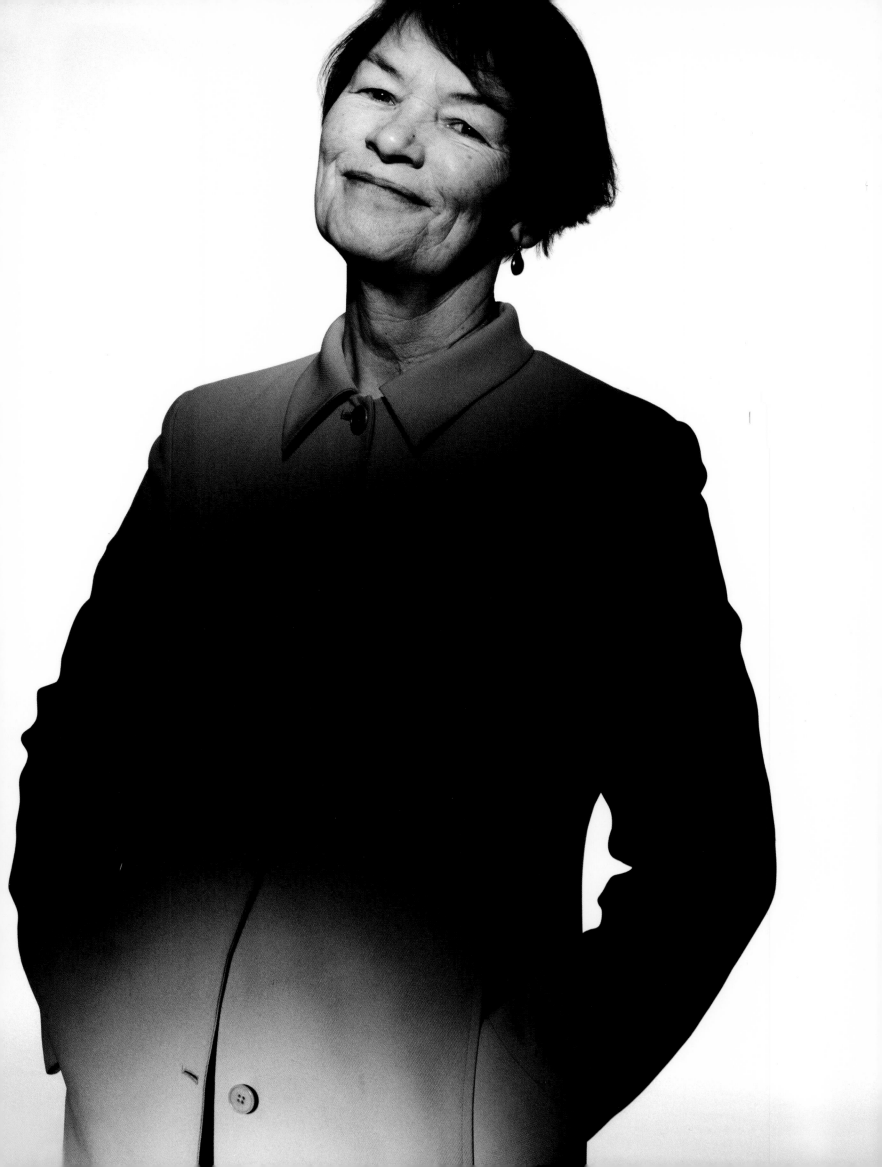

Glenda Jackson MP, CBE

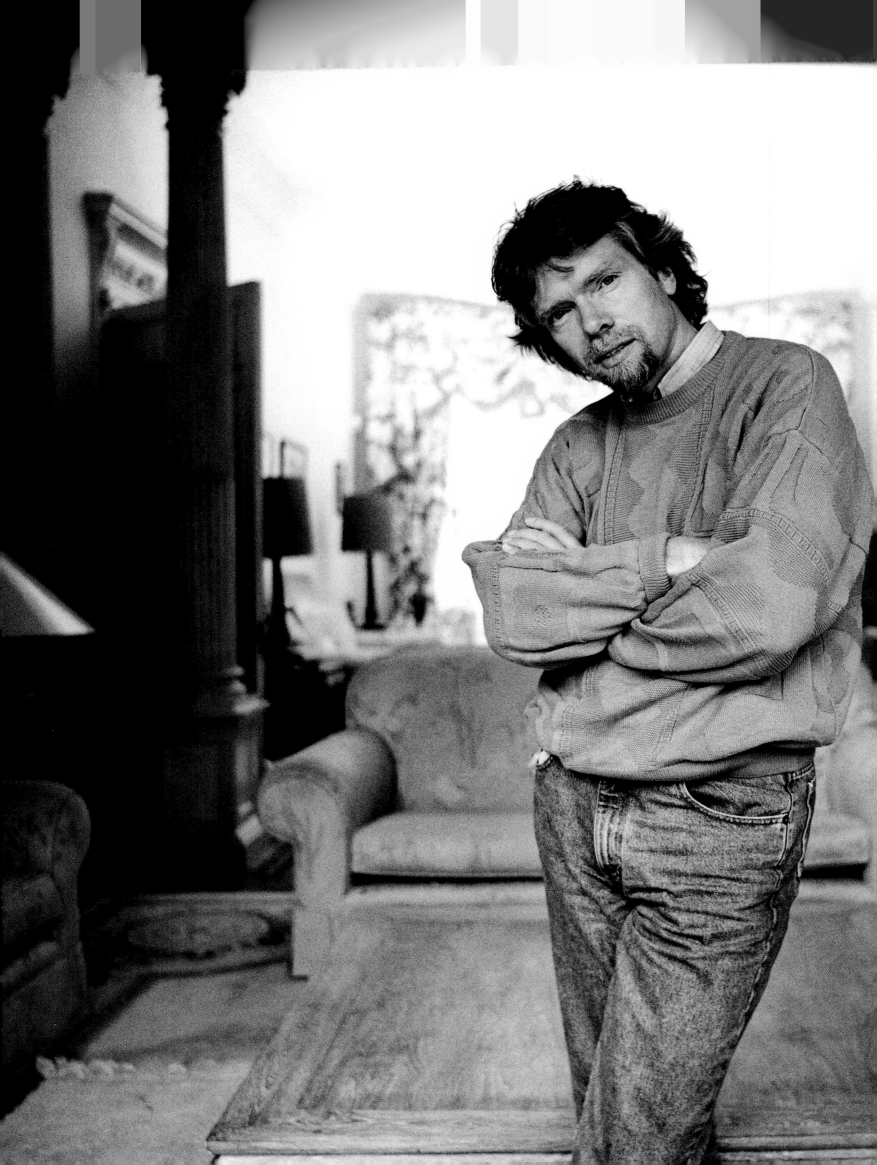

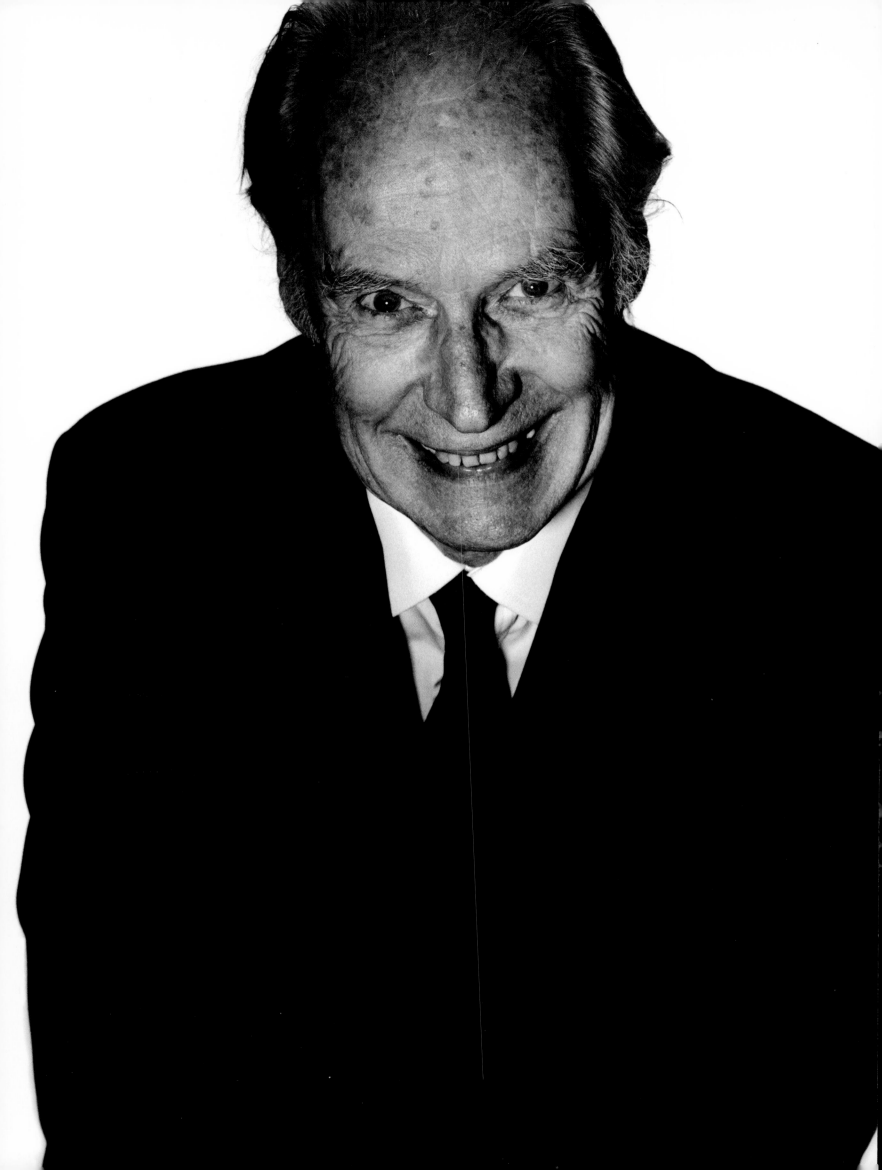

**Sir Tim Rice**
Lyricist

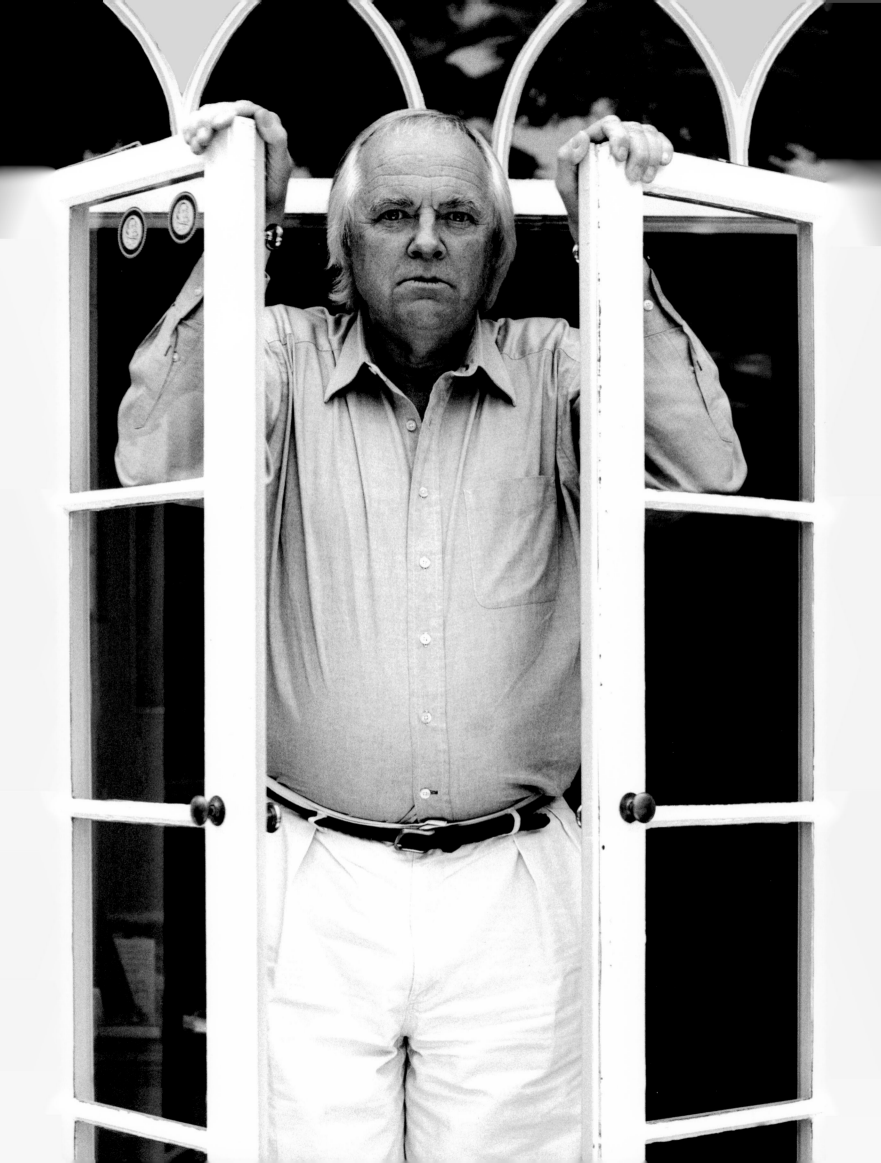

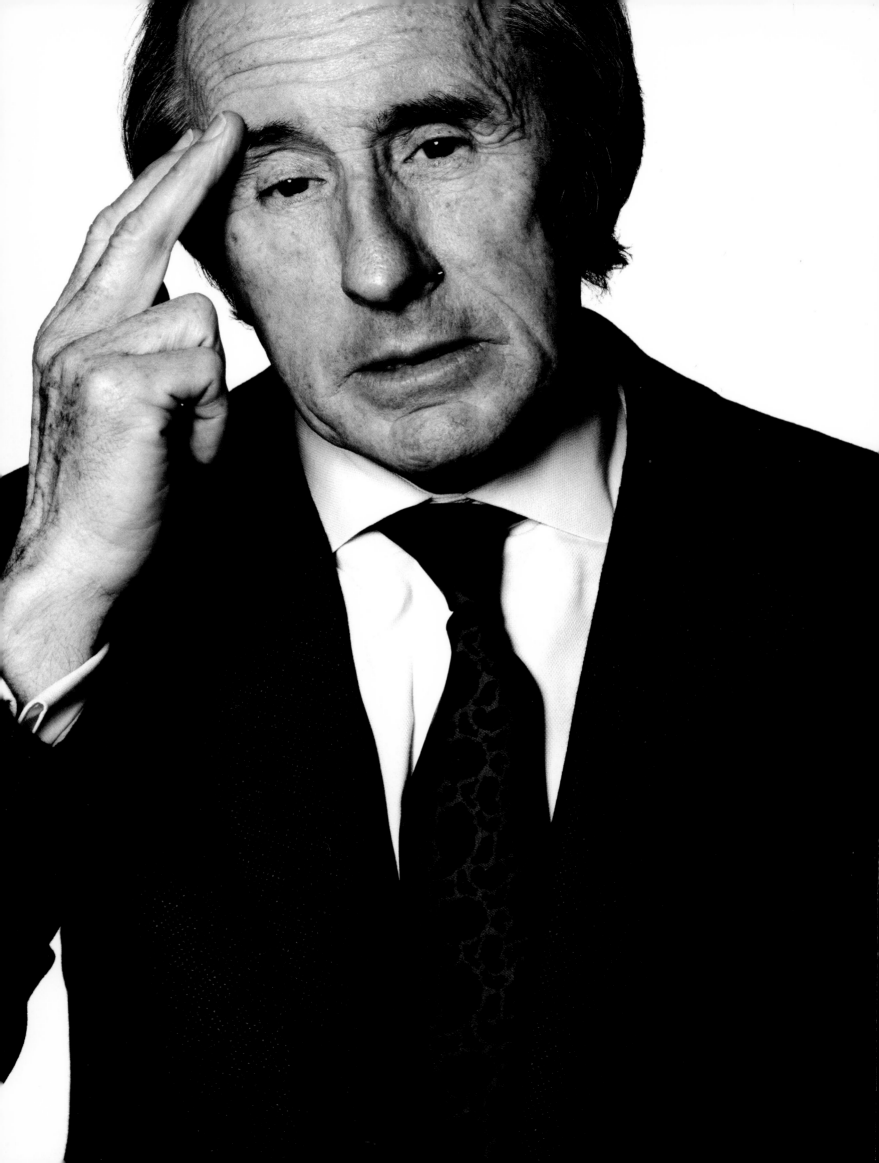

**Jane Asher**
Actress, writer & businesswoman
President of the National
Autistic Society

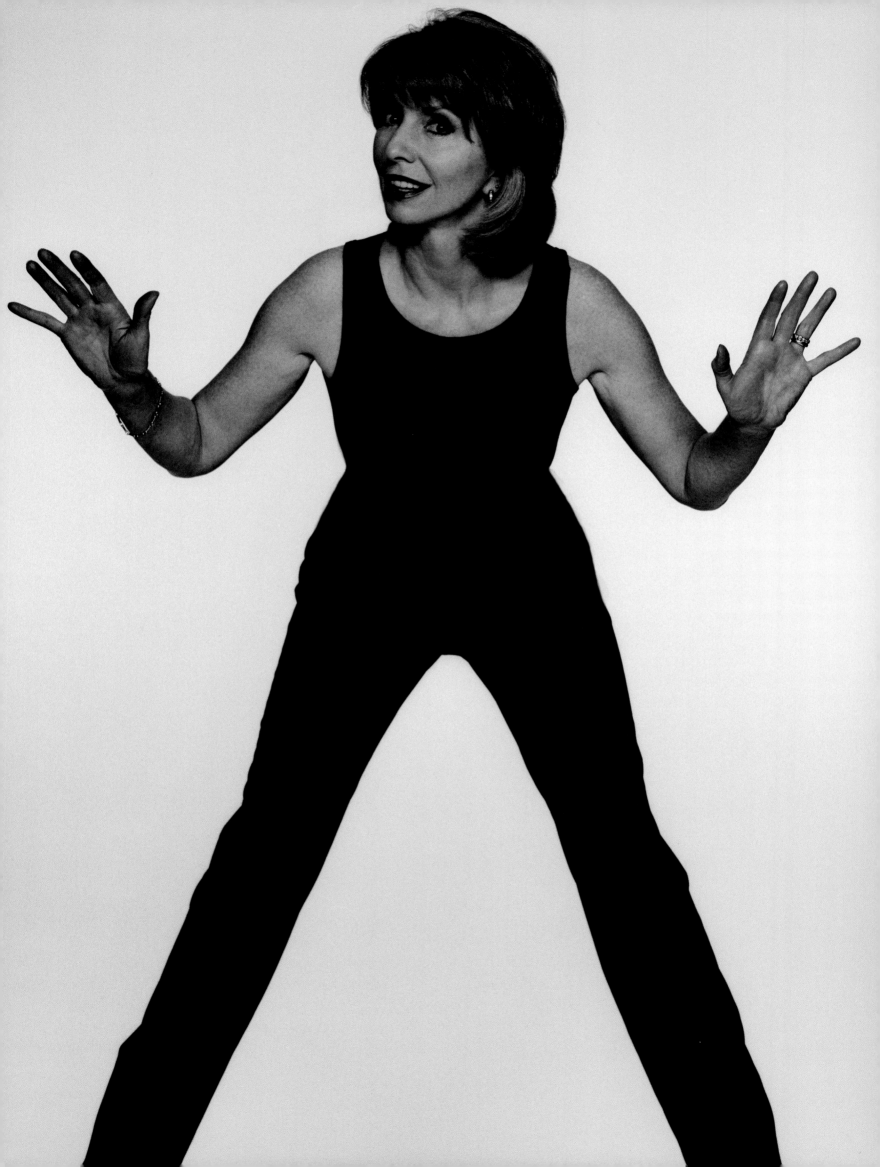

**Jeff Banks**
Designer

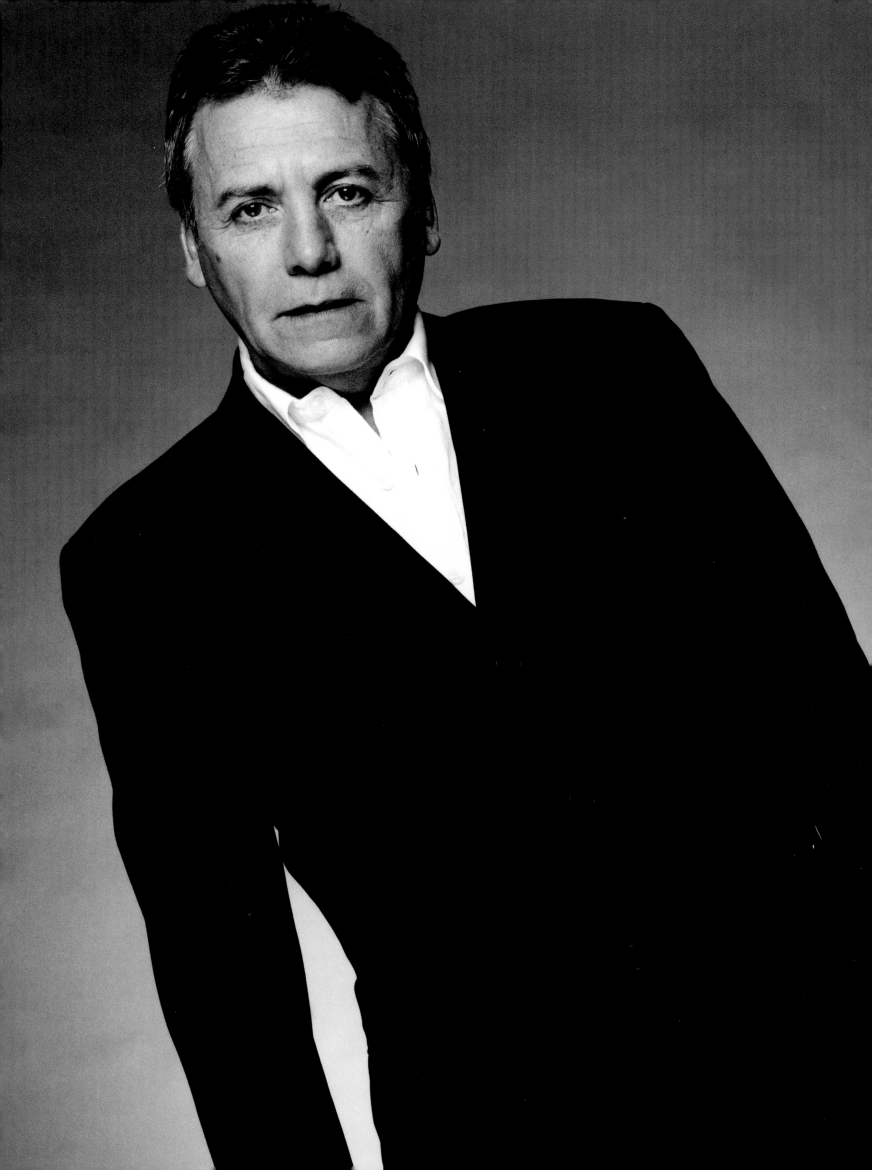

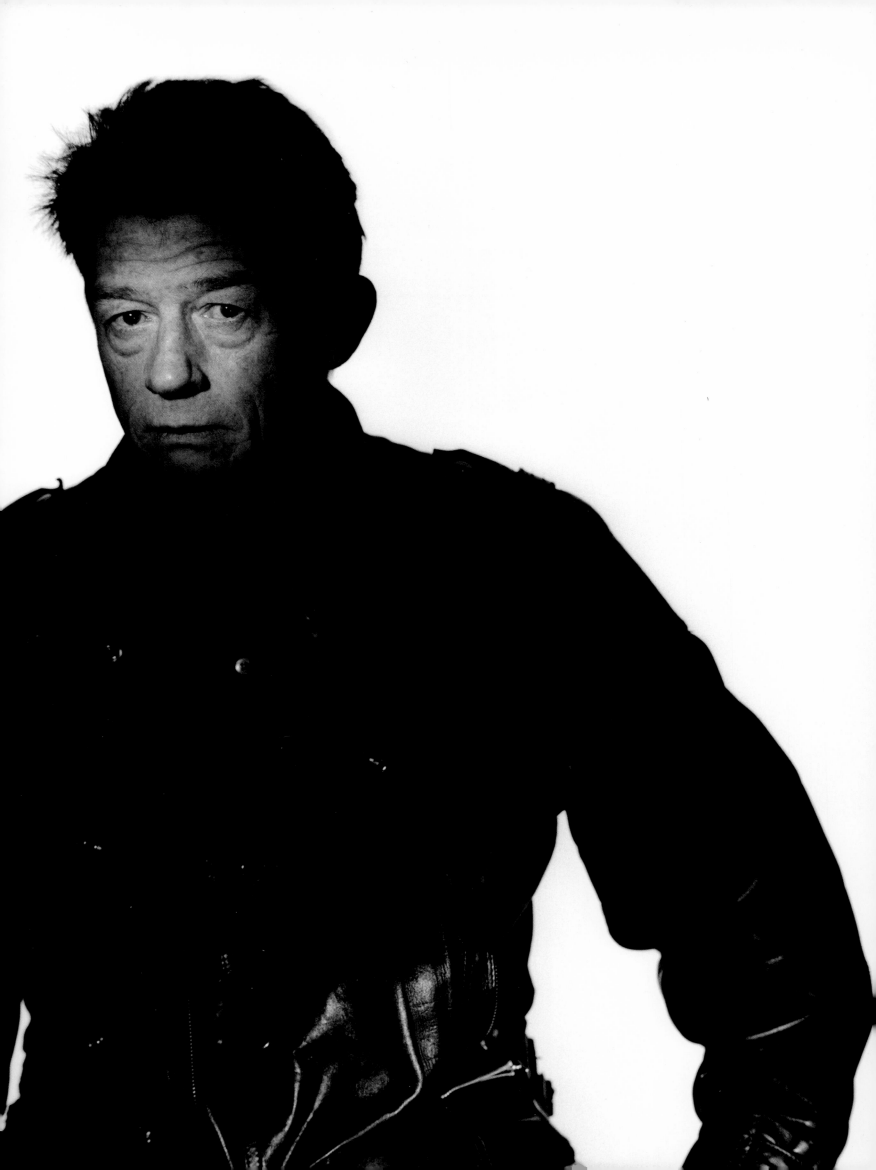

**John Hurt**
Actor

**Nicky Haslam**
Interior designer

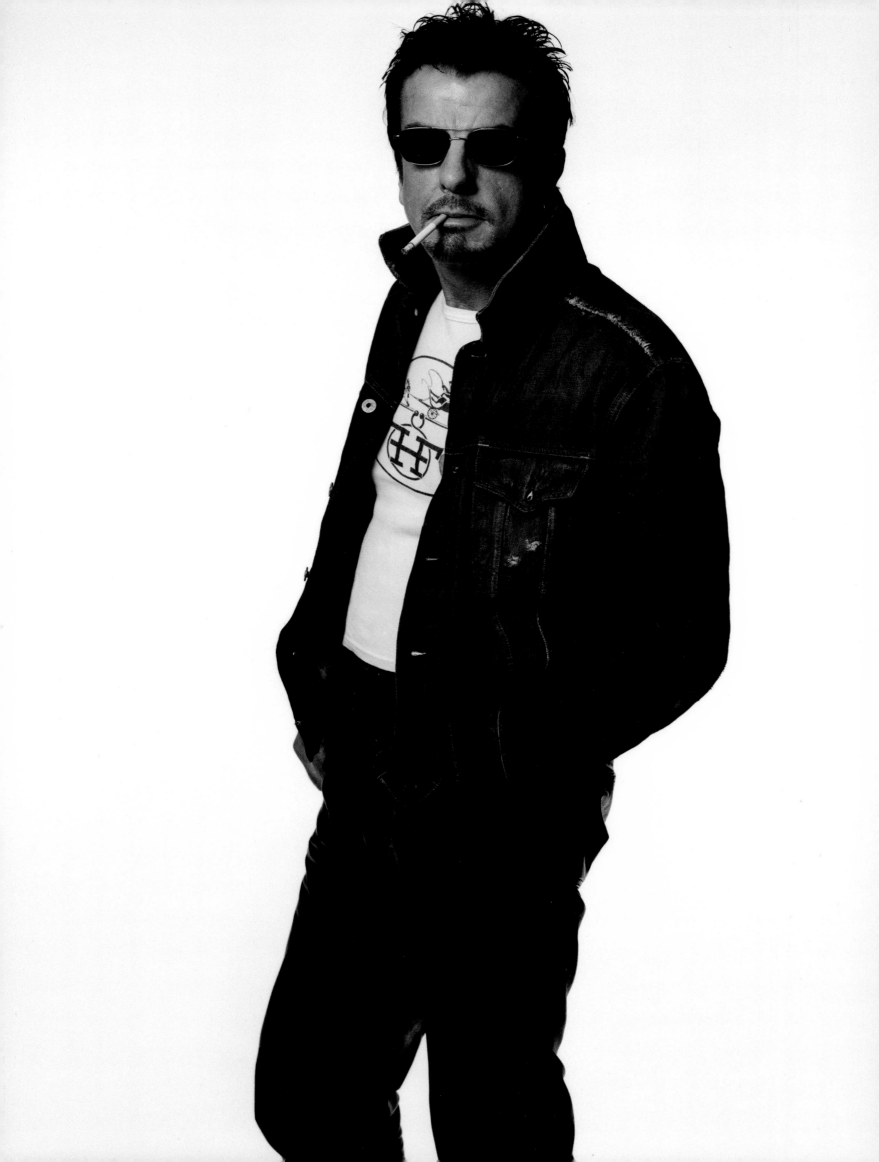

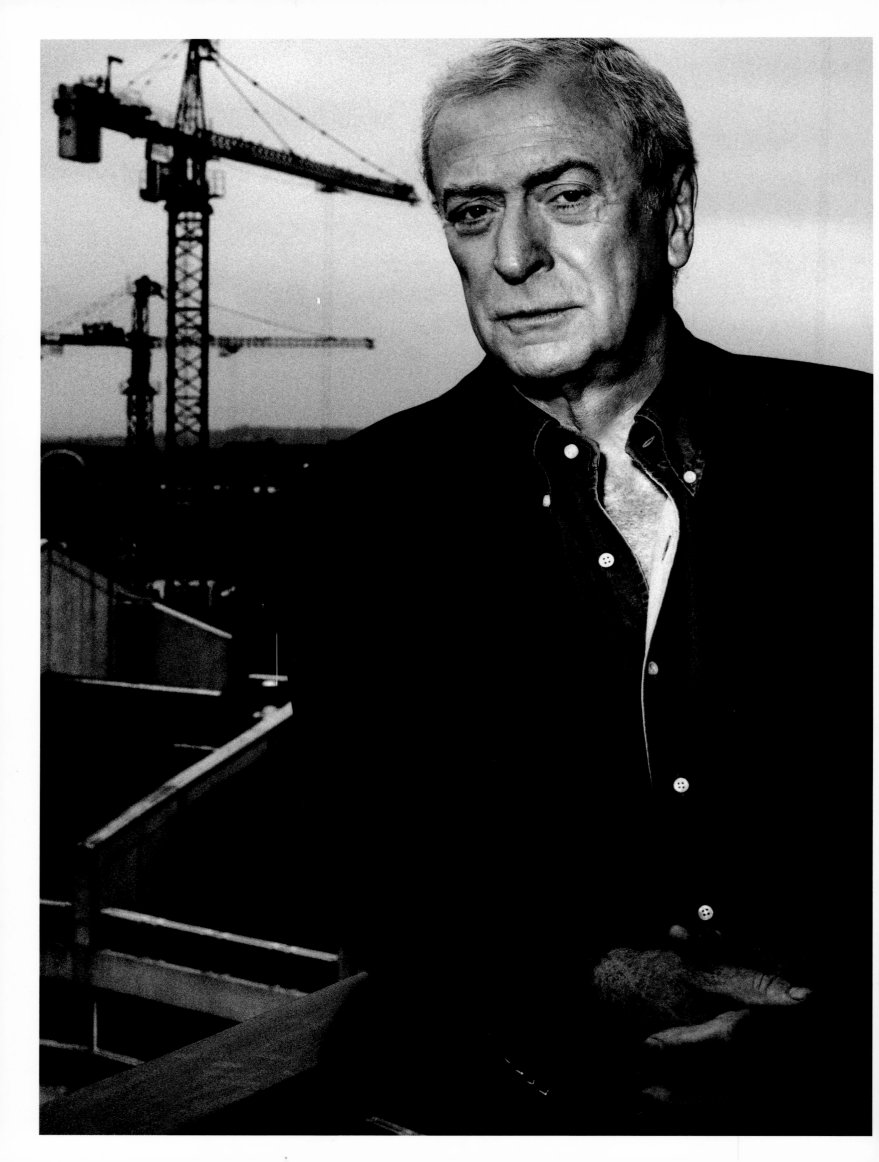

Sir Michael Caine
Actor

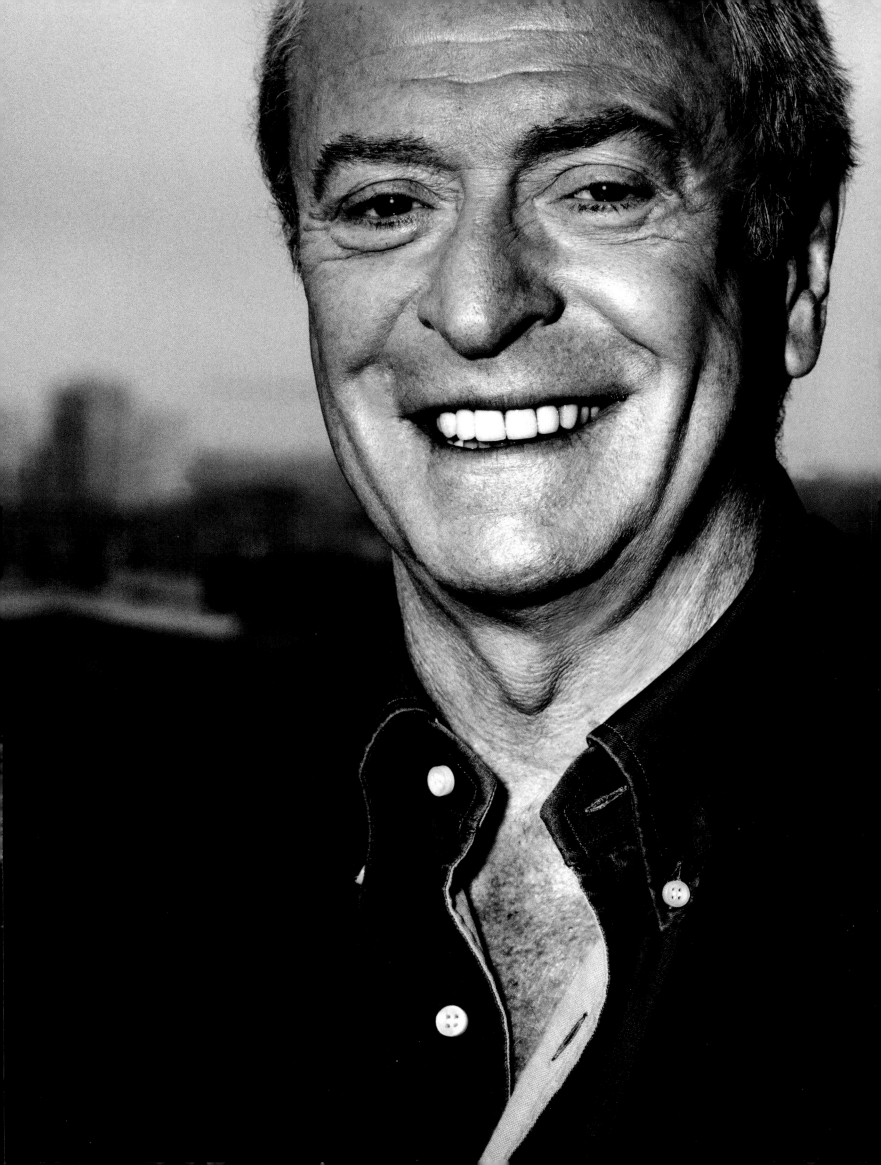

**DR Lady Mary Archer**
Scientist & Chairman of
Addenbrooke's NHS Trust

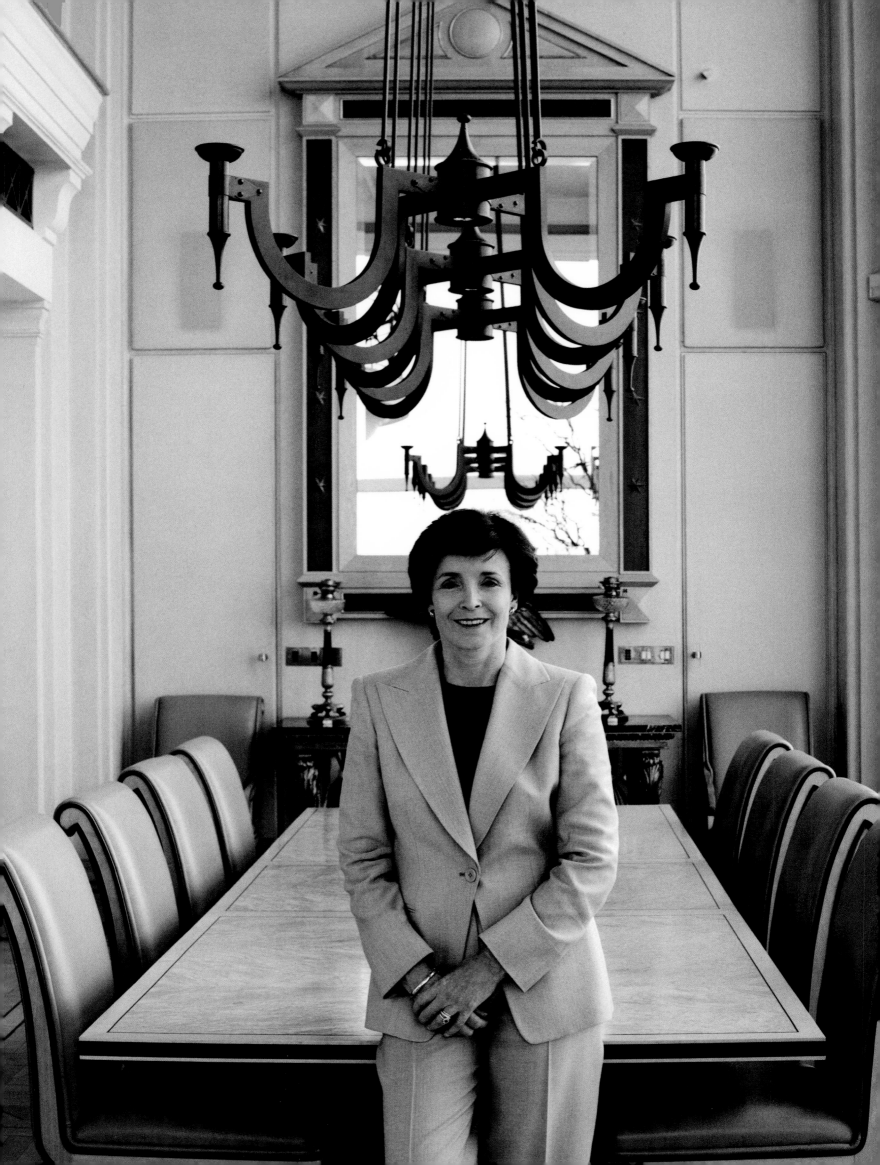

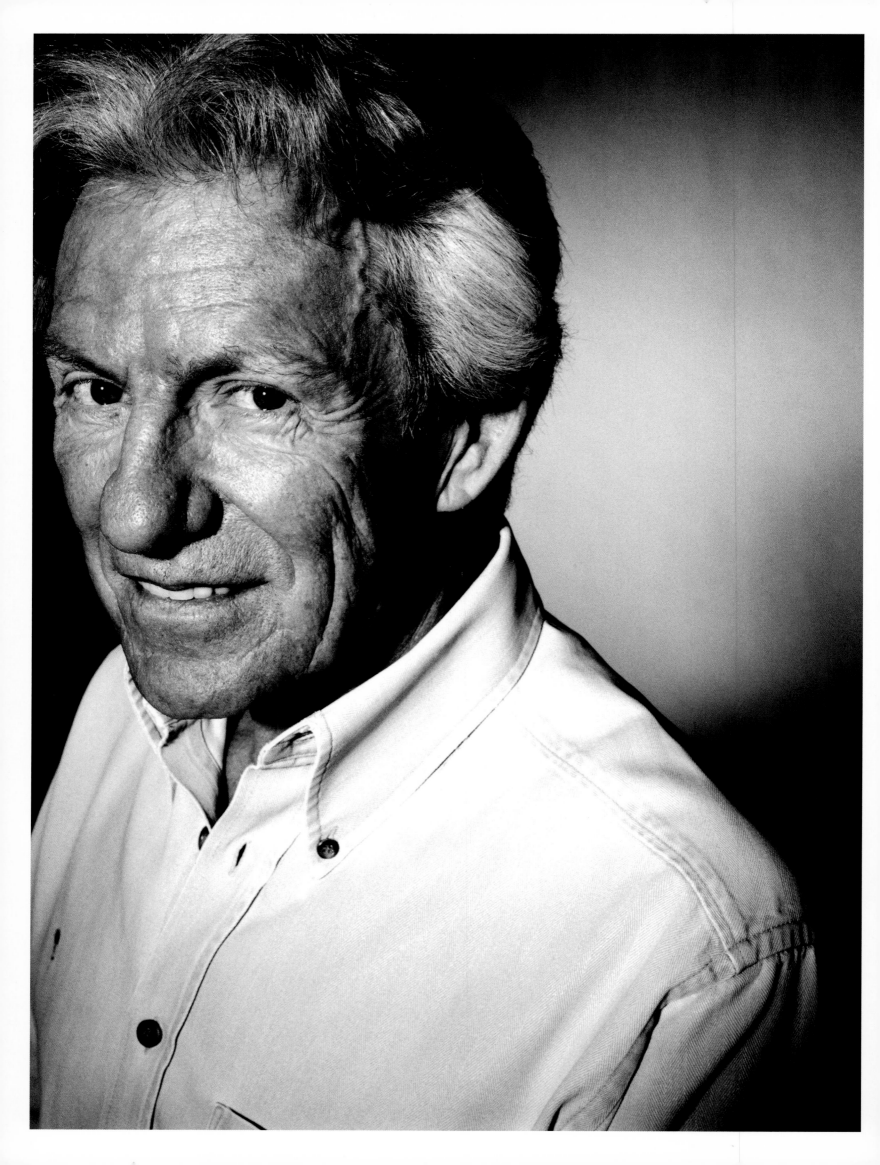

Michael Palin CBE
Travel writer & explorer

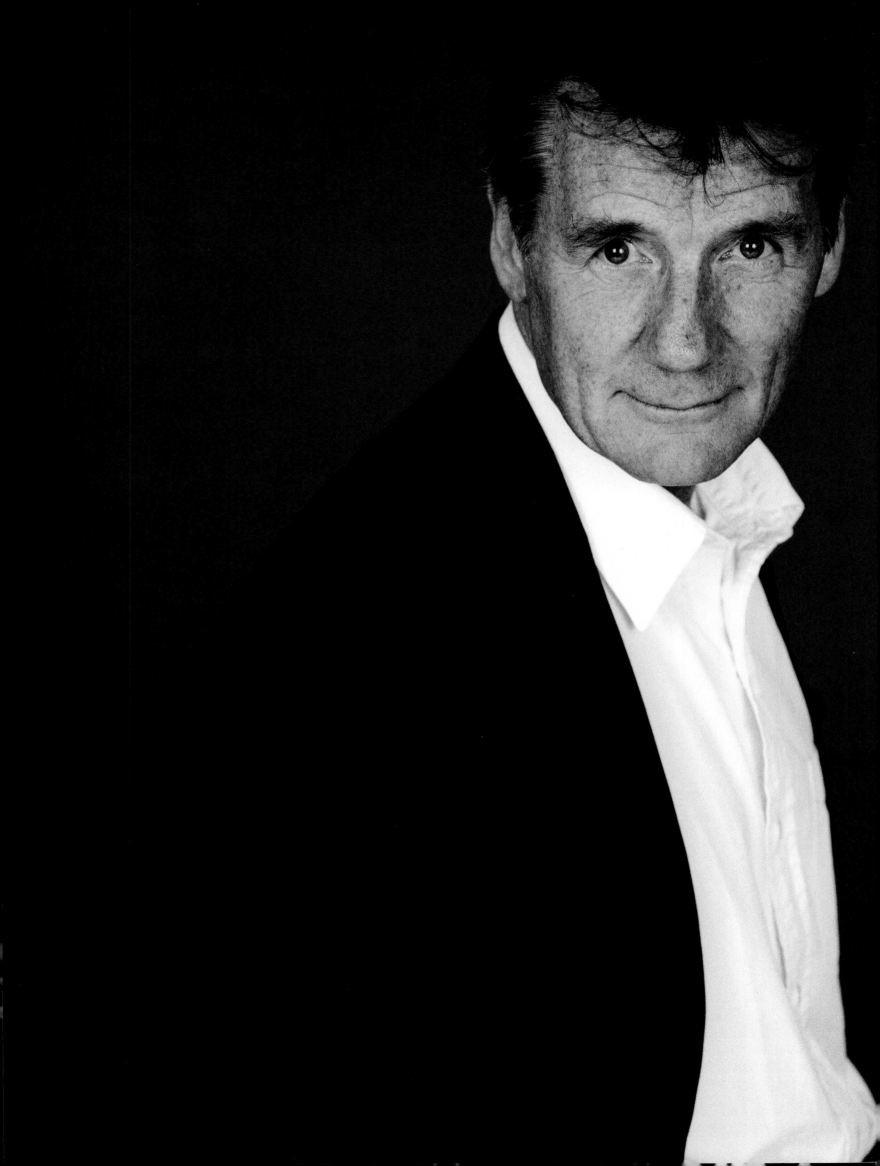

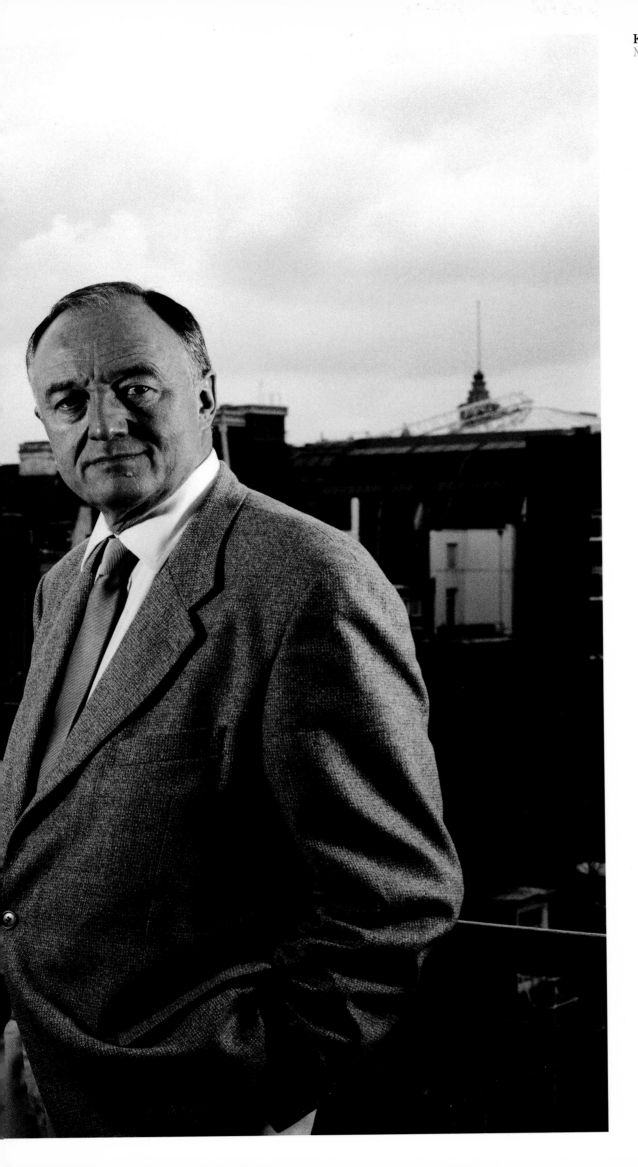

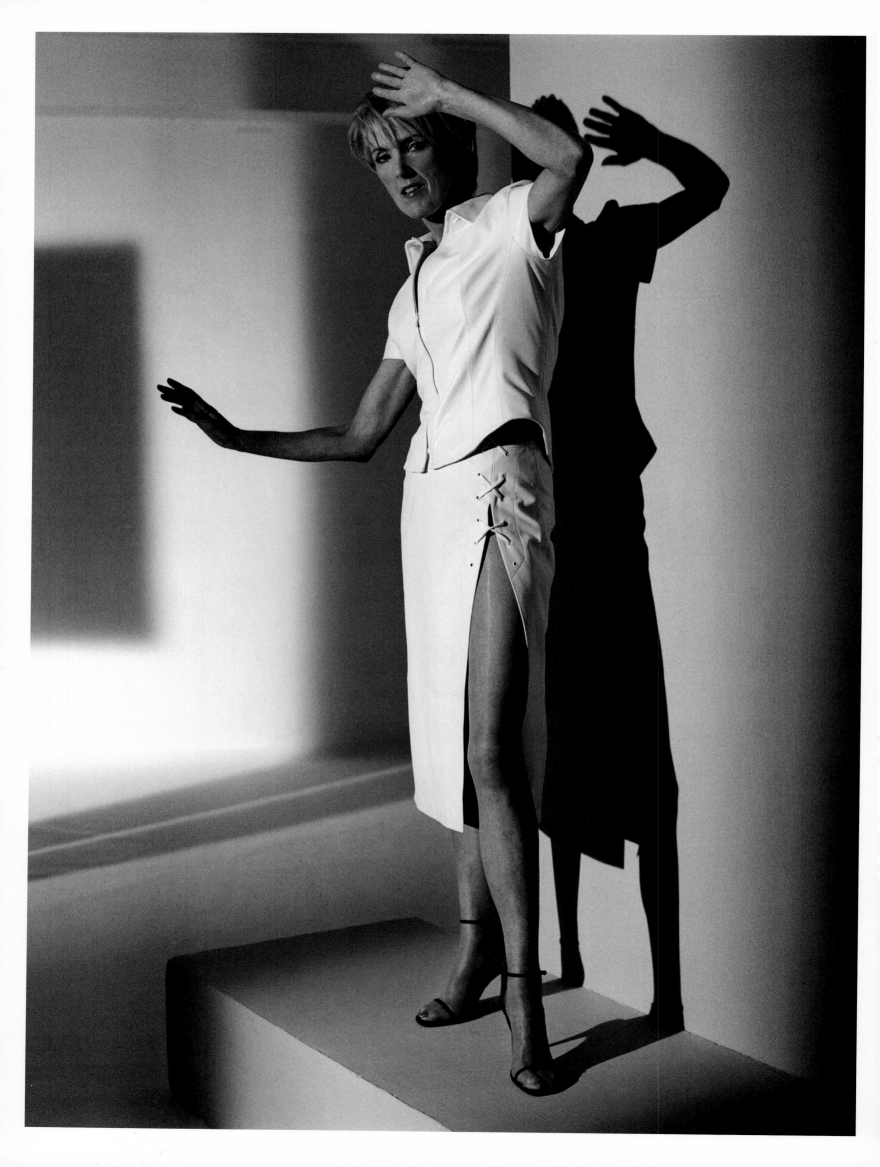

Joanna Trollope OBE
Author

**Mary Quant OBE**
Designer & cosmetics entrepreneur

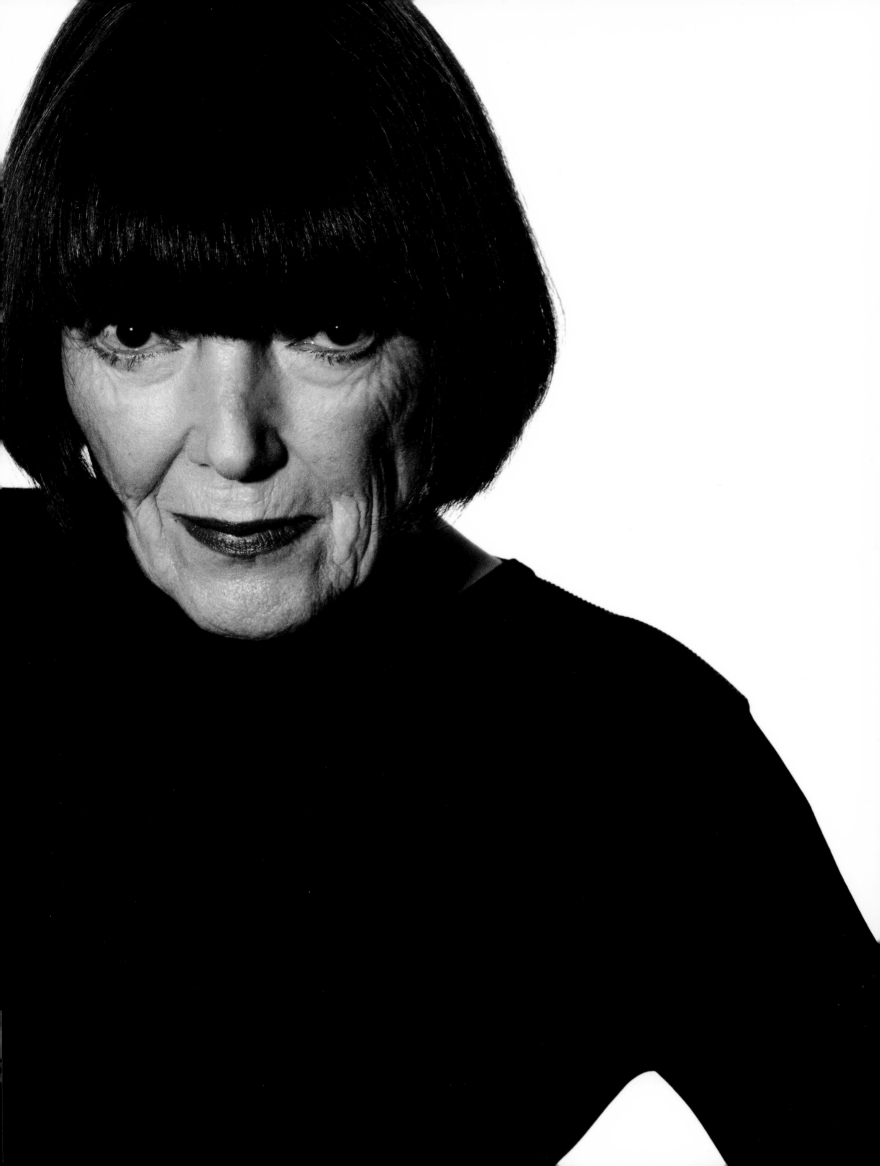

**Michael Parkinson CBE**
Broadcaster & writer

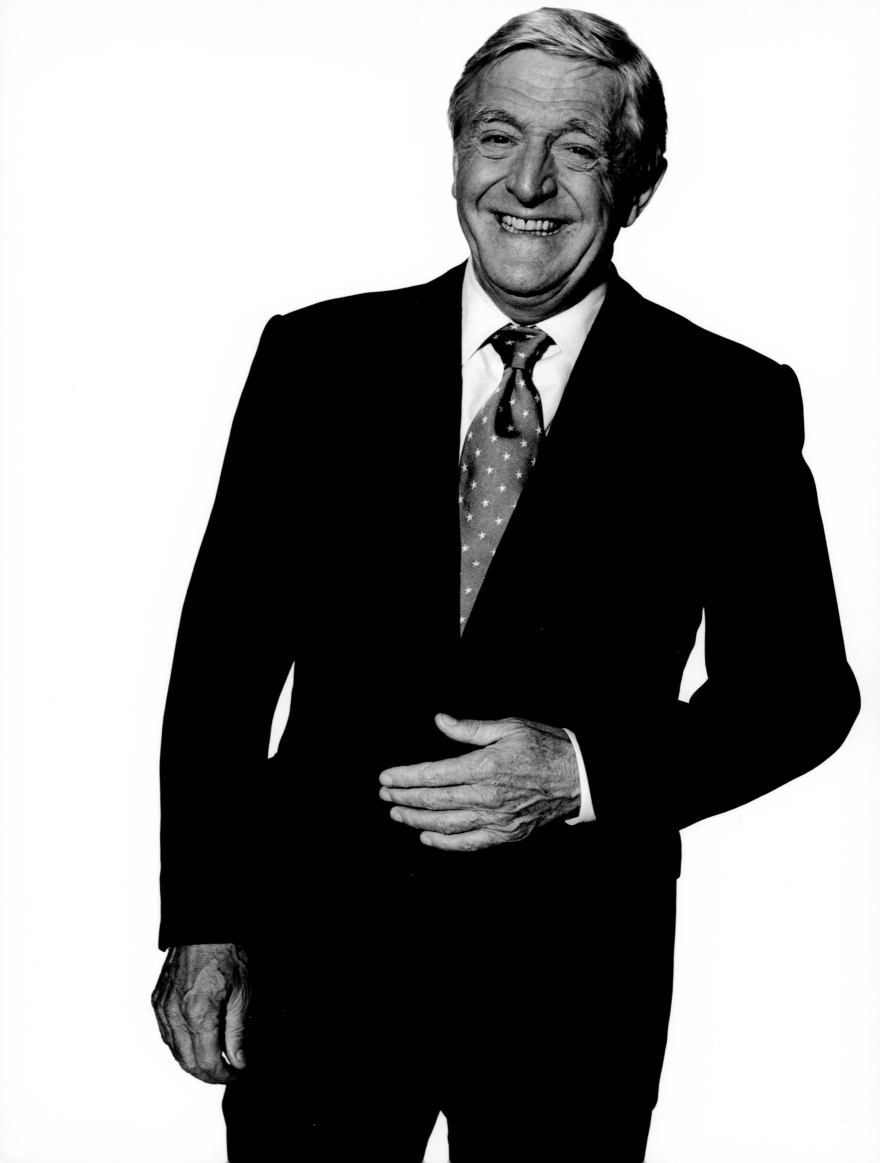

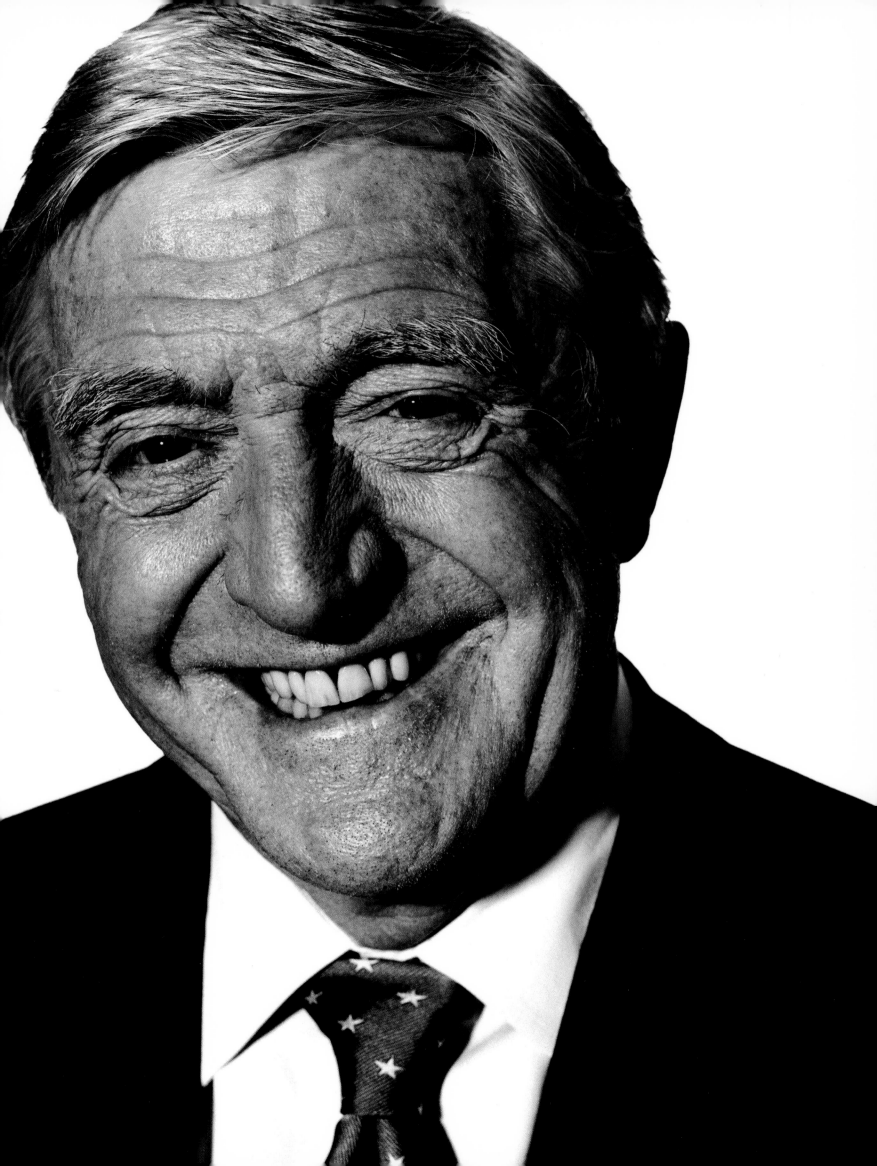

**Sir Norman Foster**
Architect

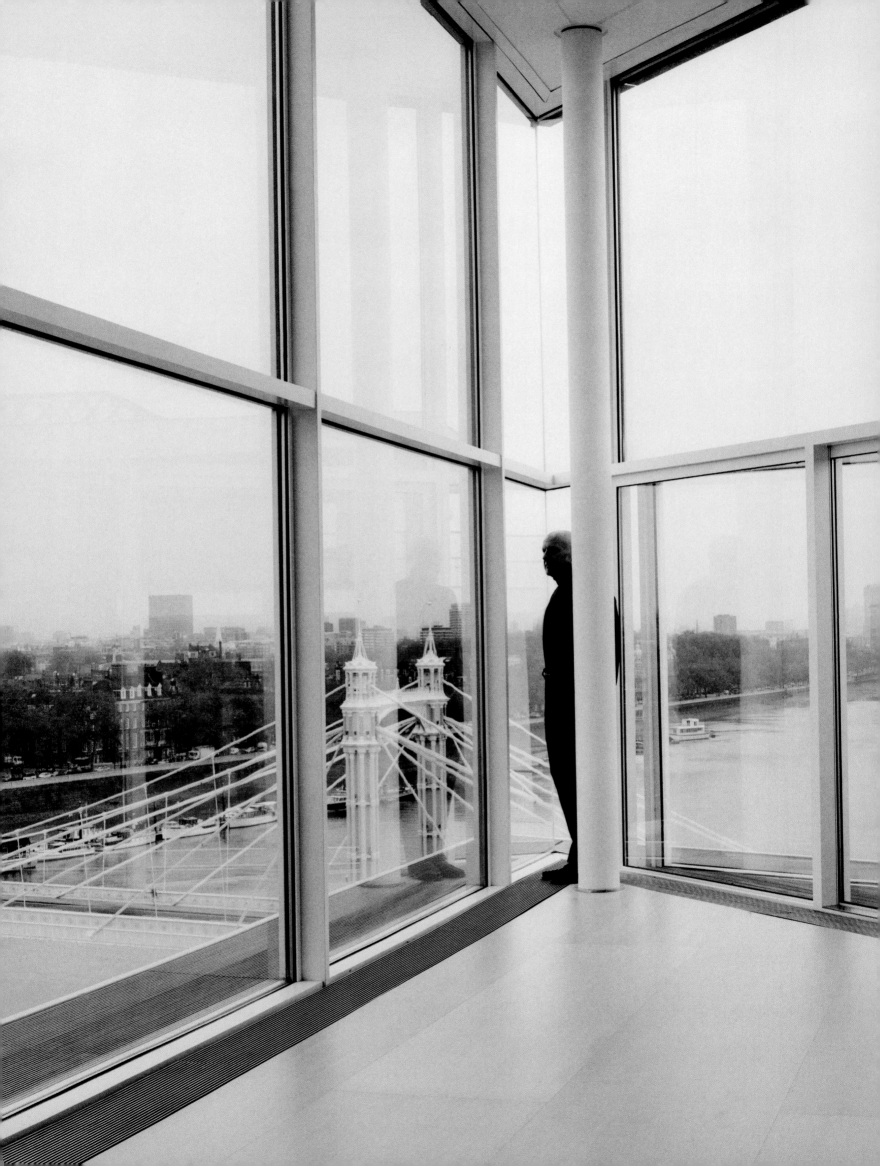

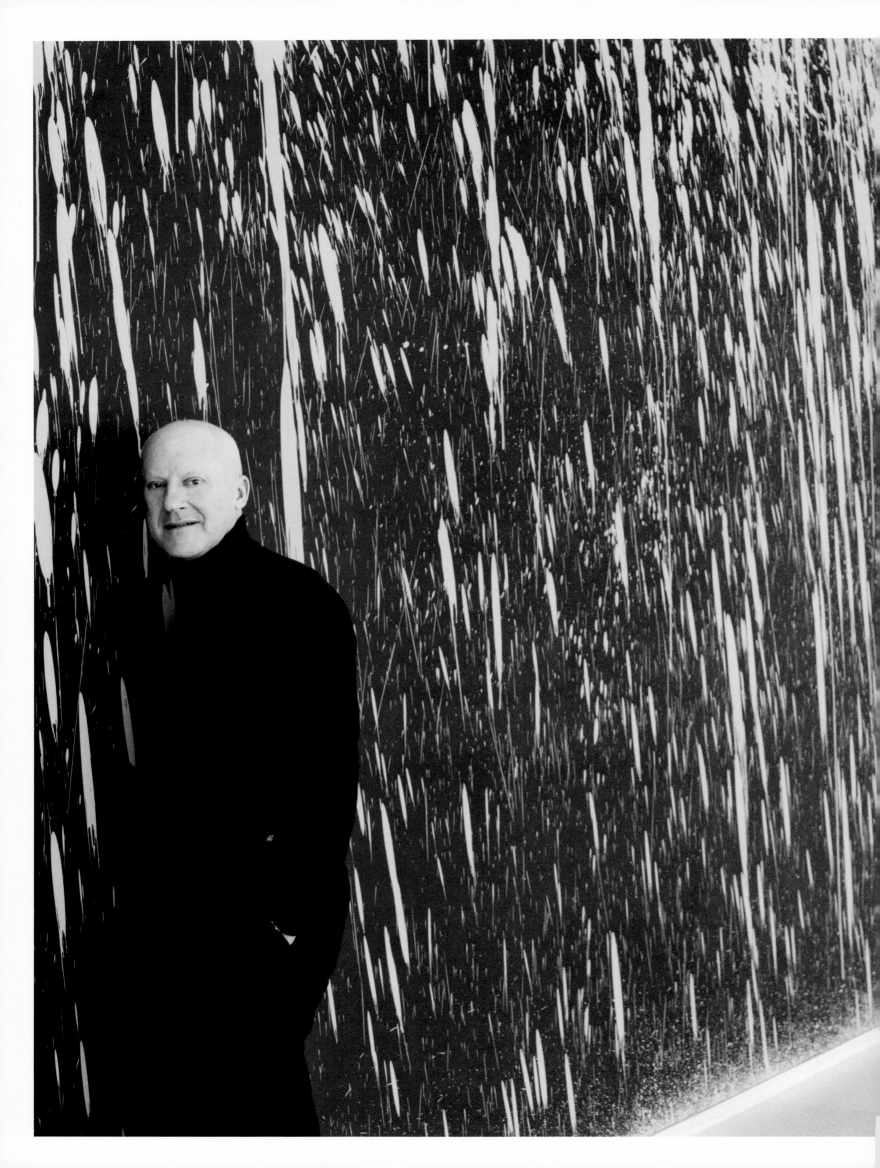

**Lord Lloyd Webber**
Composer

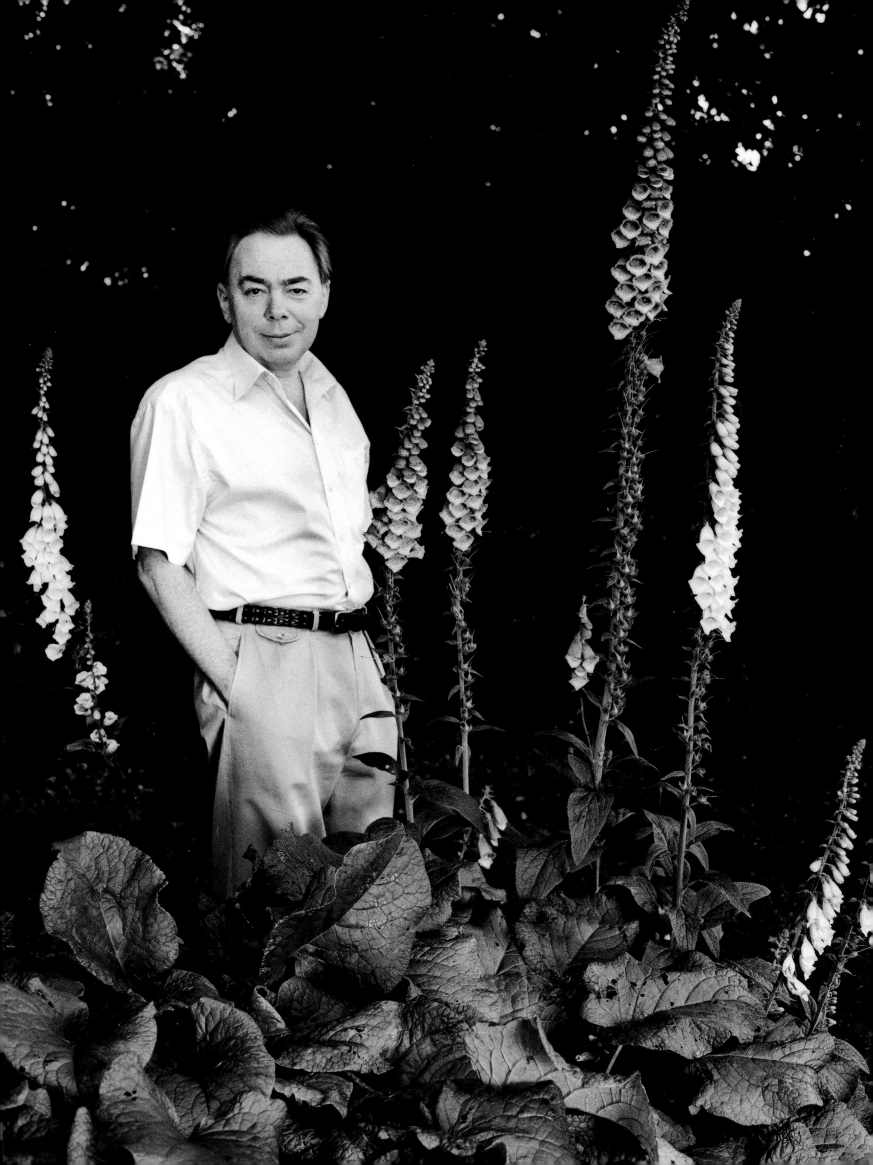

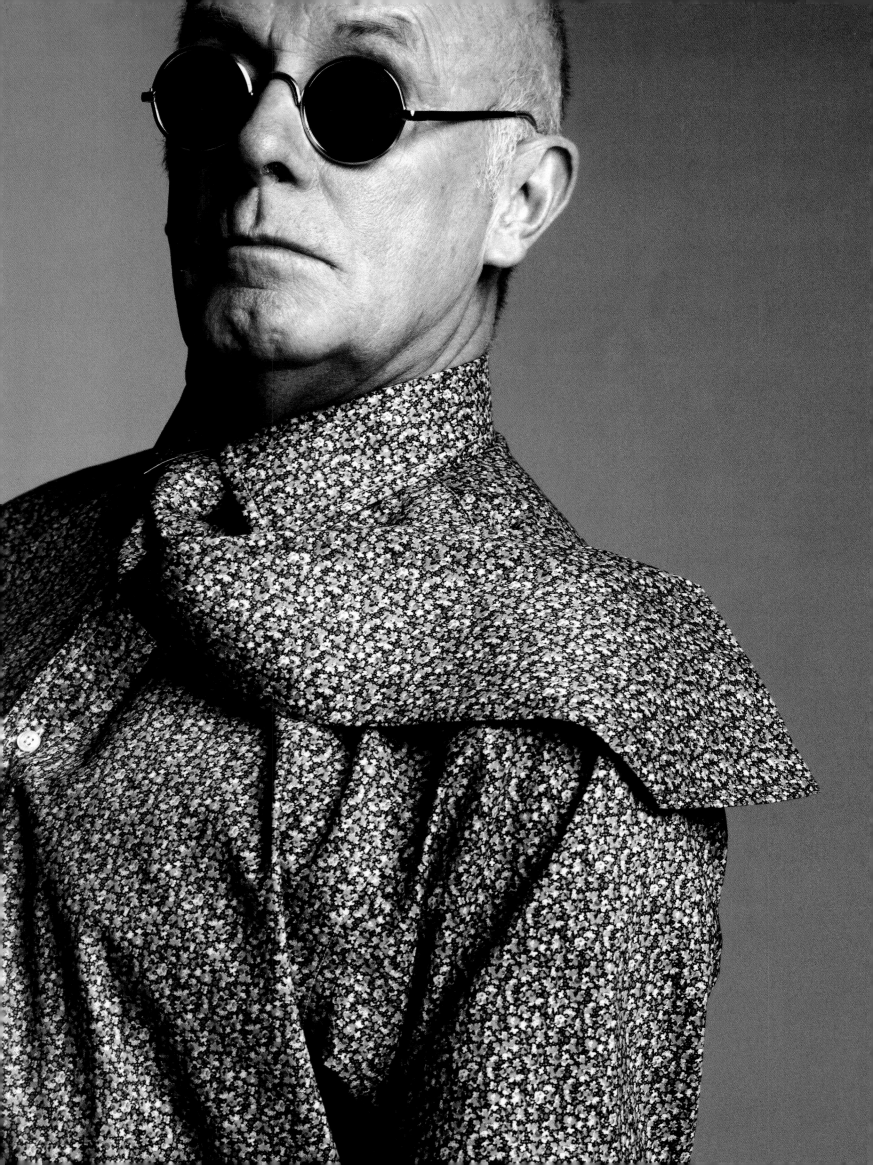

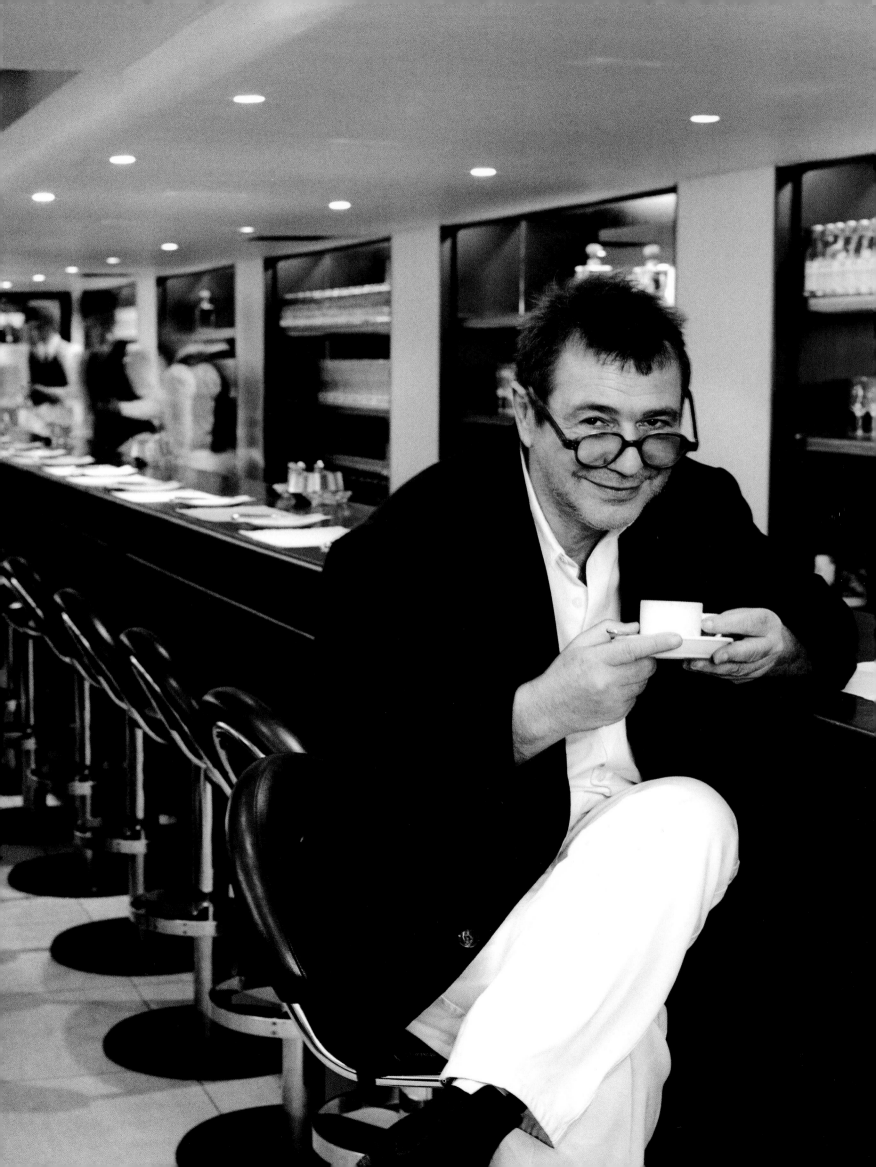

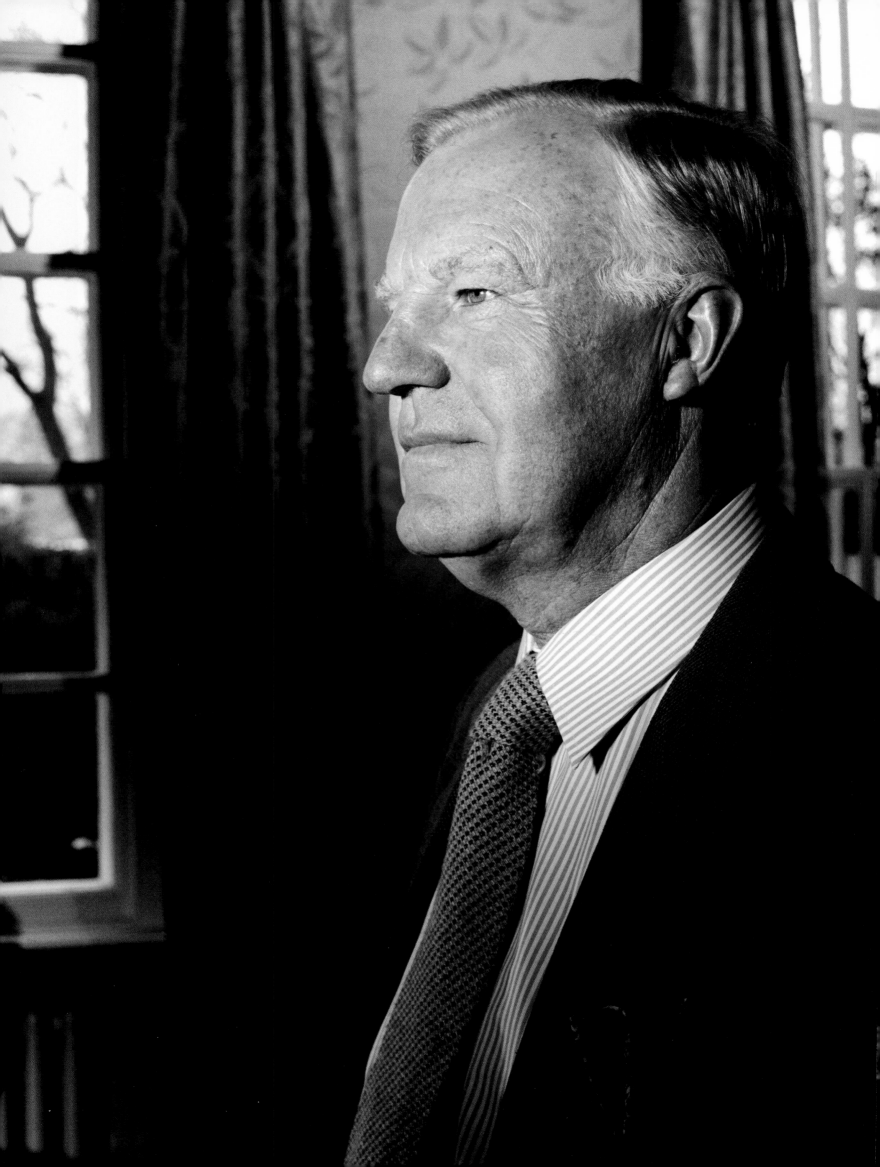

**Lulu OBE**
Singer & songwriter

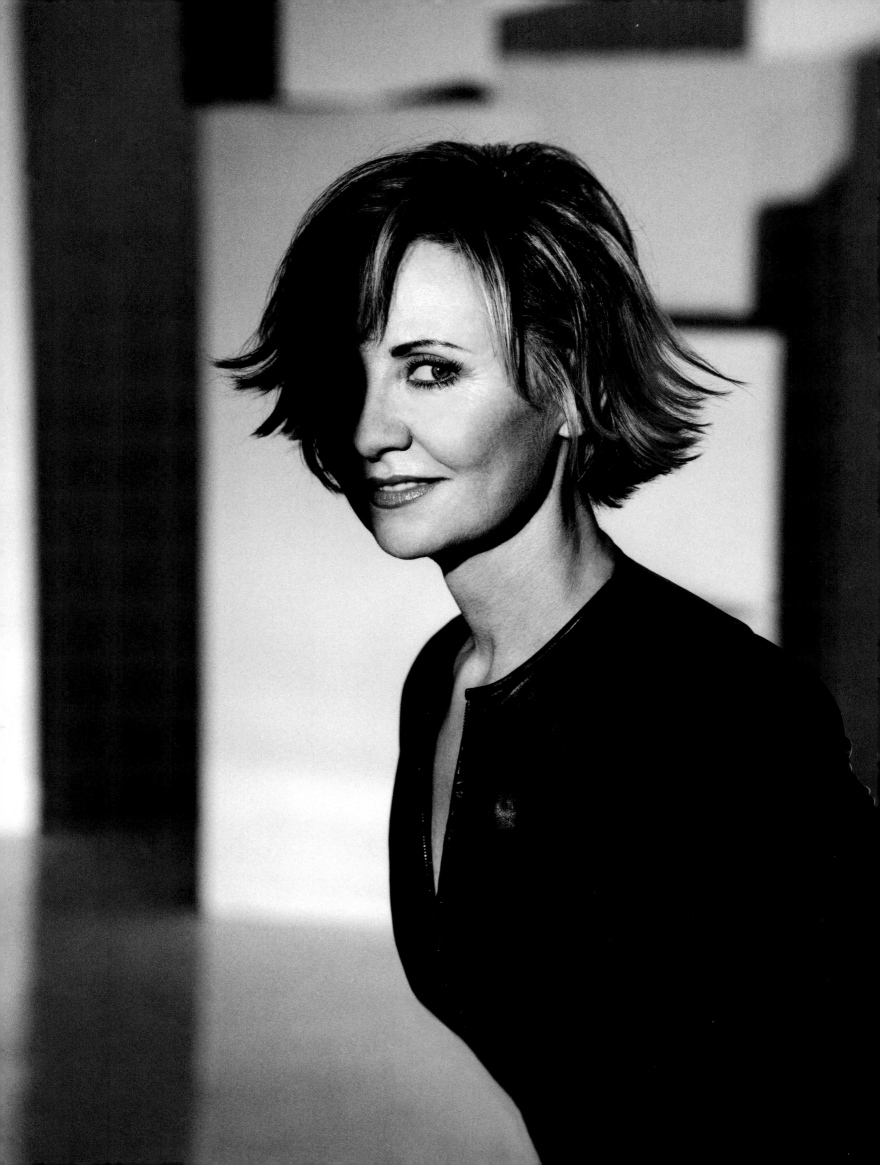

**Rod Stewart**
Singer & songwriter

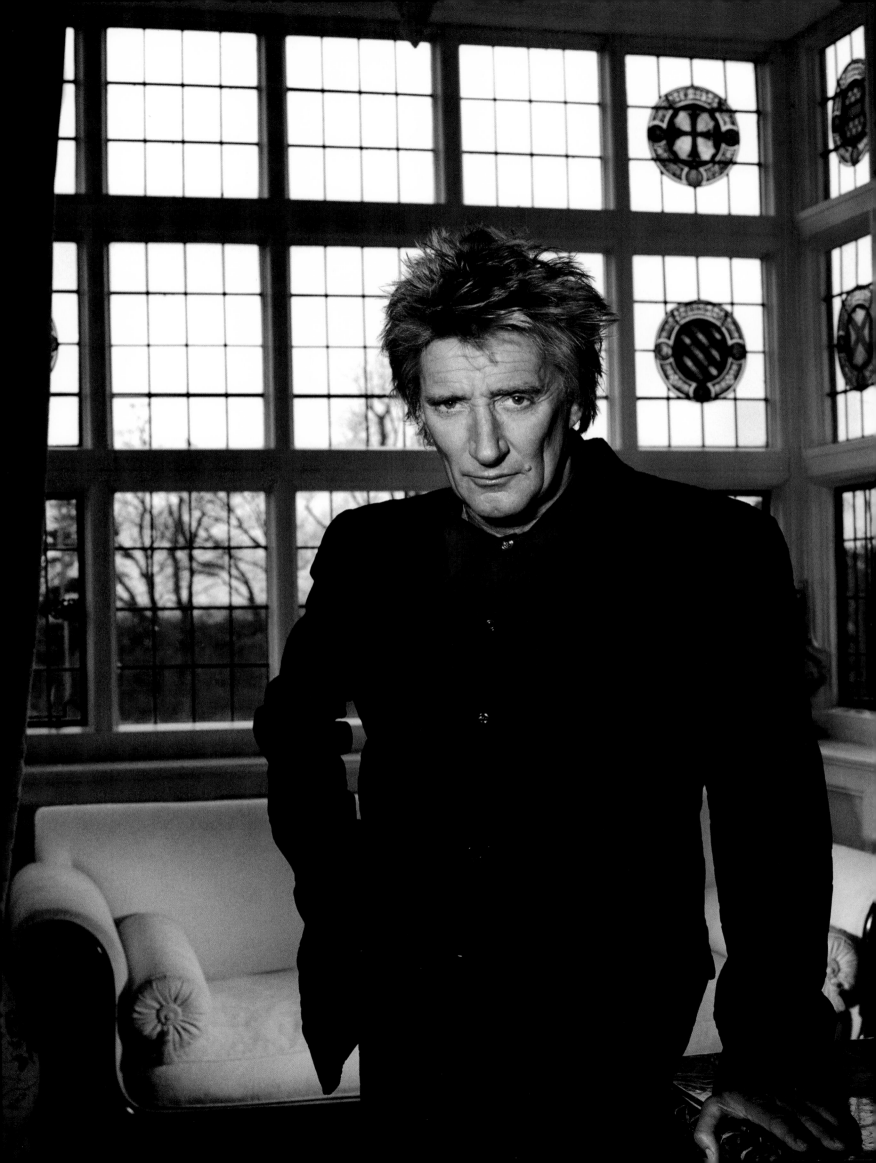

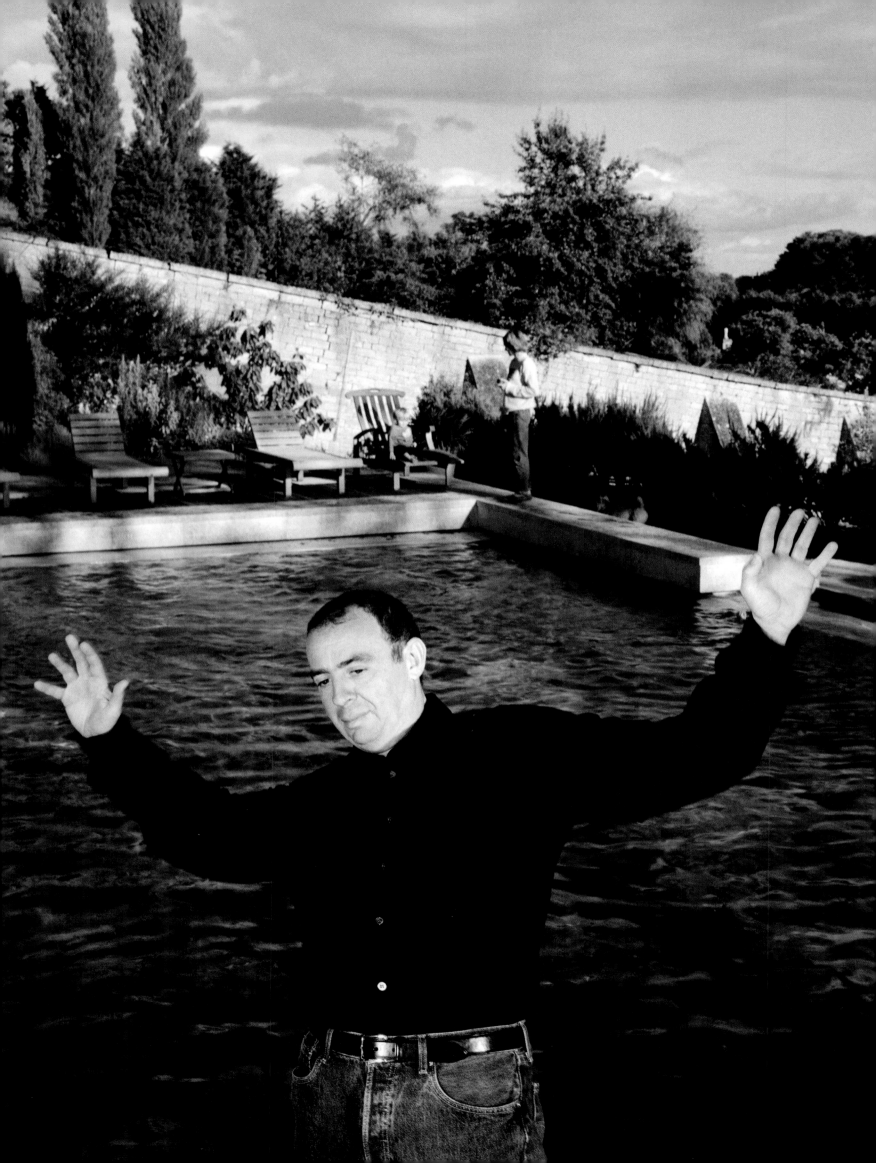

**Lord Snowdon**
Photographer

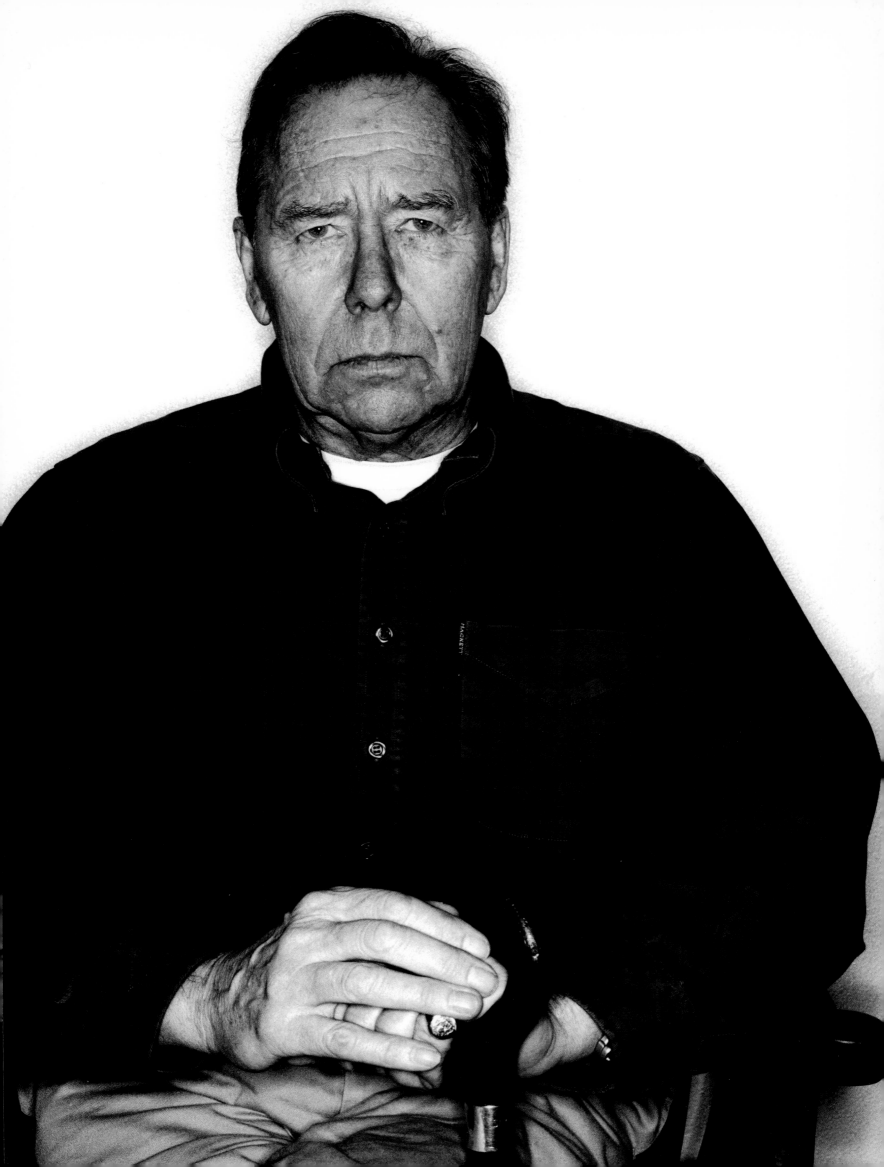

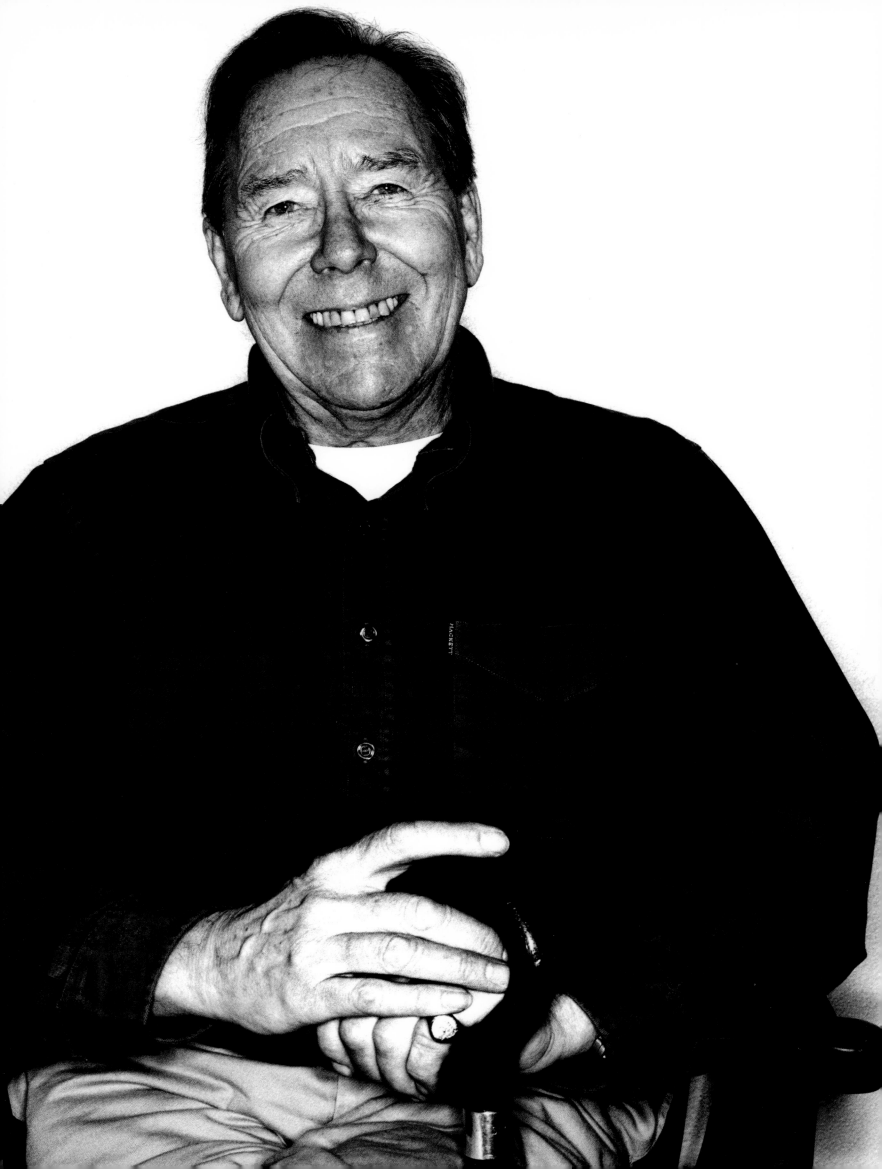

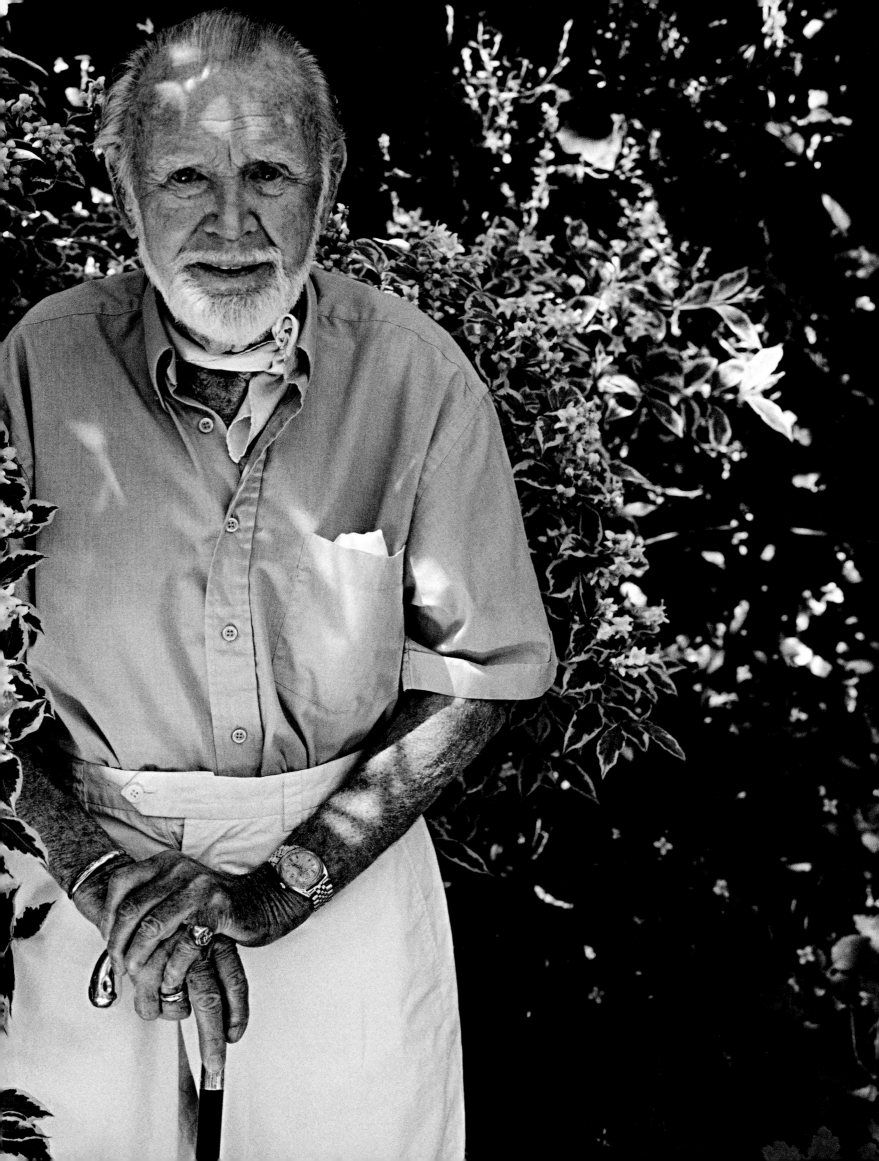

**Lord Attenborough**
Actor & director

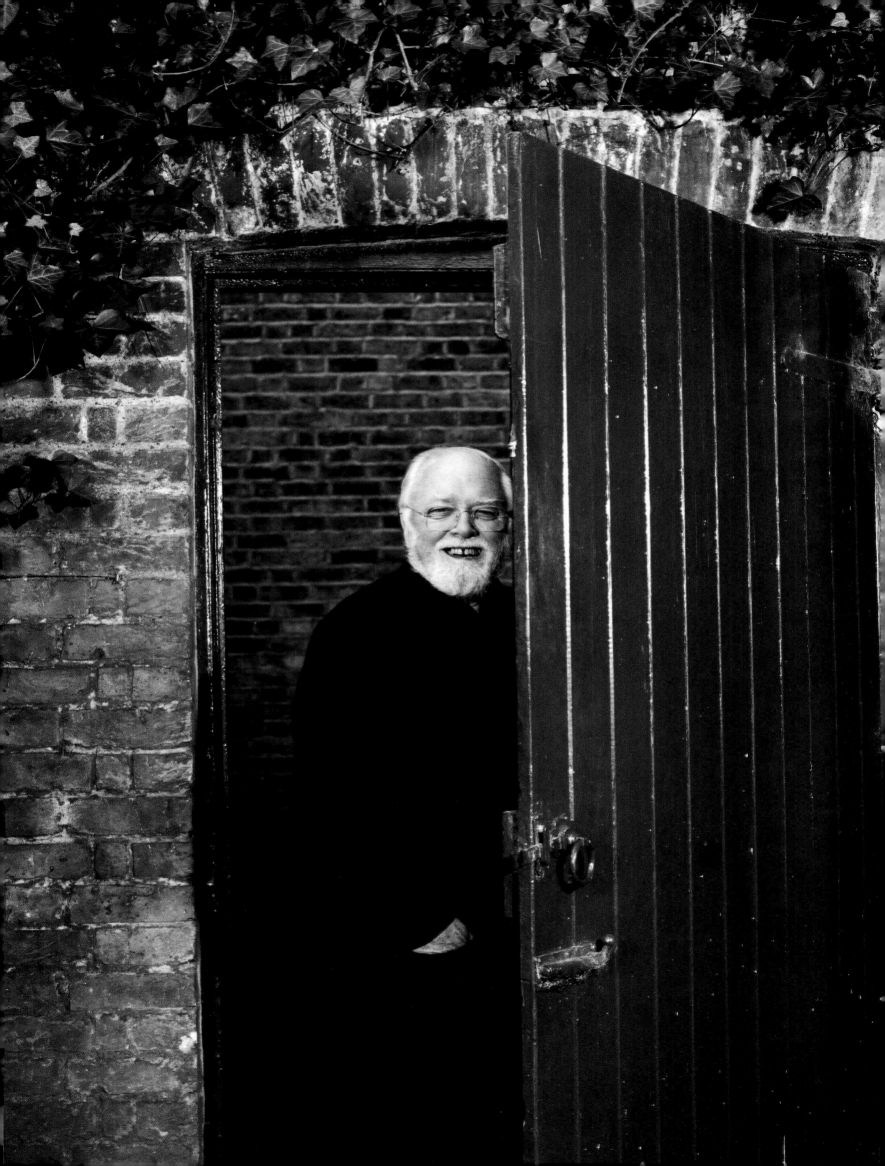

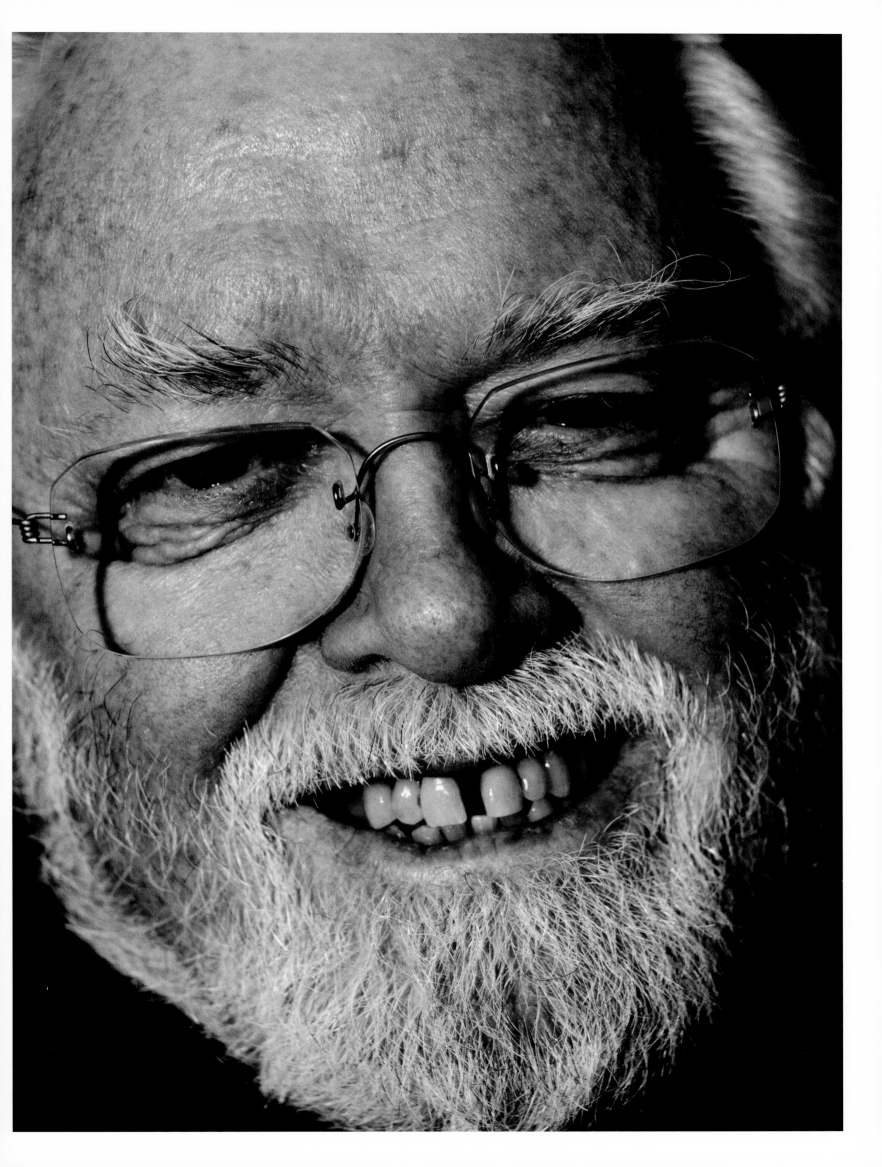

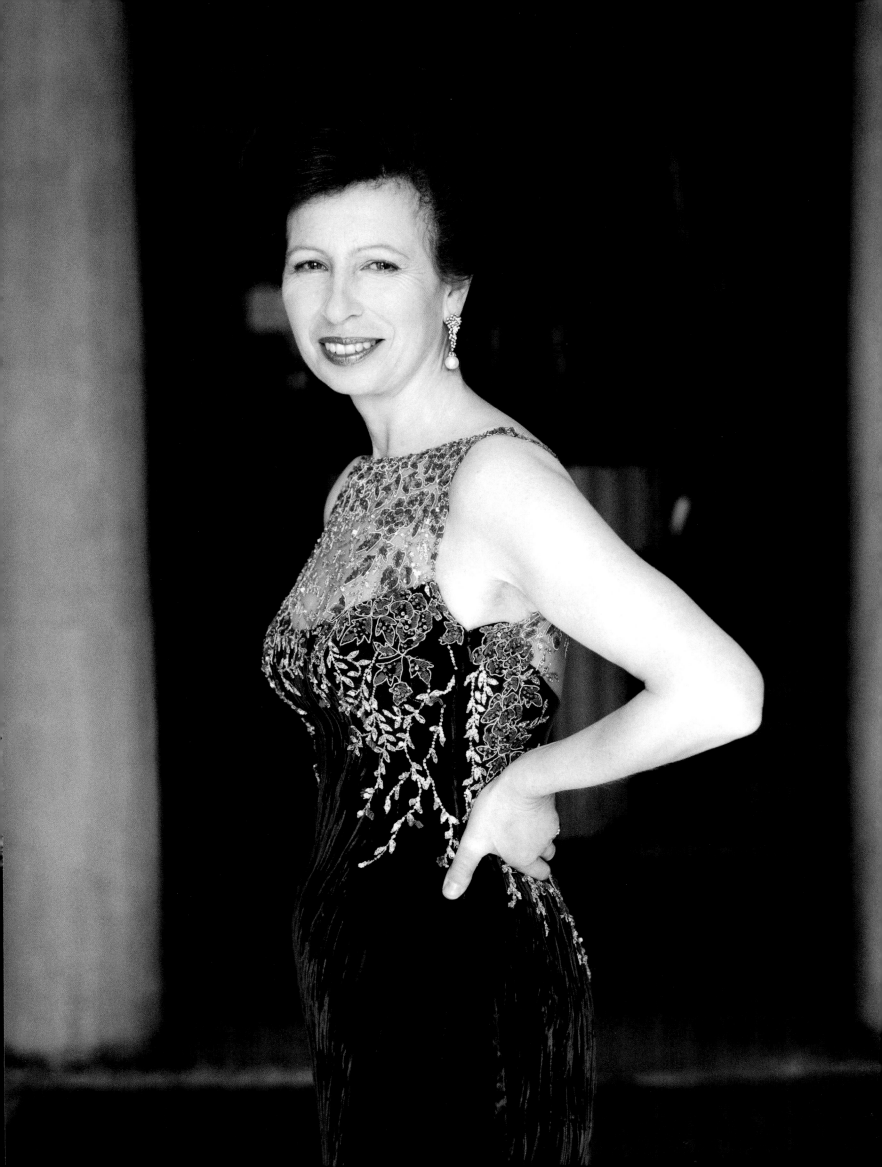

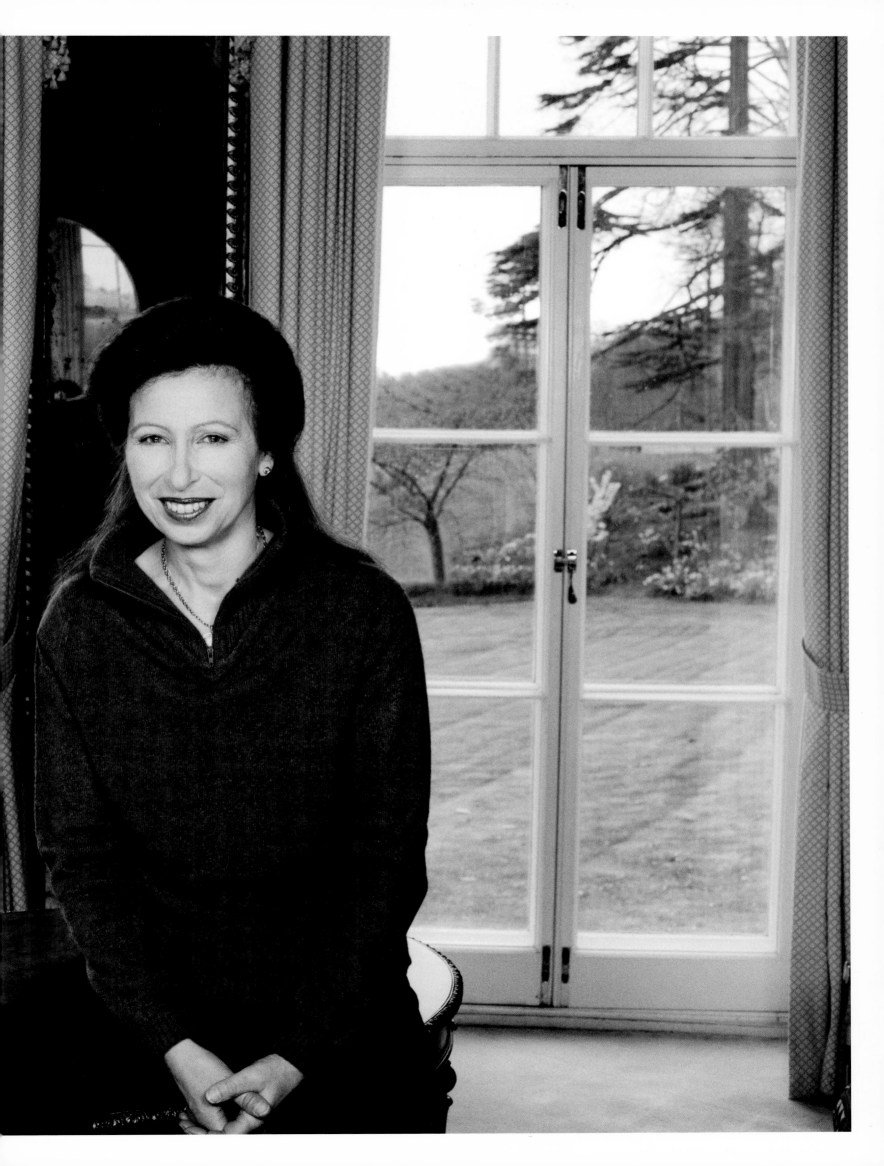

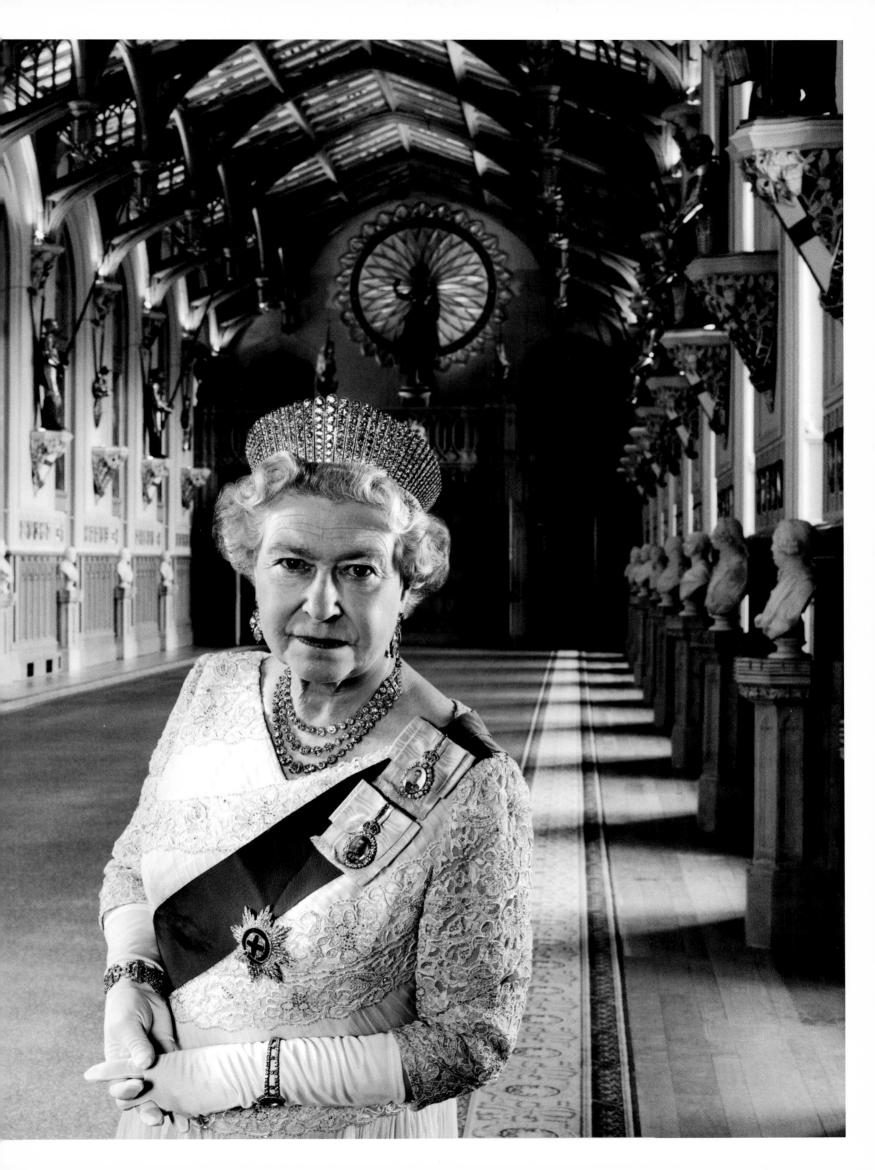

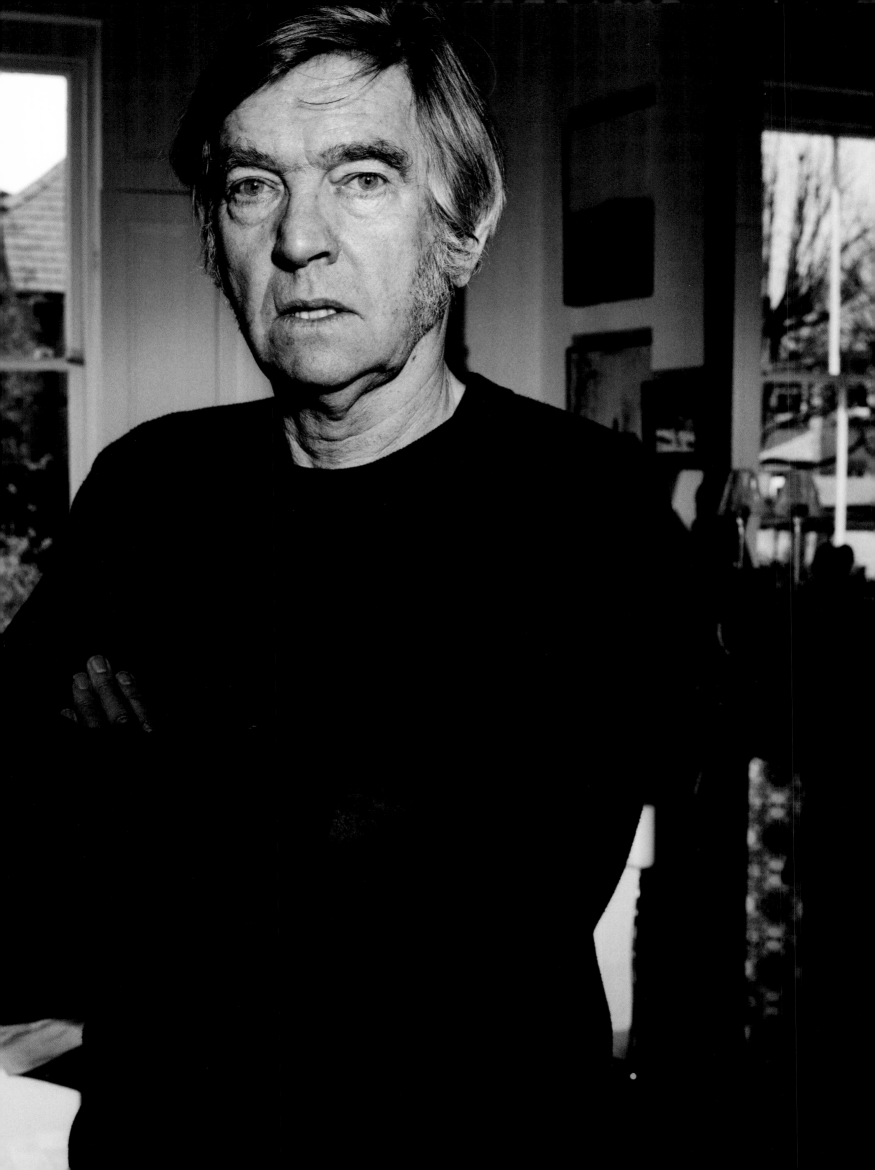

**Sir Tom Courtenay**
Actor

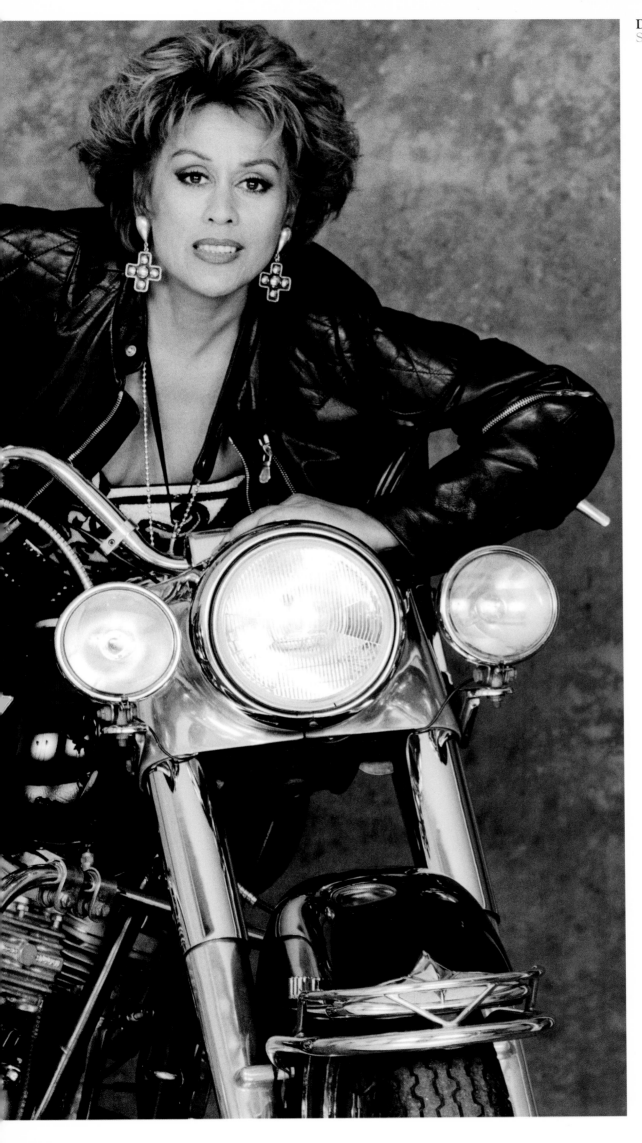

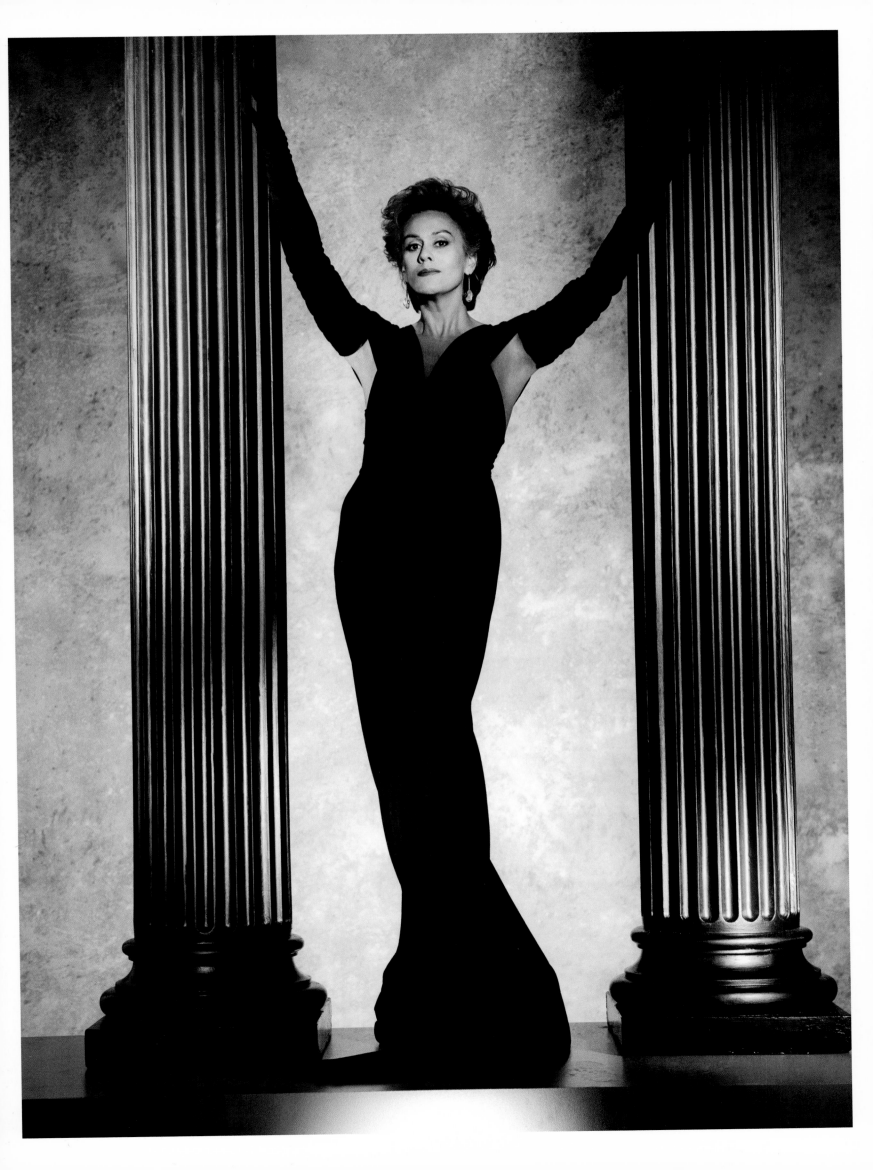

**Rowan Atkinson**
Actor, writer & comedian

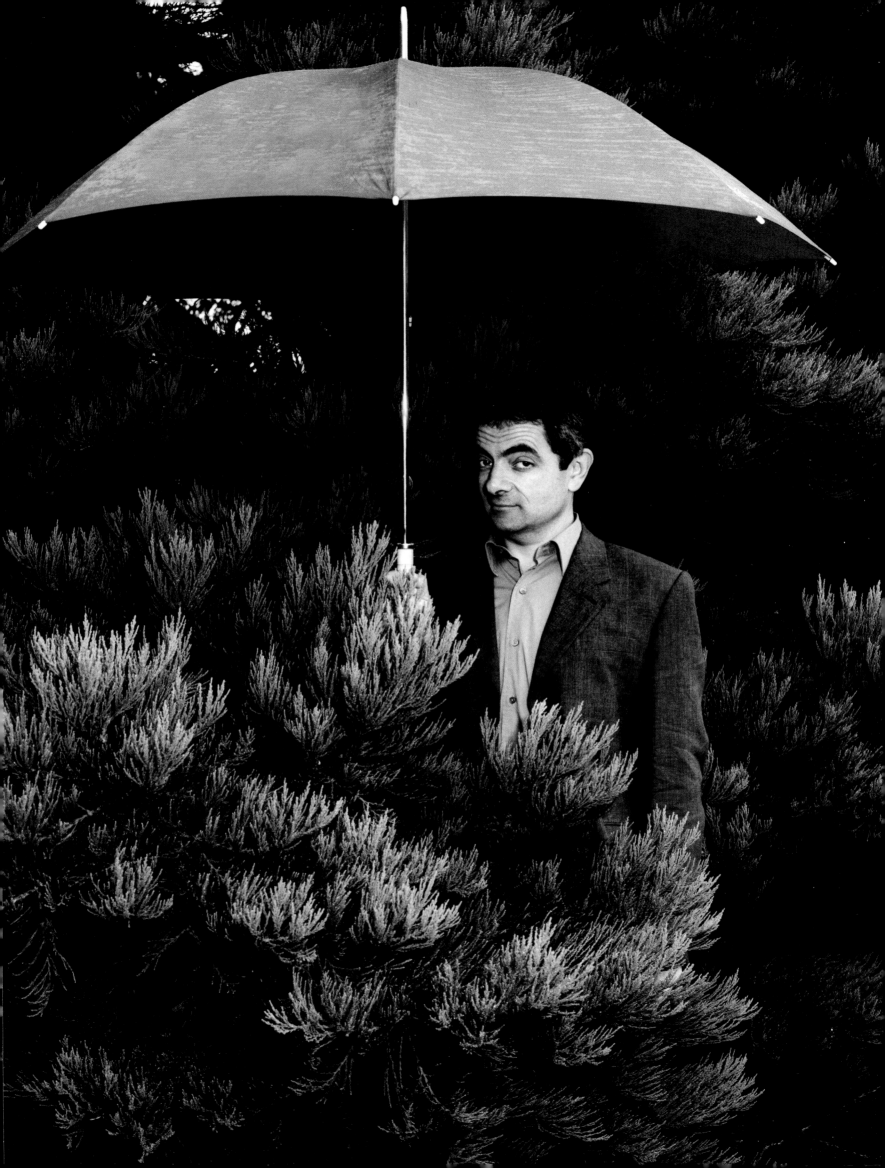

Peter O'Toole
Actor

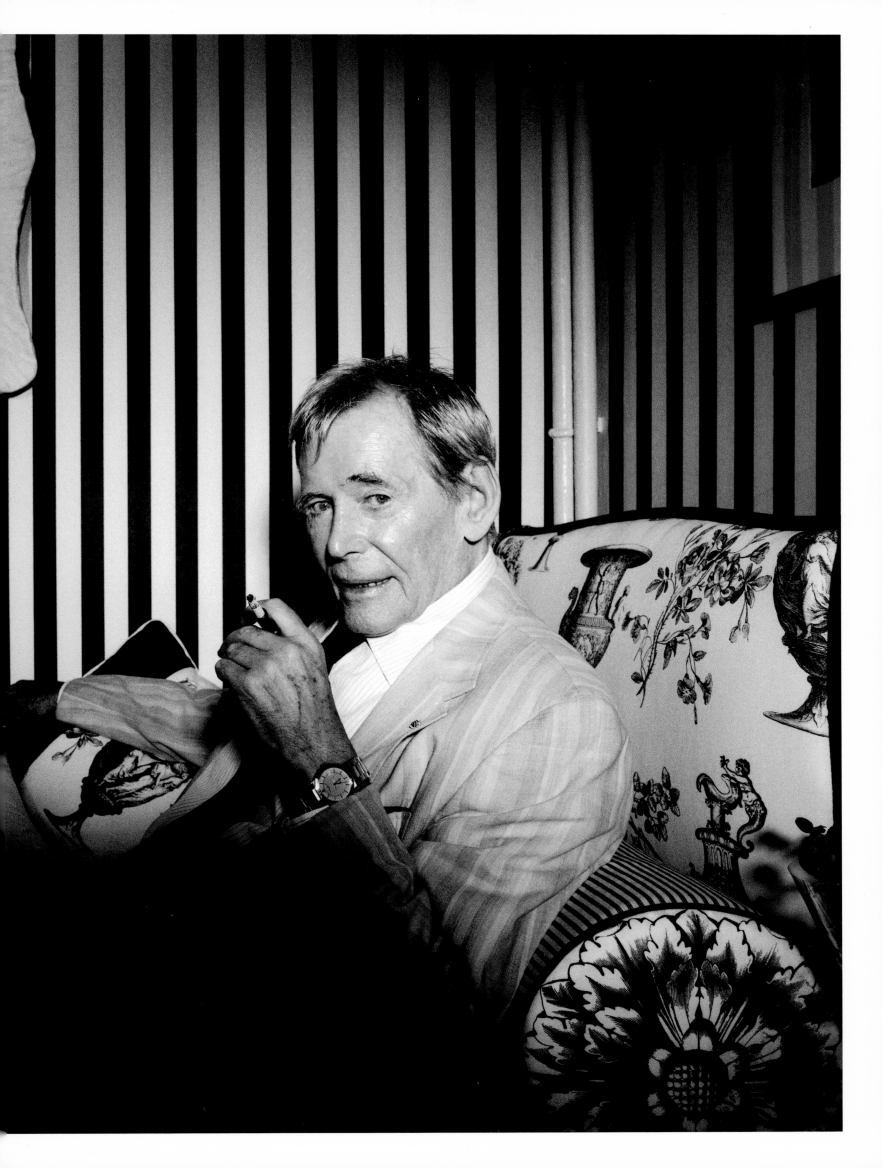

**Nigel Dempster**
Diarist

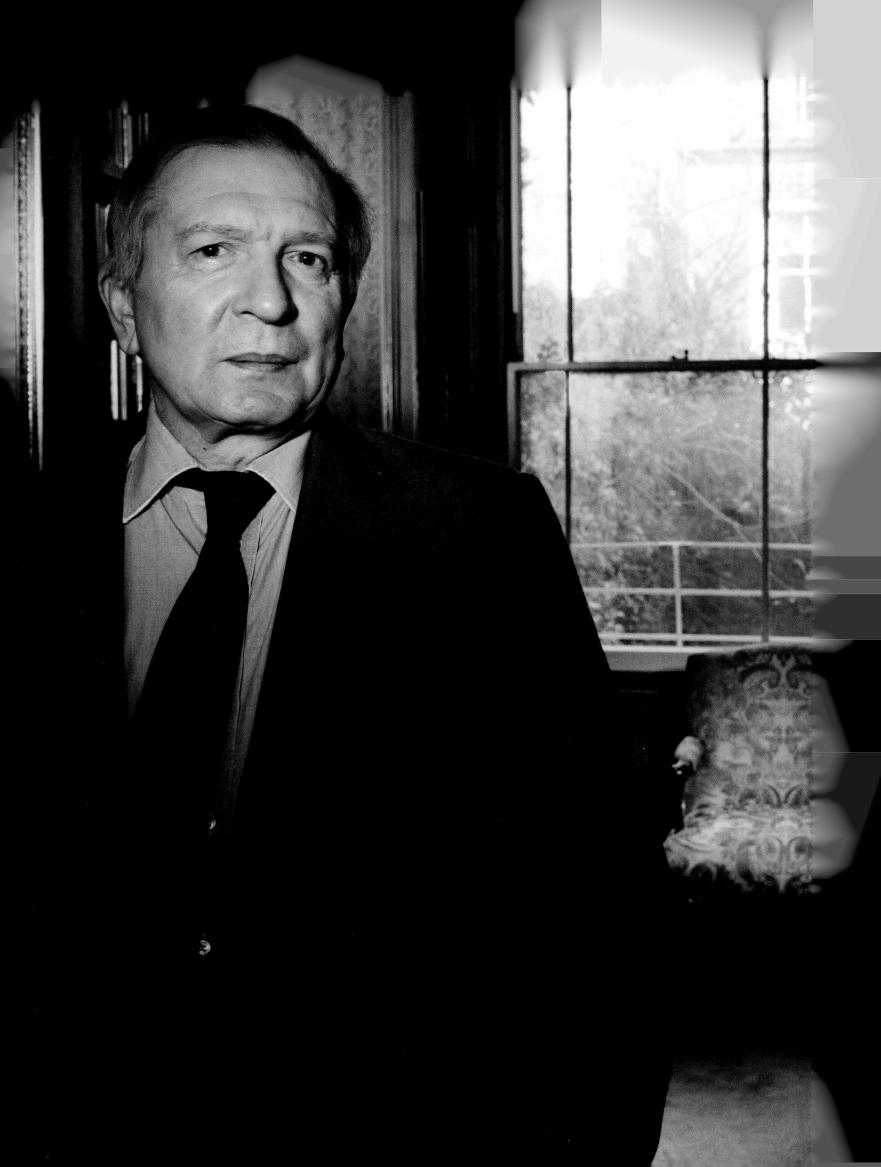

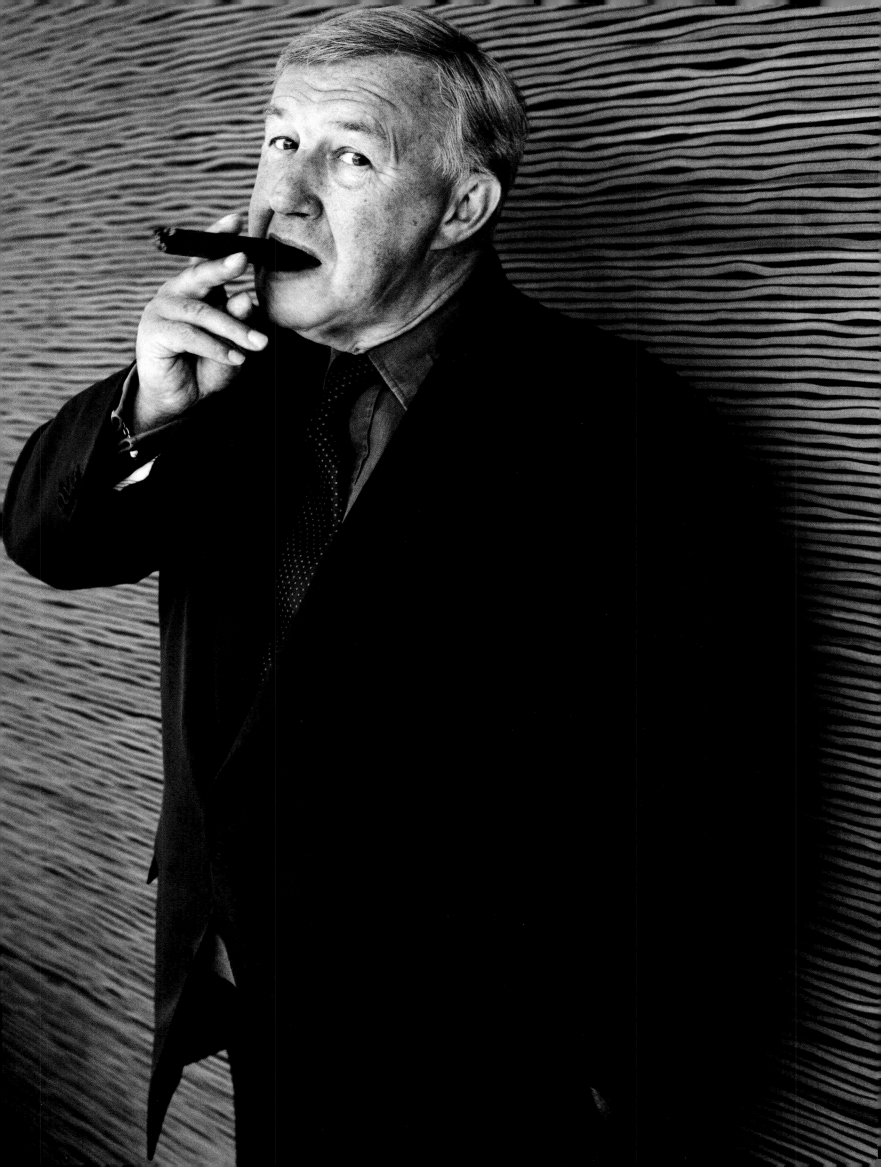

**Sir Roy Strong**
Writer, historian & gardener

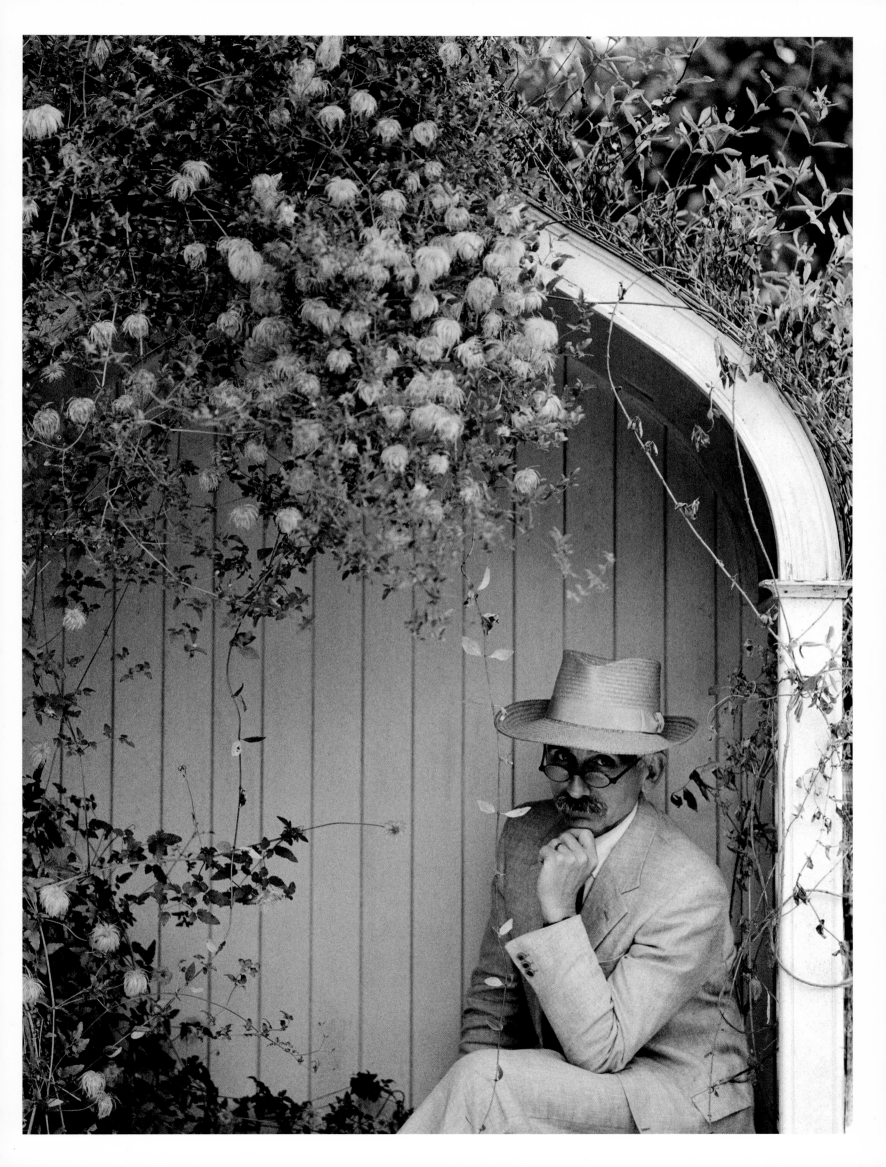

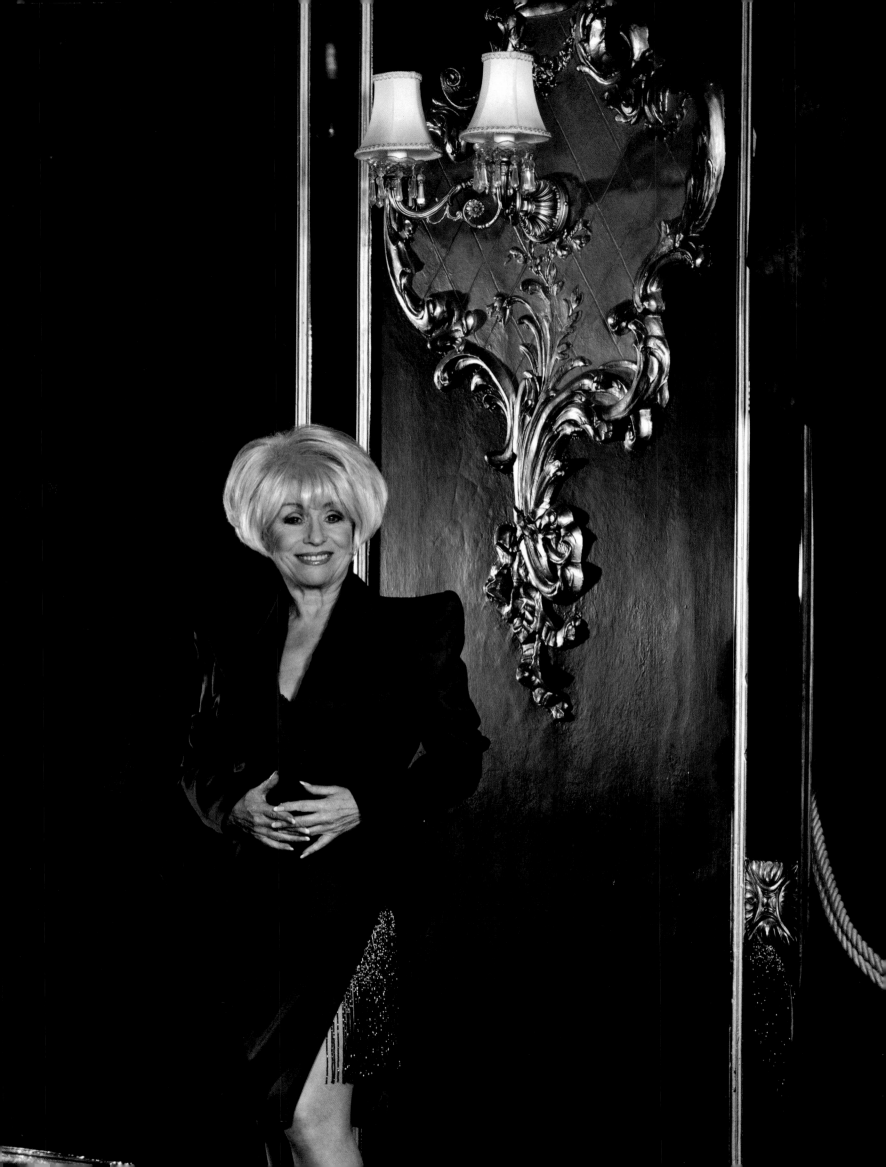

**Barbara Windsor MBE**
Actor

**Barbara Windsor MBE**
Actor

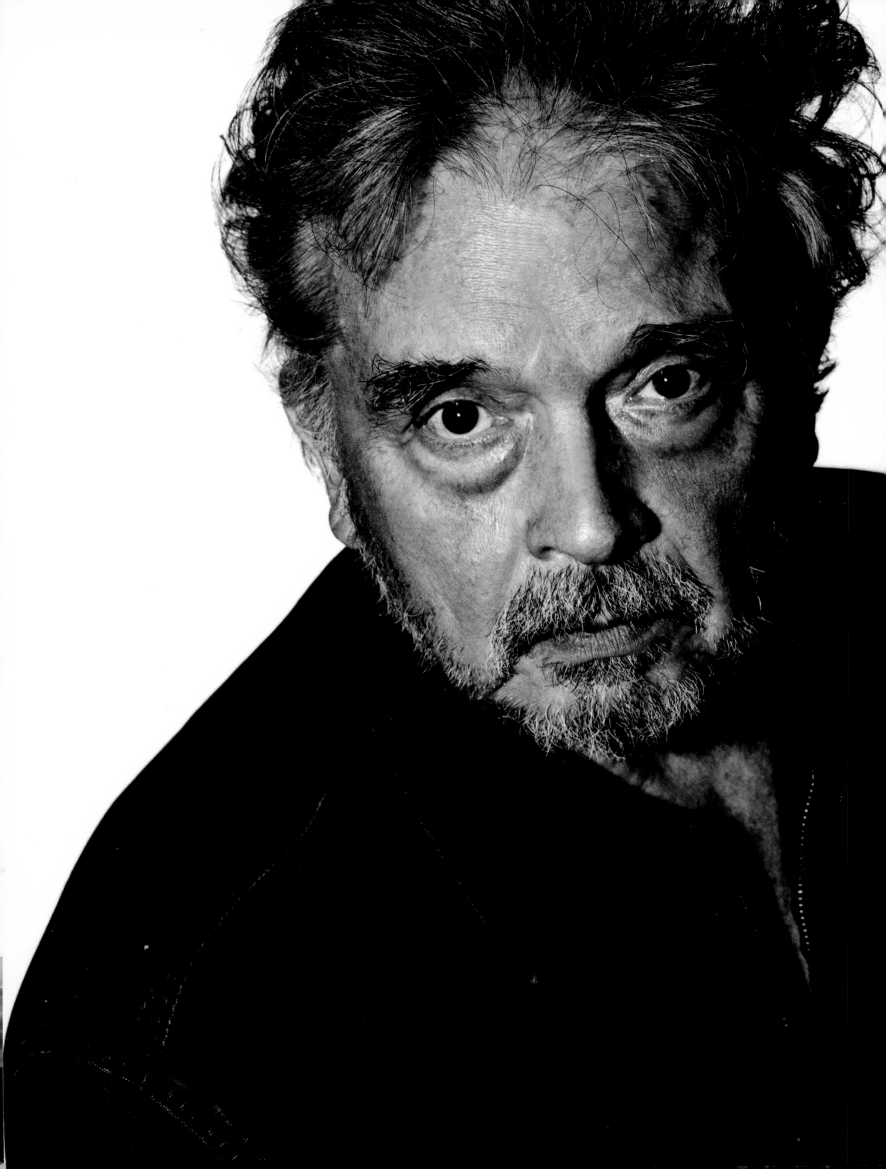

**Anne Robinson**
Journalist & TV personality

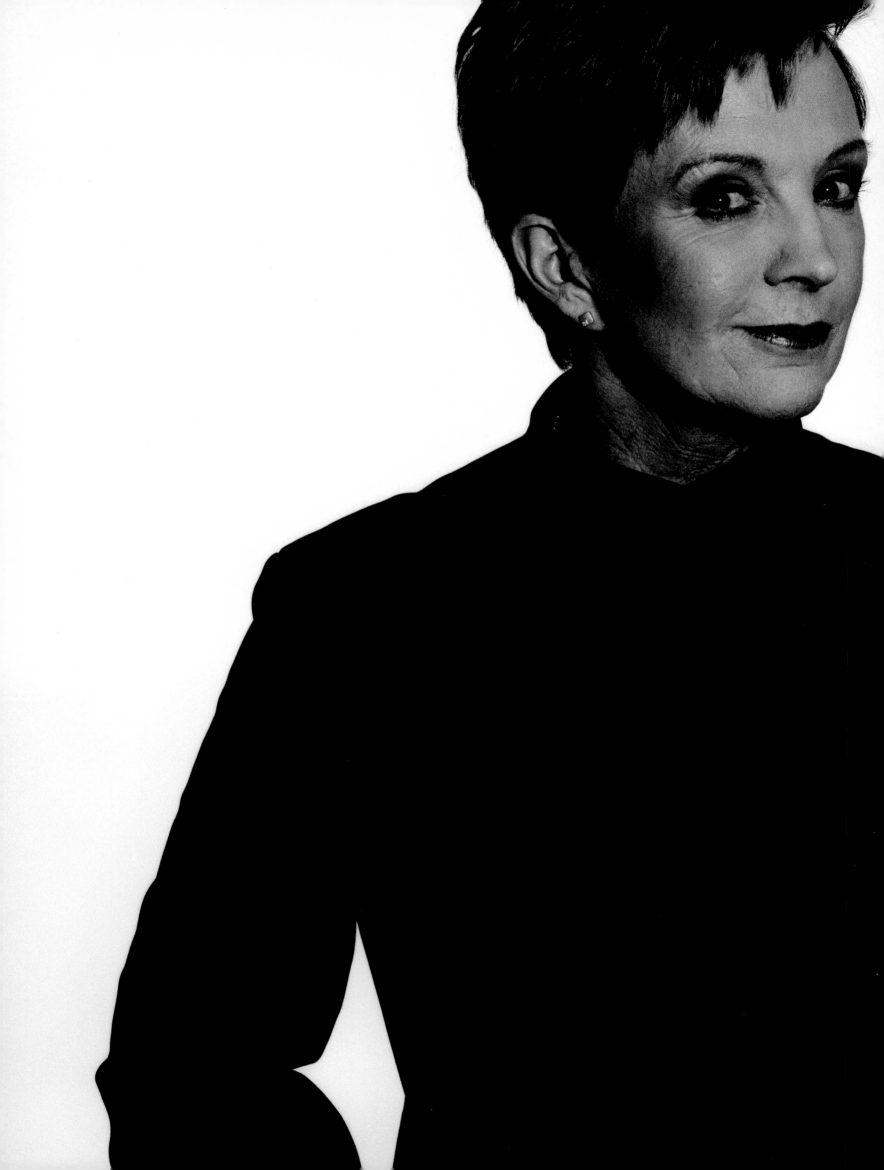

I'm
not
standing
any
more

**Sir John Gielgud**
Actor

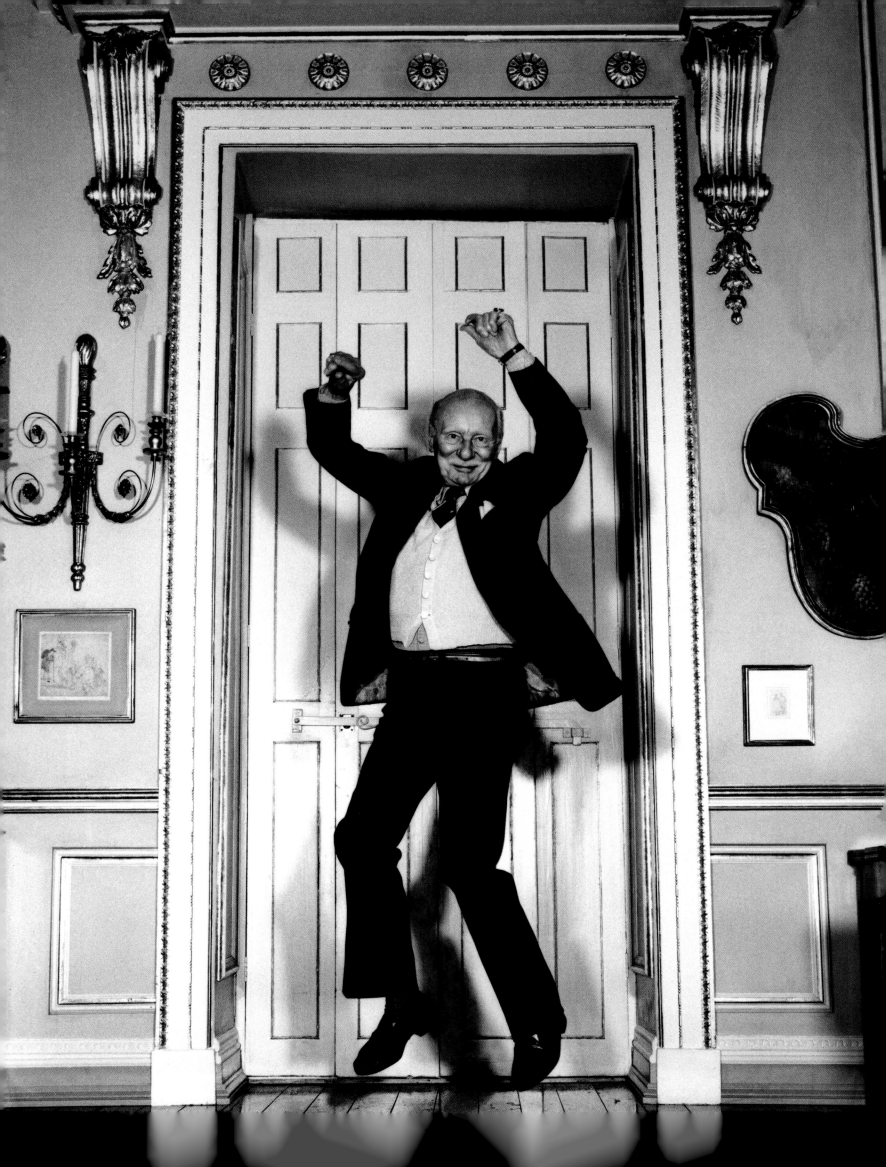

HM Queen Elizabeth
The Queen Mother

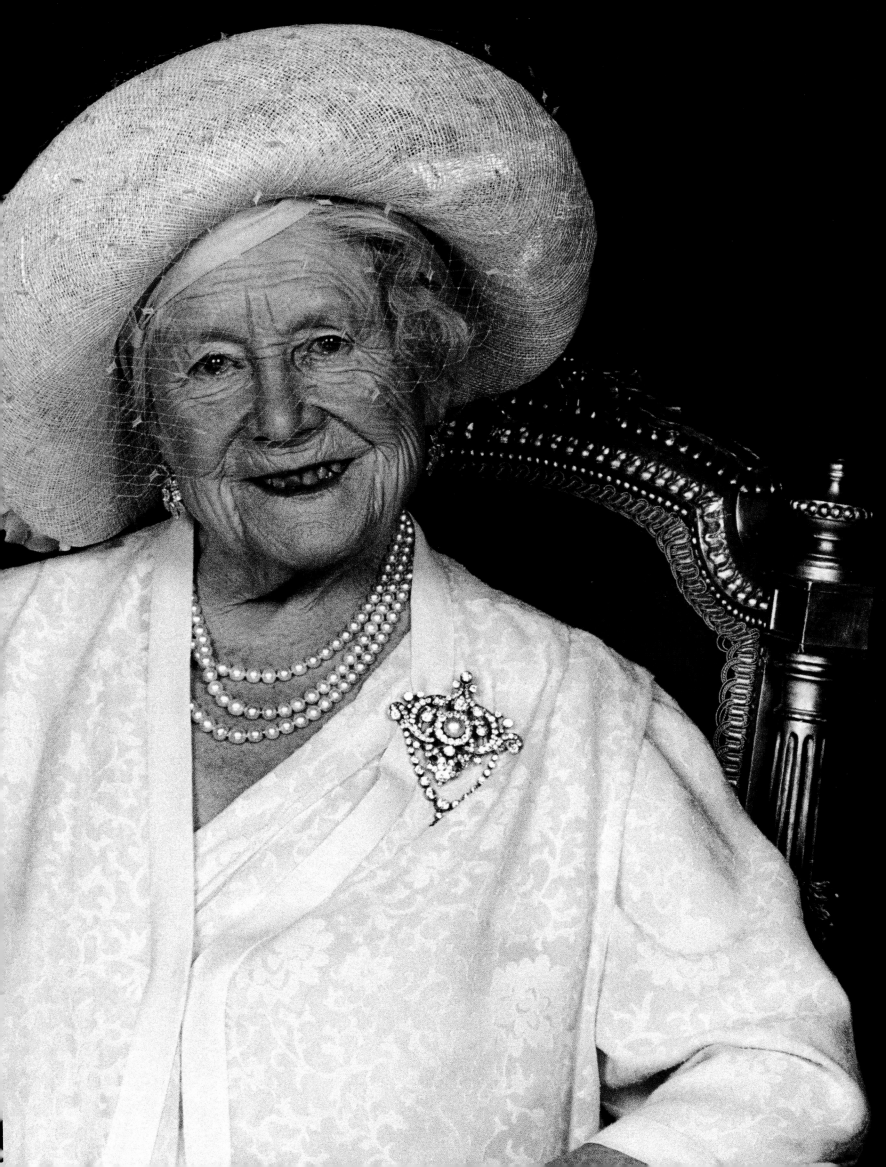

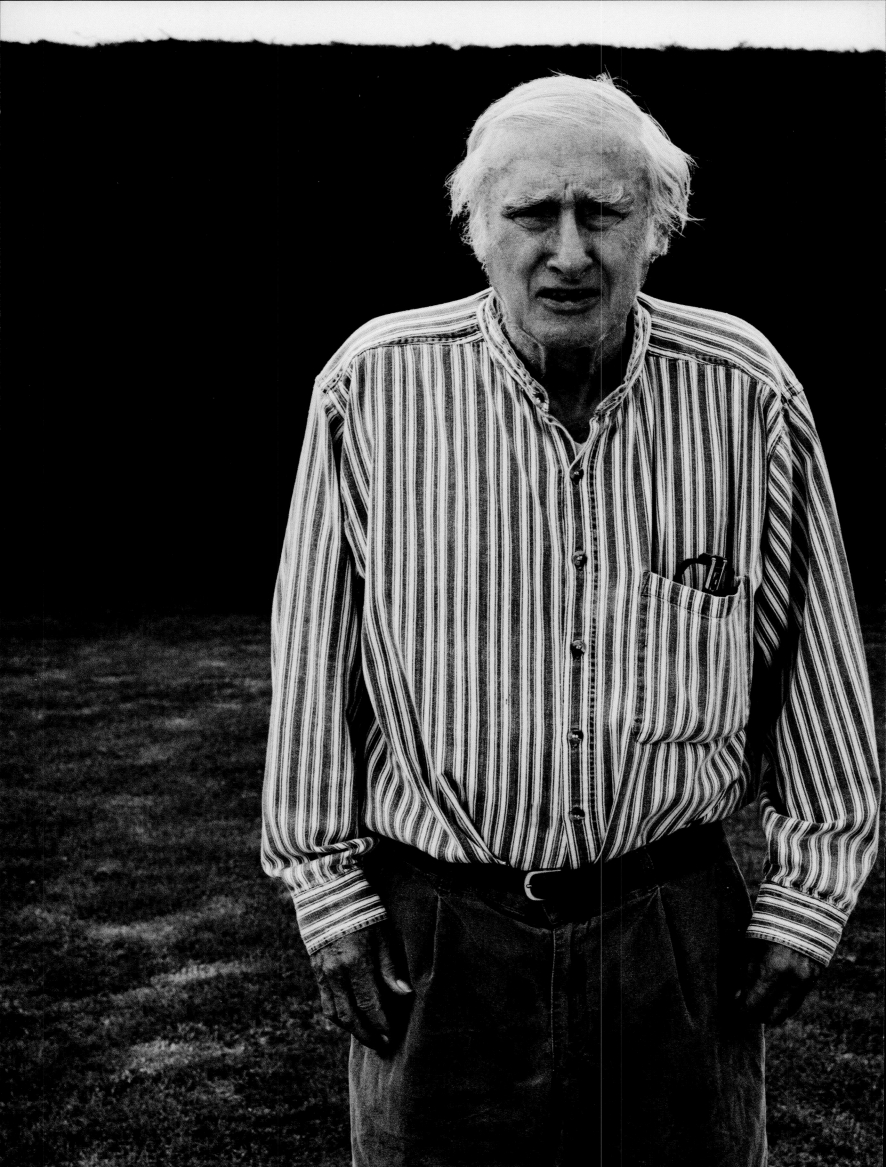

**Sir Spike Milligan**
Writer & comedian

195

# Index

11 **Bryan Ferry**

12 **Sir David Frost OBE**

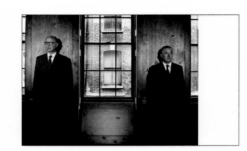

14-15 **Gilbert & George**

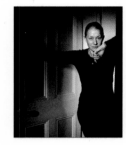

17 **Helen Mirren**

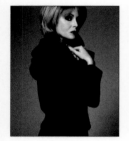

19 **Joanna Lumley OBE**

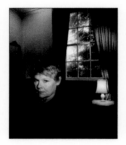

20 **Dame Judi Dench**

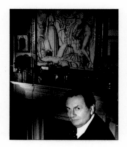

23 **Barry Humphries**

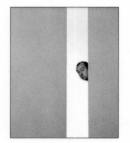

25 **Mel Smith**

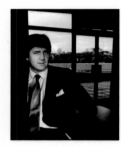

27 **Lord Bragg**

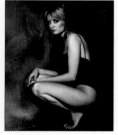

28 **Twiggy**

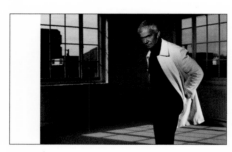

30-31 **Vidal Sassoon**

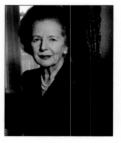

32 **Baroness Thatcher**

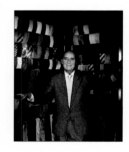

34 **Doug Hayward**

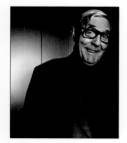

37 **Eric Sykes**

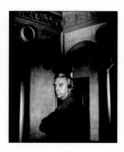

39 **Sir Frank Lowe**

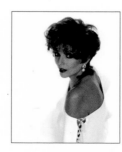

41 **Joan Collins OBE**

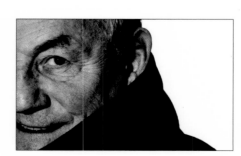

42-43 **Johnny Gold**

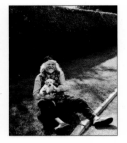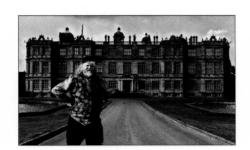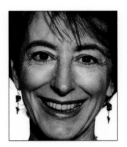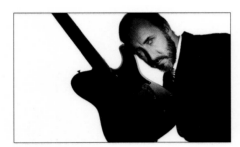

44-47 **The Marquis of Bath**

48-51 **Maureen Lipman CBE**

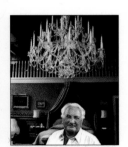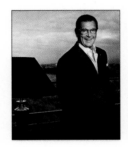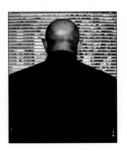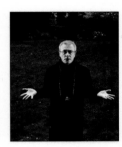

53 **Michael Winner**

54-55 **Pete Townshend**

57 **Roger Moore CBE**

58 **Terry O'Neill**

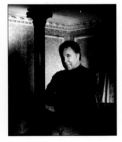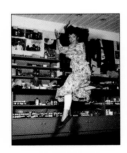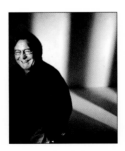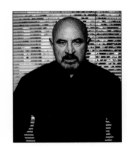

60 **Tom Jones OBE**

63 **Anita Roddick OBE**

64 **Sir Alan Parker**

67-69 **Bob Hoskins**

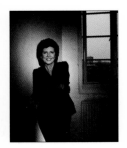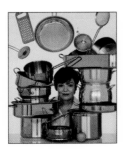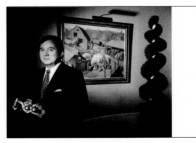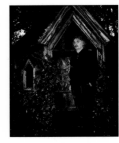

70 **Cilla Black OBE**

73 **Delia Smith**

74-75 **Sir Anthony Bamford DL**

76 **Billy Connolly**

# Index

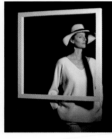

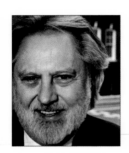

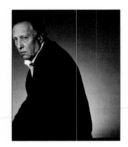

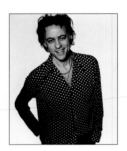

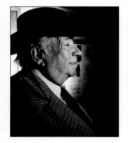

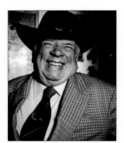

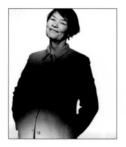

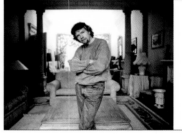

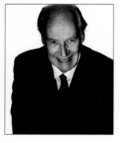

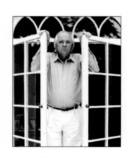

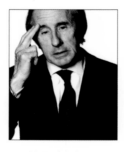

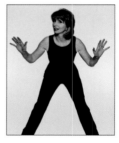

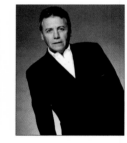

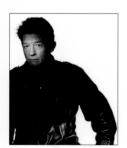

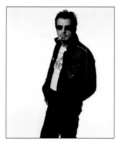

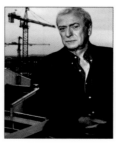

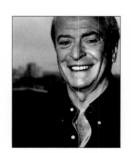

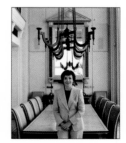

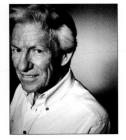

116 **Lord Litchfield**

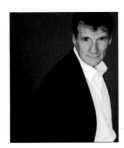

119 **Michael Palin CBE**

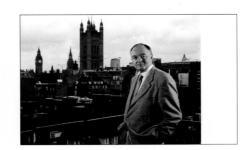

120-121 **Ken Livingstone**

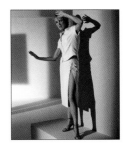

122 **Joanna Trollope OBE**

125 **Mary Quant OBE**

127-129 **Michael Parkinson CBE**

130 **Michael York OBE**

133 **Sir Norman Foster**

134-135 **Sir Norman Foster**

137 **Lord Lloyd Webber**

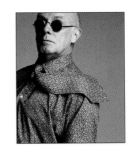

138 **Richard Wilson OBE**

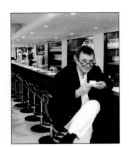

141 **Joseph**

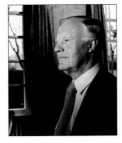

142 **Sir Jocelyn Stevens CVO**

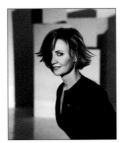

145 **Lulu OBE**

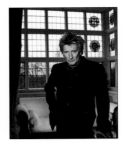

147 **Rod Stewart**

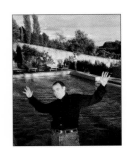

148 **Paul Weiland**

# Index

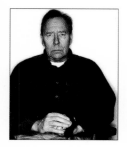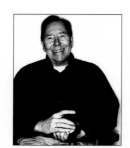

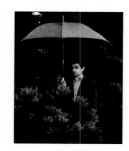

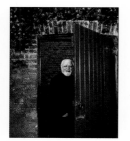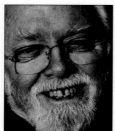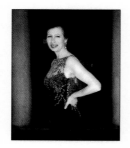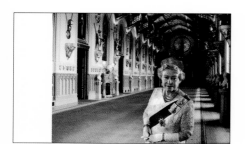

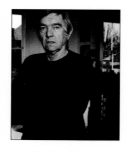

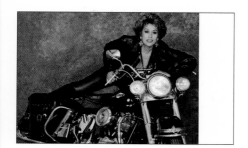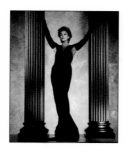

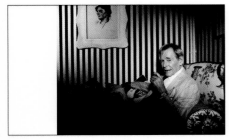

174-175 **Peter O'Toole**

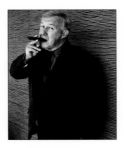

177 **Nigel Dempster**

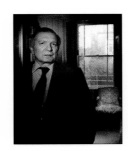

178 **Sir Terence Conran**

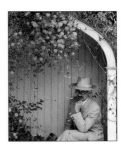

181 **Sir Roy Strong**

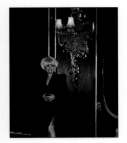

182 **Barbara Windsor MBE**

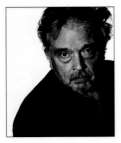

185 **David Bailey**

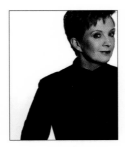

187 **Anne Robinson**

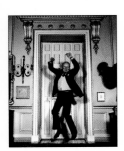

191 **Sir John Geilgud**

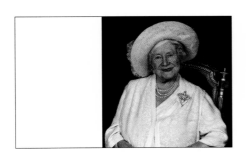

192-193 **HM Elizabeth The Queen Mother**

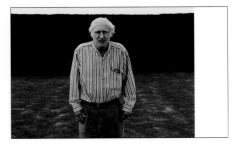

194-195 **Sir Spike Milligan**

# Acknowledgements

**Thanks to**

Allan Finamore
Anthony Pye Jeary
Barry Robinson
Barry Taylor
Core London
David Burnham
David Vintiner
Doug Hayward
Hilary Alexander
Joy Goodman
Kathy Philips
Katy Niker
Keishi
Kirk Teasdale
Lisa Ling
Marianne Lah Swannell
Maureen Lipman
Metro
Michael Palin
Michael Rasser & John Prothero
Nick Mason
Norma Farmes
Pat Booth
Penny Lancaster
Prue Rawlings
Rachel Leach
Rankin
Robin Morgan
Roger Eldridge & Jacqui Wald
at Camera Press
Sally Greene
Shakira Caine
Sir Roy Strong
Terry O'Neill
Tim Ashton
Tom Reynolds

**A special thank you to Rachel Down
& Robert Mackintosh, without whom
this book would not have been possible.**

# Credits

**Photography by John Swannell**

Contributing Editor Dan Crowe
Art Direction and Book Design Lisa Ling
Reprographics AJD Colour Ltd
Print Toppan

I'm Still Standing first published in Great
Britain in 2002 by Vision On Publishing
112-116 Old Street
London EC1V 9BG
T +44 (0)20 7336 0766
F +44 (0)20 7336 0966
www.vobooks.com
info@vobooks.com

ISBN 1 90339 67 X

Printed and bound in Hong Kong

www.vobooks.com

VISION ON